Whistler's Mother:
An American Icon

Edited by Margaret F. MacDonald

Whistler's Mother:
An American Icon

Lund Humphries

First published in 2003 by
Lund Humphries
Gower House
Croft Road
Aldershot
Hampshire GU11 3HR

and

Suite 420
101 Cherry Street
Burlington
VT 05401-4405
USA

www.lundhumphries.com

Lund Humphries is part of Ashgate Publishing

British Library Cataloguing-in-Publication Data
A catalogue record for this book is available from the British Library

ISBN 0 85331 856 5

Library of Congress Control Number: 200310656

Typeset by Tom Knott
Designed by Chrissie Charlton & Comapny
Printed in China by Midas Printing International Ltd for Compass Press Ltd

Front cover
James McNeill Whistler
*Arrangement in Grey and Black:
Portrait of the Painter's Mother* 1871
Oil on canvas, 1443 x 1625 mm
Musée d'Orsay, Paris
© Photo RMN – J.G. Berizzi

Back cover
James McNeill Whistler
Butterfly 1890/2
Pen and purple ink on off-white wove paper,
175 x 110 mm
Hunterian Art Gallery, University of Glasgow
Birnie Philip Bequest

Lloyds TSB
Scotland

Contents

Acknowledgements

I would like to thank all who helped with this project, starting with Georgia Toutziari, Joy Newton, Kevin Sharp, Will Vaughan and Martha Tedeschi, who have written such thoughtful, scholarly and entertaining essays. Thanks also to my colleagues in the University of Glasgow: to my fellow Whistlerians in the Centre for Whistler Studies, currently preparing an edition of Whistler's correspondence, Ailsa Boyd, Graeme Cannon, Sue Macallan, Ian and Joanna Meacock, Patricia de Montfort, Nigel Thorp, Charlene Tinney, and my former assistant, Liz Haine; to all the staff of Special Collections, particularly Nikki Pollock, Paul Fitzpatrick and David Weston, the photography department, and the Hunterian Art Gallery, including Josephine Anthony, Peter Black, Lynda Clark, Pamela Robertson and Sheenagh Young. I thank the University Court of the University of Glasgow, holders of Whistler's copyright, for permission to quote from correspondence. I appreciate the help of many galleries, museums and libraries, particularly the Freer Gallery of Art, Mitchell Library, Glasgow, the Library of Congress, the Musée du Louvre and Musée d'Orsay. Many thanks to the friends who have sent information relating to Whistler's *Mother* over the years, and helped generously with research – including Ronald Anderson, Avis Berman, David Park Curry, Ruth Fine Day, Richard Dorment, Susan Galassi, Bob Getscher, Kathy Goebel, Evelyn Hardyn, Martin Hopkinson, Dorothy and Robert Kemper, Geneviève Lacambre, John and Collis Larkin, Mark S. Lasner, Katharine A. Lochnan, Paul and Elaine Marks, Linda Merrill, Kenneth Myers, Wolfgang Rohdewald, Pierre Rosenberg, Robin Spencer, Nesta Spink, Anita and Juli Zelman. We are grateful also to the artists who have given permission to reproduce their works, to the collectors who have given permission to see and reproduce works from their collections, and others who wish to remain anonymous. My deepest gratitude to my husband, Norman, for his invaluable research and insight throughout, to Kathy and Helen, life-members of the MacDonald team, and to that amazing woman, my mother. Thanks to everyone at Lund Humphries, particularly Alison Green, Lucy Clark and Lucy Myers, and to the book's copy-editor, Vanessa Mitchell, and designers, Chrissie Charlton and Robin Clark. I am very grateful to the Art Institute of Chicago, Freer Gallery of Art, Washington DC, The Frick Collection, New York, and the Hunterian Art Gallery and Arts Faculty in the University of Glasgow for their support, and above all to Lloyds TSB Scotland, whose generous sponsorship has greatly enhanced this production, and helped bring to life a most important figure, an American Icon, Whistler's *Mother*.

Margaret F. MacDonald

Sponsor's foreword

Lloyds TSB Scotland has a strong interest in the visual arts and has supported major exhibitions throughout Scotland. As part of this focus, we are delighted to be title sponsor for a wide-ranging public programme of events at the University of Glasgow marking the centenary of the death of James McNeill Whistler. The University's Whistler Collections, centred on the artist's estate, are of international importance. Lloyds TSB Scotland is therefore particularly pleased that, through that partnership, it is able to support this publication, an authoritative and wide-ranging discussion of Whistler's masterpiece, *Arrangement in Grey and Black: Portrait of the Painter's Mother*, which will be exhibited at the University of Glasgow's Hunterian Art Gallery during 2003.

Susan Rice
Chief Executive
Lloyds TSB Scotland

 Lloyds TSB Scotland

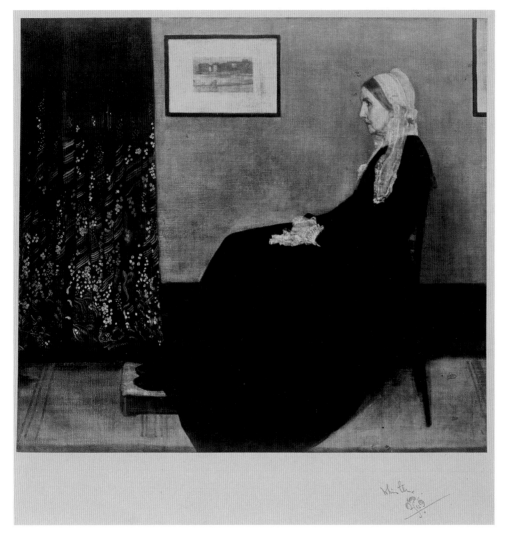

1 James McNeill Whistler

Arrangement in Grey and Black:
Portrait of the Painter's Mother 1871
Photograph, 1892
For the album 'Nocturnes, Marines and Chevalet Pieces'
Glasgow University Library

Introduction

Margaret F. MacDonald

This is the story of what a Woman's patience can endure, and what a Man's resolution can achieve.

Wilkie Collins, *The Woman in White*, 1857

This is a book about a woman, Anna Matilda McNeill, and her portrait (Fig.1), painted by her son, James McNeill Whistler. The centenary of the artist's death in 1903 (and the bicentenary of the mother's birth, in 1804) provide the opportunity for a new look at a famous son and his much loved mother. The portrait, *Arrangement in Grey and Black: Portrait of the Painter's Mother*, now hangs in the Musée d'Orsay in Paris. Whistler's *Mother* achieved immortality for both the sitter and her son. The painting is beautiful in colour and composition, reflecting the inner peace and strength of character of the mother, and the technical skill and aesthetic taste of the son.

It is also a familiar image to those who know nothing whatsoever about the mother and little about the son. It draws a smile, a laugh, from those who encounter it in cartoons and movies. It is an image as familiar as Leonardo's *Mona Lisa* (see Fig.79) and Grant Wood's *American Gothic* (Fig.86), joining Michelangelo's *David*, Botticelli's *Flora*, Munch's *Scream*, as cultural commodities familiar throughout the western world. This book aims to discuss the artist's mother as individual, as model, as theme, and as a phenomenon which became what might be called an American icon.

In the manner of Wilkie Collins' novel, quoted here, I shall narrate the parts of her story that I know best, and pass to my collaborators specific aspects that they know best.

Georgia Toutziari focuses on the life of Anna McNeill (later Anna Whistler) (Fig.6), the family and circle in which she moved, the households that she directed and her experiences in America, Europe, and Russia. She was a lively and intelligent woman, a great letter-writer, widely travelled and well read, with strong moral and Christian beliefs, which upheld her through joys and disasters.

My own essay explores the context and circumstances surrounding the painting of the portrait, at a time of personal and artistic crisis for Whistler. Anna's relationship with Whistler, particularly at the time she sat for her portrait, and the trials of artist and model in posing, designing, painting and completing the portrait, emerge from contemporary documents, including the sitter's letters. The painting itself, as viewed by contemporaries and through twenty-first-century analysis, reveals the secrets of its creation.

From as early as 1872, when it was first exhibited at the Royal Academy in London, the simplicity of the composition delighted cartoonists (Fig.2). By 1883, when it was first shown in Paris, cartoonists blamed English weather and smoking chimneys for the artist's

2 'Recollections of the Royal Academy'
Fun, 18 May 1872, p.202
Photograph courtesy of Katherine Goebel

3 'Une pauvre dame abandonnée dans appartment,
dont les cheminées fument'
L'Univers Illustré 1883, from Whistler's press-cutting album
Glasgow University Library

sombre studio and his mother's black mourning dress
(Fig.3). Joy Newton joins with me to describe the
exhibitions, promotion and marketing of the portrait.
Through a combination of artistic pressure and
political astuteness, it was sold to the French
government in 1892, becoming the first picture by
an American to enter the Musée du Luxembourg.
By describing the personalities and machinations
involved in its sale, we gain insight into Whistler's
personality and aims, and contemporary views of both
artist and picture.

Kevin Sharp focuses on a significant period in the
history of Whistler's *Mother*, when, for certain
personal, political, and art-historical reasons, the
painting toured the United States in 1932–4. This
became the occasion for a triumphant jamboree

(complete with adoring scouts). The press responded
to and encouraged public interest in the event,
stressing the picture's monetary, moral and artistic
value, and the extreme methods taken to protect it.

Will Vaughan broadens our theme to explore the
subject of artists' mothers as models, using such
artists as Rembrandt, Cassatt and Lucian Freud as case
studies to explore the relationship between artists and
their mothers. Psychoanalysis provides tools for
defining and discussing these relationships, and
provides intriguing insights into the artists' aims and
achievements.

Finally, Martha Tedeschi discusses the changing status
of the picture, from nineteenth-century Aesthetic
masterpiece to twenty-first-century American icon. The
increasingly familiar image of Whistler's *Mother* was
promoted by the artist himself, caricatured in the
press (Fig.4), and recreated in various forms, from pop
to politics, with layers of additional associations
accumulating over the years.

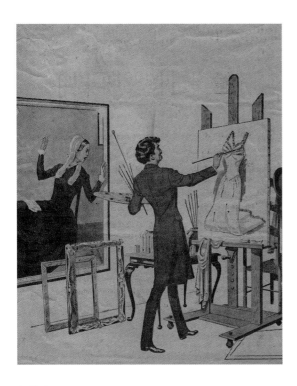

4 Cartoon
New York Herald, 5 September 1948
Glasgow University Library

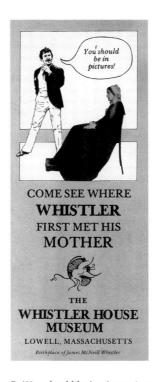

5 *'You should be in pictures'* 1990s
Leaflet
The Whistler House Museum, Lowell,
Massachusetts

Thus her appearance (with added flowers) on a 1934 postage stamp assimilated her into a cosy, Norman Rockwell, apple-pie America. Two generations later, in 1970, this image was subverted by the American director Roger Corman, who displayed the stamp with the credits for his movie *Bloody Mama*, about a violent, criminal and incestuous Southern family of the 1930s.

By the time that Whistler's *Mother* visited the National Gallery in America in 1995, she was the focus of enormous interest. I watched a woman bringing her two young children into the room where the famous painting hung. She held their hands tightly: 'There She is!' she whispered, and they stood for an age in front of it, gazing reverently.

The picture apparently inspires reverence, admiration and affection: both the picture itself, and the Whistler House in Lowell, MA, become objects of pilgrimage – not entirely serious pilgrimage. The museum in Lowell, MA, in the house where Whistler was born, added a joky caption to their promotional leaflet, 'You should be in pictures!' says Whistler to his mother (Fig.5).

Such images are funny, and good publicity, but make it a little difficult to approach the picture afresh. In our book, Whistler's *Mother* is retrieved from over a century of debris, of rich archaeological layers, where she lay concealed, buried with skeletons old and new. What re-emerges from our excavation is a beautiful, fascinating, and richly rewarding portrait, a masterpiece, and a great American icon.

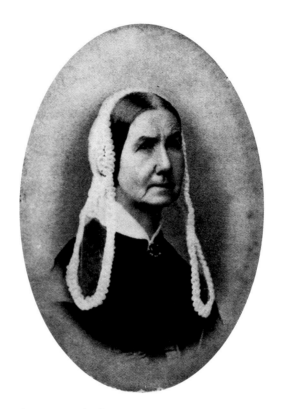

6 Anna M. Whistler
Photograph, *c.*1870
Glasgow University Library

Chapter 1 Anna Matilda Whistler: a life

Georgia Toutziari

Whistler's mother was a most delightful old lady, who always treated him as if he were a little boy, and used to scold him and reprove him. She stayed with him in Lindsey House for some time. She was very tactful and very pious. When my cousin Nell Ionides married Jimmy's brother, the mother lectured her on the necessity of being a constant attendant at church, and regular in her devotion.[1]

Luke Ionides

The quiet and pious woman immortalised in her son's *Arrangement in Grey and Black: Portrait of the Painter's Mother* has been gazed upon by millions of viewers, but her life has rarely been examined.[2] Anna Whistler inherited no titles or property to smooth her path in life. Her dependence on the male members of her family, together with her domestic and faithful character, sat well with the ideology of American motherhood and the 'Cult of True Womanhood' (embodying the virtues of piety, purity, submissiveness, and domesticity).[3] Women were often expected to stay in a 'separate sphere', the home, while men worked as breadwinners. Anna shared this widely diffused ideology.

While meeting these domestic expectations, Anna Whistler also experienced a series of more public activities: transatlantic travel, residence overseas and an active role in her son James's artistic career, including the promotion and marketing of his work. This public aspect of her life mirrors the profoundly changing environment of the nineteenth century. She was a prolific letter-writer, and her letters and journal present a rich social, cultural and family history over a period of thirty years, giving valuable insight into the social rituals of the white middle classes in Britain and America in the nineteenth century.[4]

Her story could be said to have started in 1739, over sixty years before she was born, the year in which her grandfather, William McNeill, emigrated from Kintyre in Scotland to North Carolina.[5] Anna's father, Dr Daniel McNeill, a native of Bladen County, NC, renewed his family's Scottish roots in 1784 when, on a visit to Edinburgh, he married Alicia Clunie, of Whitekirk, East Lothian. They had two daughters: Alicia Margaret (see Fig.33) and Eliza. Alicia never married and lived in Scotland most of her life. Eliza was married twice: first in Scotland and then again in Preston, Lancashire, to a solicitor, John Winstanley.[6] After his wife's death, Dr McNeill's second marriage was to Martha Kingsley (Fig.7), of Wilmington, NC, who bore six children: Isabella, Mary, William Gibbs, Anna Matilda, Catherine ('Kate') Jane, and Charles Johnson McNeill.

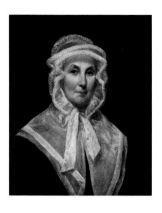

7 **Samuel Waldo
and William Jewett**
Martha McNeill
née Kingsley, 1834
Oil, photograph in Pennell-
Whistler Collection, Prints
and Photographs Division,
Library of Congress,
Washington DC

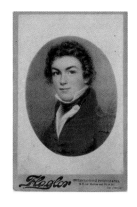

8 **Flagler Company**
William Gibbs McNeill 1820/30
Miniature photographed by Flagler,
San Francisco
Glasgow University Library

Little is known of the early life of Anna McNeill. She was born in 1804 and probably went to a private school or received education at home, as was considered appropriate for young girls of her standing. Her father was practising medicine in New York from around 1810 into the 1820s, which would suggest that Anna probably lived there for some time. According to a relative, William McNeill, Anna spent the first ten years of her life at Oak Forest, the ancestral home of the McNeills in the Brown Marsh area of Bladen County, NC.[7] From her writings we know that she spent a considerable amount of time in the South, at places such as St Augustine, Florida, which was close to her family's plantations.[8]

Her sisters Isabella and Mary married navy officers; the latter settled in the south of England. Kate married Dr George E. Palmer of Stonington, CT, and settled there. Charles J. inherited land from their Floridian uncle, the wealthy planter and former slave trader Zephaniah Kingsley, and settled at St John's, East Florida. The 'transatlantic character' of the McNeill family was well established by the early nineteenth century.

Of her siblings, William Gibbs McNeill (Fig.8) had the greatest influence on Anna Whistler's life. William

Gibbs attended the United States Military Academy at West Point, NY, where he met his sister's future husband George Washington Whistler (Fig.9). At the time, the Academy provided training in engineering, and Whistler and McNeill both pursued this path. In 1828, while still in the army, they were both sent to Britain to study railroad engines; they became prominent railroad engineers.[9] Whistler, a charismatic man of Irish descent, was known to Anna McNeill (in her youth) as 'Brother George'.[10] After the death of his first wife, Mary Roberdeau Swift (Fig.10), Whistler was left with three children to look after: George William, later an army officer and railroad engineer; Joseph Swift, and Deborah Delano ('Debo'). Anna's interest in 'Brother George' was known to her family, and their wedding in 1831, at her brother's house in New York, must have come as no surprise.

Marriage

Thus at the age of twenty-seven, Anna inherited a family of three, which, along with her own family members on both sides of the Atlantic, gave her considerable domestic responsibilities. She herself bore five children: James Abbott, William McNeill,

Kirk Boott, Charles Donald and John Bouttatz, of whom the last three died before the age of five. While her husband had to support his expanded family, Anna Whistler looked after all domestic affairs, and was largely responsible for supervising and providing her children's education and welfare; yet later in life she would come to depend on her children. Anna Whistler's reliance on male support during her single, marital and widowed years clearly reflect a patriarchal world that promoted the relegation of women to a separate sphere.[11]

The changing patterns of employment for the men in Anna Whistler's life affected both her living conditions and family relationships. Her husband changed his profession from army officer to railroad engineer soon after their wedding. His involvement in the construction of railroads (such as the Baltimore & Ohio, Boston & Lowell, and Providence & Stonington) saw the family move to New Jersey, Lowell, MA (Fig.11), Springfield, MA (Fig.12), and Stonington, CT.[12] Her son James, the future artist, was born in Lowell in 1834. With her growing family, Anna adjusted to recurring upheaval and provided a comfortable home in all these places. At all times the 'best cooking and the neatest house', was for her 'what made the very nicest housekeeper ever'.[13] The continuous upheaval experienced in the United States was continued in the 1840s in foreign lands. In 1842 Tsar Nicolas I of Russia appointed Whistler as chief engineer for the construction of the railroad between St Petersburg and Moscow, on a salary of $12,000 a year.[14] The attractive salary must have been a great temptation to the Whistlers, who felt that it would allow them to have a better lifestyle, free from financial constraints. Anna Whistler, her children and maid followed him a year later; but to their great grief, their youngest son, Charlie, died at sea en route to Russia.[15]

Life in Russia

The Whistlers remained in St Petersburg for six years. During this time they enjoyed an affluent lifestyle. They rented substantial houses in the most prominent locations of the city: first on the English Quay, and later in the Galernaya, on the left bank of the river Neva. These areas were occupied initially by British merchants resident in the city, and were known as the British or English Factory.[16] Their church, the 'Chapel of the English Factory', was frequented by both British and American families.[17] These two communities comprised some of the first foreign residents of the city, and the companies that they represented grew quickly and prospered in Russia. The Whistlers' acquaintances, the Mirrielees and Ropes families, the Gellibrands, Princes and Ingersolls, were merchants and diplomatic officials, socially connected through the prominent role played by the English Chapel. Anna Whistler's writings in Russia shed light on the lives of all these people. Their story was common enough in nineteenth-century British and American history – social elevation through mercantile success. George Whistler's professional acquaintances became Anna Whistler's social world. The locomotive partners Harrison, Winans and Eastwick (self-taught engineers and inventors from Philadelphia and Baltimore), who were associated with the building of the railroad, had all known her husband in the United States.[18] While in Russia, they operated the Alexandroffsky Mechanical Works (Fig.13), one of the biggest mechanical establishments in St Petersburg,[19] which provided the rolling stock and locomotives for the railroad. The project made the partners millionaires, and kept some of them in Russia until well into the 1860s.[20] They enjoyed a wealthy lifestyle, and spoiled their wives with expensive gifts, as indicated in one of Anna Whistler's letters:

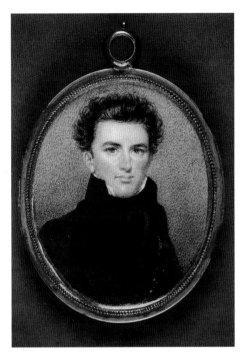

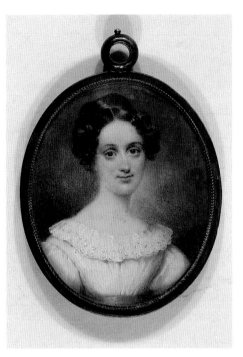

9 *George Washington Whistler* 1820/30
Miniature, 680 x 550 mm
Hunterian Art Gallery
University of Glasgow
Joseph Whistler Revillon Bequest

10 *Mary Roberdeau Swift* 1820s
Miniature, 680 x 550 mm
Hunterian Art Gallery
University of Glasgow
Joseph Whistler Revillon Bequest

11 *The Whistler House at Lowell, MA* 1908
From E.R. and J. Pennell, *The Life of J. McN. Whistler*
London and Philadelphia

12 *The Whistler House at Springfield, MA*
Recent photograph
Courtesy of the Connecticut Valley
Historical Museum, Springfield, Massachusetts

13 *Alexandroffsky Head Mechanical Works* c.1845
St Petersburg, Russia
Drawing, reproduction
Collection of David and Estelle Knapp

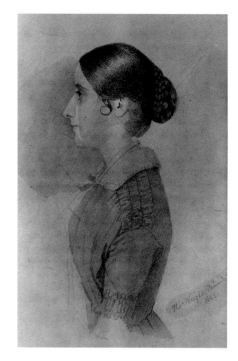

14 **Thomas Wright**
Anna Matilda Whistler 1845
Watercolour, 169 x 106 mm
Hunterian Art Gallery
University of Glasgow
Birnie Philip Gift

*upon her husbands second hint to examine the
contents of her baby shoes, she [Celeste Winans]
discovered a costly bracelet of purest gold & emerald hid
under the sweeties, and Julia Winans also found one of
gold & rubies in her box of bon bons, & young Mrs
Revillon a diamond ring as a guard to her wedding
ring.*[21]

By contrast, Whistler's professional success never
became a financial one. While her husband was away
supervising the rail tracks for long periods of time,
Anna (Fig.14) was responsible for good housekeeping
(including the supervision of a large number of
servants), and the education and welfare of her
children. The Whistler boys were privately schooled

alongside the best of the Russian and foreign elite.[22]
Trips to England were frequent, and Debo's marriage
to the surgeon Francis Seymour Haden in 1847
introduced a new family connection in London. Haden
was an enthusiastic print collector, who encouraged
the young James Whistler (Fig.15) to pursue his
artistic talent, and to study the drawings and etchings
in his collection.[23]

The Russian winters had damaged James's health,
so he stayed on in England. Meanwhile, in 1848,
Russia was affected by a cholera epidemic.[24] George
Washington Whistler contracted the disease, and died
in their residence, 'Dom Ritter', on 7 April 1849. His
mother wrote to James:

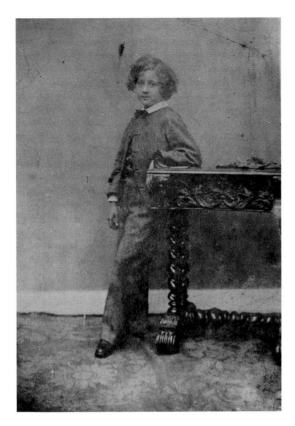

15 *James McNeill Whistler* c.1844
Photograph
Glasgow University Library

16 *Old Corner House, Stonington, CT* 1890s
Photograph
Glasgow University Library

Oh Jemie this home is so desolate without him! I mourn my loss so deeply! ... Prayer strengthens me, & the word of God comforts me but this morning I have been only reading my own heart, while writing to Grandmother & to your Uncle McNeill, & I sink under the weight of my selfish sorrow.[25]

Anna Whistler was left with an income derived from railroad stocks from her husband's estate.[26] Her shares were worth $8000 and came from the United States, Philadelphia Wilmington & Baltimore, Albany City (Western), and Boston & Providence Rail Roads. With the help of Harrison and Ropes from Russia, Anna, her boys and 'so faithful'[27] servant, Mary Brennan, arrived back in the United States on 10 August 1849.[28] Later in the month, her husband's coffin followed, and his burial at Evergreen Cemetery in Stonington, CT, closed a chapter in Anna Whistler's life.[29]

The role of the widow

Stonington is a coastal town in the south of Connecticut.[30] Anna's sister, Kate, was by then well settled there, and the Palmers' 'Old Corner House' (Fig.16) gave shelter to the Whistlers at many a difficult time. However, Anna's sense of responsibility for the education of her children did not allow her to settle there. Religion had always been an integral part of her life, and was now directing her to fulfil the role of the widow as defined by Timothy in the Bible:[31] 'Now she that is a widow indeed, and desolate, trusteth in God, and continueth in supplications and prayers night and day.'[32] Anna Whistler was guided by Timothy's text for the rest of her life. She always saw herself first and foremost as a Christian mother. Her

17 *Cavalry Drill at West Point* 1855
After an engraving from *Gleason's Pictorial*
West Point Museum, United States
Military Academy, West Point, NY

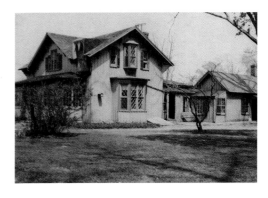

18 *'The Cottage' at Church Lane, Scarsdale*
Photograph
Scarsdale Public Library, NY

role of training her children to be good Christians was now more important than ever.

Her decision to move to Pomfret, CT, a rural community, was instigated by the provision of Christian schooling there.[33] This benefit evidently outweighed its geographical isolation; the place was awkward to reach from Stonington, Baltimore and Scarsdale, NY, places visited often by Anna Whistler in the years to come. The attraction was Christ Church School, whose rector, Professor Roswell Park, the tutor of the Whistler boys, later established an Episcopal college at Racine, CT. Anna Whistler, her boys and one servant lived at Pomfret between 1850 and 1852: her household and income was by then drastically reduced in size. She initially thought that her income would be about $1500 per annum[34] but in 1851 she wrote that her own income united with William's was no more than $900; however, this was sufficient for basic living in humble circumstances in a rural resort such as Pomfret.[35]

In 1852 the educational needs of her sons prompted another move, to Scarsdale, NY. James Whistler had entered the Military Academy at West Point (Fig.17), following in his father's footsteps, and William had enrolled at Columbia College, NY, to train for his chosen career in medicine.[36] Anna Whistler was 'passive' to both choices, as she would have preferred a career in architecture for James, and one in the ministry for William.[37]

Scarsdale was within easy reach of both West Point and Columbia. The other reason for choosing Scarsdale was that Margaret Getfield Hill, a pious single woman of Irish descent, and a loyal friend, lived there, with her sister Sarah Stewart Hill. Margaret's next-door neigbours were her sister Jane and Jane's husband William S. Popham, an affluent landowner and coal merchant (one of the first established in New York). Popham's prosperity suggests that it was he who built the cottage (Fig.18) that Anna Whistler intermittently occupied in Scarsdale between 1853 and

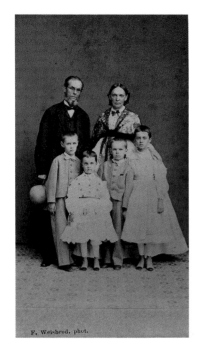

19 **F. Weisbrod**
*Julia De Kay Whistler, George William
Whistler, and their children Julia, Tom,
Ross and Neva* August 1865
Photograph
Glasgow University Library

20 *Baltimore, view from Shot Tower* Autumn 1849
Photograph
Maryland Historical Society Library, Baltimore, Maryland

1857.[38] The Hills' and Pophams' involvement in the local church, St James the Less, for the building of which the latter granted part of his land, was an added attraction.[39] Its rector, the Reverend Ollssen, became a frequent visitor to the simply furnished 'Scarsdale Cottage', just as the Reverend T. Ellerby had been to the Whistlers' houses in St Petersburg, and as the Reverend Robinson would be to James Whistler's London residence in later years.[40]

James Whistler did not comply with the strict academic curriculum of West Point, and was finally dismissed in May 1854 due to poor grades.[41] Constantly committed to her son's welfare, Anna secured a professional post for him at the United States Coast and Geodetic Survey in Washington DC.

James did not last long there either, and seemed to have made up his mind by this stage to become an artist. Again his mother supported his plans, and negotiated his first commissions through the Winans. Thomas De Kay Winans had by now returned to the United States and built an imposing villa bearing the same name as his mechanical works in Russia, 'Alexandroffsky'. He became an early patron of James, and also offered a temporary post to his brother William in his shop in Baltimore (the latter had temporarily postponed his studies).[42] Meanwhile, Anna Whistler's stepson George William had married Julia De Kay Winans, sister of Thomas (Fig.19).[43] The professional connection through Anna Whistler's husband now became a family one.

21 *Maria Isabella Rodewald née McNeill* 1860/65
Photograph
Private Collection
Courtesy of Wolfgang Rohdewald

During this period, a number of personal tragedies affected Anna Whistler. Three years earlier, in 1852, her mother, Martha, had died. In 1853, William Gibbs McNeill, Anna Whistler's much loved elder brother, had died on his return from a trip to England. His son, William Wyatt McNeill, died a few months later. William Gibbs left behind three daughters, Maria Isabella (Fig.21), Julia Catherine and Eliza. Anna kept in close contact with her late brother's family. The first two married two brothers, Adolphe and Frederick Rodewald, bankers of German origin; and Maria settled in England. Eliza married Edward Flagg, a clergyman and brother of the well-known painter Henry Collins Flagg, of New Haven, CT.[46] Then, in 1857, Anna's sister at Preston, Eliza Winstanley, died, and with her a British connection that had been an integral part of Anna Whistler's life.[47]

The artist's career

In 1855, James Whistler had set off to Paris in pursuit of his artistic career. His mother remained faithful in her support during his training in Paris, and his later development and rise to become one of the most influential and controversial artists of his era. The correspondence of the late 1850s between mother and son shows, at times, an agent–artist relationship, as when Anna Whistler wrote, 'I have not been advised to send the etchings yet to Mr T. Winans, but he knows they are in my safe keeping ... Capt and Mrs Swift are to spend an hour soon with me looking at the set you gave me.'[48]

In 1854, due to her sons' ever-changing patterns of employment, and their deteriorating finances, Anna Whistler left Scarsdale and moved for a short period to Baltimore (Fig.20).[44] The collapse of railroad shares in 1855 seriously affected the family income, forcing them to live with her nephew Donald McNeill Fairfax, a naval officer at Preston Street, Baltimore. In April 1855, when visiting the Winans' estate, she confessed,

> *Bills came pouring in & I am helpless, I have been tempted to talk to our host here! ... I am not dishonest tho poverty has overtaken me. I feel my winter bonnet! I see my old gown of two summers wear, foxy & thread bare. Still I know my respectability does not depend on dress, tho comfort does upon neatness.*[45]

In 1858, while James was producing his first well-received set of etchings, *Twelve Etchings from Nature*, 1858 (the 'French Set', K.9–11, 13–17, 19, 21, 22, 24),[49]

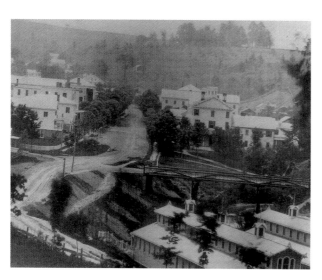

22 *Sharon Springs, New York c.1865*
Sharon Historical Society, New York
Courtesy of Mr and Mrs Manko

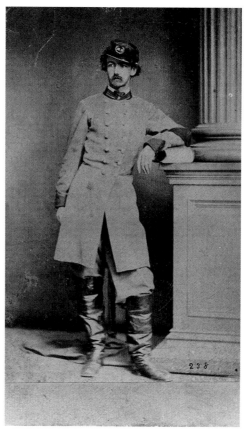

23 *William McNeill Whistler 1862/63*
Photograph
Glasgow University Library

his brother William decided to return to medical studies. He went to Philadelphia where he completed his apprenticeship with Doctor James Darrach and gained his medical diploma from the Pennsylvania Medical School.[50] Anna followed William to Philadelphia, where the families of Harrison and Eastwick from St Petersburg were now settled. She visited their newly built elegant mansions at Rittenhouse Square and Bartram Hall (both designed by the architect Samuel Sloane),[51] and commented on their wealth and its effect upon their behaviour: 'I seldom meet any of the family [Harrison], the distance is too far for me to walk to Ritten house Square often & they have such a rich, fashionable circle now of course they do not invite me.'[52]

The recurrent ordeals of illness, death, family separation and the constant movement between new homes in the severe winters of New England had a harmful effect on Anna Whistler's health. In the late 1850s and early 1860s, she visited Sharon Springs (Fig.22), and Richfield, NY, both popular spa resorts, which by the mid 1850s had gained popularity for their mineral waters. Sharon at the time had

developed into a luxury resort.[53] Lavish hotels and bathhouses served the elite and smaller boarding houses served people like Anna Whistler, with a lower income; as she described it, 'The Eldredge house equally respectable & nearer the Spring. Ten dollars a week suiting my purse better that [sic] Fifteen!'[54] Although the springs brought Sharon to prominence, they provided only temporary relief to Anna. Rheumatism and deteriorating eyesight brought her to Northampton, MA, in 1862, in the midst of the Civil War (1861–5).

The Civil War

While his mother was benefiting from the water cure establishments of Dr Edward E. Denniston and Dr Carl Munde, of Northampton,[55] William Whistler, by now married to Ida, daughter of Ralph King (Anna's financial adviser in the early 1850s, and husband of her cousin Isabella Gibbs), had joined the Confederate army as an assistant surgeon (Fig.23). Anna was appalled: 'Dear, dear Willie I know he is acting conscientiously & can have no idea how much he makes me suffer.'[56] Willie served in battlefield hospitals and indeed encountered the bloodiest war ever in the history of the United States.[57] With her family and social ties to both the north and the south, Anna found herself caught between the two sides of the war and was reluctant to express an opinion in favour of one side or the other. In 1861, she told James, 'Truly, I know no North, I know no South.'[58] Her views were shaped by her domestic concerns: what motivated her was her belief that the Southern domestic order was under threat. As she wrote to her friend James H. Gamble, 'The struggling South is not fighting for Slavery! but in defence of its homes.'[59]

She joined her son William at Richmond, VA, in 1863, where she nursed his wife Ida, whose death occurred later that year. It was there that Anna finally formulated her views on what she had previously called a 'most inglorious war'.[60] She instructed James and Deborah, 'not to believe what the northern papers say about the south, I have met many of your father's dear old friends on this side of the Army & some who knew Jim at W. Point ... alas for the Army how trying!'[61]

Life in London

Anna Whistler did not witness the end of the Civil War. In December 1863 she travelled to England, where she was to spend the rest of her life,[62] and joined James Whistler in his house at 7 Lindsey Row in London (Fig.24). Having spent the first years of his artistic career in Paris, he had decided that London was the place to pursue his career. His stepsister Deborah (Fig.25) had been living there since 1848, and her husband, Seymour Haden, had offered great encouragement to James in the early stages of his career. Whistler had been living rather beyond his means in London with his chief model and mistress, Joanna Hiffernan.[63] His lifestyle would have discomfited Anna Whistler, who constantly bestowed on him moral and religious messages.[64] 'Seek first the kingdom of God & His righteousness & all else shall be added to you ...' was a typical exhortation. 'Why may I not rejoice of you? am I not a christian Mother? have I not trained you faithfully?'[65]

In deference to her sensitivities, Whistler 'purified' the house before her arrival,

24 *Lindsey Row* 1908
From E. R. and J. Pennell, *The Life of J. McN. Whistler*
London and Philadelphia, 1908

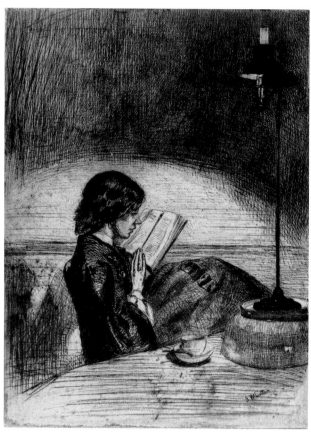

25 **James McNeill Whistler**
Reading by Lamplight 1858
Etching, 158 x 118 mm
Hunterian Art Gallery
University of Glasgow
Birnie Philip Bequest

Tout d'un coup en plein affaire arrive ma Mère des Etats Unis! – Alors! bouleversement generale!! – J'ai eu une semaine à peu pres pour vider ma maison et la purifier depuis la cave jusqu'au grenier! – Chercher un 'buen retiro' pour Jo – Un appartement à Alphonse – aller à Portsmouth à la rencontre de ma Mère! enfin tu vois des affaires! des affaires! – jusqu'au cou des affaires![66]

Surprisingly enough, she fitted well in her son's newly 'purified' home, and lived with him on and off for nine years. Her London writings reveal a busy life set in a domestic environment: 'I am the only one to receive callers in this house or to answer notes, or attend to the daily domestic cares, having only young thoughtless Servants who need my watchful guidance & following up their headlesness [sic].'[67]

Over the next ten years she became acquainted with Whistler's circle. This included artists, for example Dante Gabriel Rossetti; Henry and Walter Greaves – who were boatmen and Whistler's pupils; the poet Algernon Charles Swinburne; and the lawyer, James Anderson Rose. According to Anna Whistler, 'The

Artistic circle in which he is only too popular, is visionary & unreal tho so fascinating.'[68] She also dealt with patrons and art collectors, including Frederick Richards Leyland, from Liverpool; the Greek shipping merchant, Constantine Alexander Ionides; and the banker William Cleverly Alexander.

Her commentary on her son's achievements has long been regarded as of value in questions of provenance and artistic production. For instance, she saw him at work on his earliest oriental subject pictures, including *Purple and Rose: The Lange Leizen of the Six Marks* and *Variations in Flesh Colour and Green: The Balcony*, with models dressed in kimonos and 'a tea equipage of the old china' (see Fig.28).[69]

Anna Whistler's other son, William, soon followed his mother, and set up his practice in the British capital.[70] In 1865, for the first time in a decade, she was reunited with her sons. Now her role as attentive mother and presiding spirit of the family expanded to that of James Whistler's housekeeper, agent, personal assistant and religious mentor.[71] She corresponded with his patrons, ran his household, and trained both her sons' servants. The financial insecurities James underwent in the 1860s and 1870s had a personal impact on Anna Whistler, who shared her sons' financial anxieties and tried to help, where she could. In 1868 she wrote: 'it will be months before the income whereas he must pay models for them every day a shilling the hours [sic] & they must be well fed! besides an Artists materials are so expensive.'[72] She would also continue being James Whistler's agent, back in her native land, when she returned in 1867 for one last time.

A cultivated woman who kept up with current affairs, Anna Whistler had by now lived in America, Russia and Britain for a considerable time, and was experienced in the world of fine art. She had visited museums and exhibitions across two continents, and was thoroughly familiar with the struggles of her artist son; questions of patronage, dealing, collecting, exhibition, artistic genius, and financial survival are referred to vividly in her correspondence. In 1869, after six years of living with James, she wrote in an authoritative tone to his patron Leyland, 'I am his representative in Chelsea & shall welcome a call from you, if you have time to spare.'[73] She was invaluable in reconciling and soothing situations that might have otherwise proved painful. For example, when Whistler failed to complete a commission from Leyland, it was left to his mother to explain, 'he has only tried too hard to make it the perfection of Art, preying upon his mind unceasingly it has become more & more impossible to satisfy himself.'[74]

Anna Whistler always maintained her friendships and family ties. The earlier professional acquaintances of George Washington Whistler remained influential in her life. For example, in 1868, she wrote to Joseph Harrison of Alexandroffsky, now in Philadelphia, requesting a favour for William Whistler – the retrieval of his medical diploma, lost during the Civil War.[75] The core of her family, Anna Whistler received at Lindsey Row many friends from the past while she made new ones in England. The Kings of New York, the Gambles of Staten Island, and the Winans of Baltimore all came to pay their respects when in London. The Gellibrands of St Petersburg invited her to their Malvern cottage, and Susan Prince, a Lowell connection, looked after Anna Whistler at Hastings (Fig.26–7), to which seaside town she retired for health reasons in 1875.

Life and letters

The final years of Anna Whistler's life were quiet, as her only occupation was letter-writing and reading (Fig.26). Religious writings had always been her intellectual pursuit; she circulated periodicals such as the *Christian Watchman* and the *Christian Spectator* to her friends and family.[76] Her words were encoded with the writings of Thomas Arnold, Charles Wesley, Augustus Toplady, John Newton and John Milton,[77] and over time became intensely biblical. Thus, once she had lost all her brothers and sisters, she wrote, 'But at the age of 73 – my birthday 27th Sept, I am waiting & hope to be prepared for the change! to be received in the Heavenly Mansions, Where our Lord has prepared a place for all who trust in His blood & merits!'[78]

Anna Whistler's last surviving letter dates from 1878, three years before her death at the age of 77.[79] Its content is similar to many others of an earlier era, involving domestic accounts and human relationships, reinforced with her professions of piety. Her circle of acquaintances grew as the lives of her sons in London were enriched. William Whistler had married his second wife Helen ('Nellie') Euphrosyne, the daughter of the Greek consul and art patron Constantine Ionides, in 1877. James Whistler was still single and remained so for a while after Anna Whistler's death on 31 January 1881; he married in 1888.

Anna Whistler interwove in her correspondence the stories of people she knew, and set them against the backdrop of larger forces at work in both continents. There were tales of childhood, marriages, management of households, religion and morality, art and patronage, science and technology, triumph and defeat, fortune and misfortune, life and death. For a historian, her writings throw light on contemporary attitudes and expectations. For an art historian her letters provide a source of documentation necessary to understanding questions of fine art practice, authenticity, collecting, provenance and patronage. Her account of modelling for Whistler is particularly vivid.

It was in 1871 that this, the most important of her tasks was undertaken, and willingly, when Whistler surprised his mother with his request: 'Mother,' he said, 'I want you to stand for me! it is what I have long intended & desired to do, to take your Portrait.'[80] Anna, the submissive and obedient mother, accepted patiently, and the result was the memorable portrait, *Arrangement in Grey and Black: Portrait of the Painter's Mother*. Whilst her two-dimensional portrait has made her perhaps the most famous artist's mother in the world, her writings have preserved a voice, which was shared by thousands of faithful and dedicated American mothers. As Anna Whistler wrote when posing: 'It was a Mother's unceasing prayer while being the painter's model gave the expression which makes the attractive charm.'[81]

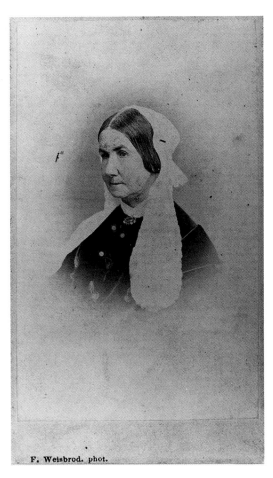

26 F. Weisbrod
Anna M. Whistler 1870s
Photograph
Glasgow University Library

27 *St Mary's Terrace, Hastings*
Recent photograph
Centre for Whistler Studies
Glasgow University Libary

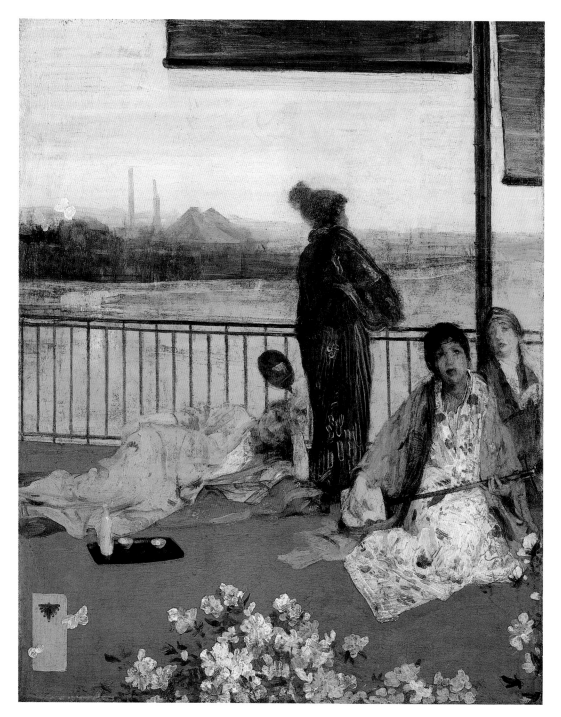

28 James McNeill Whistler

Variations in Flesh-Colour and Green:
The Balcony 1865
Oil on wood, 614 x 488 mm
Freer Gallery of Art, Smithsonian Institution,
Washington DC: Gift of Charles Lang Freer, F.1892.23

Chapter 2 The painting of Whistler's *Mother*

Margaret F. MacDonald

this whirl of excitement of ambition and hopes and dissapointments [sic] ... that has so long engulfed me and so completely as to cause even this strange silence ... to you my Mother of whose continued kind indulgence and patient forgiveness and loving cheerfulness I have so many proofs! All this struggling and preparation is now over ... I am so pleased Mother dear with the affectionate interest you take in my pictures ...

James McNeill Whistler to his mother, 1867[1]

This was a critical period for Whistler; the years of study and preparation were by no means over in 1867. It was four years before his mother's patience was rewarded, and it was she that helped Whistler to make the breakthrough, and complete her portrait quickly and to their complete satisfaction. *Arrangement in Grey and Black: Portrait of the Painter's Mother* was painted in 1871 and exhibited at the Royal Academy in 1872. As the sitter herself recognised, the creation and exhibition of this portrait marked a turning-point in his career; it established him as a painter of distinction – an influential, if controversial, player in the Victorian art scene.[2]

The subject of the portrait, Anna Matilda Whistler, had been married three years when she bore her first child, the future artist, in 1834. The child shared in his family's travels and fortunes. The few surviving letters from Whistler to his mother reveal a complex relationship. He called her 'My own darling Mother' and himself 'Your truant son ... your Prodigal', and later, with wry humour, 'Your fond though faulty Son, J. A. McN. Whistler', adding his butterfly monogram (based on his initials 'JW').[3] The butterfly was an ironical choice, as his mother must have known. She had warned him against the dangers of being a butterfly, 'sporting about from one temptation to idleness to another' and, when he abandoned the US Coast and Geodetic Survey, in favour of an artistic career, she called him 'My own dear Butterfly'.[4] Desperately, she urged him to wait until they had more money, and cultivate 'habits of frugality industry and order, without these you can never flourish as an Artist'.[5] Ignoring her advice, in 1855 he left to study art in Paris. 1858 marked what might be considered his graduation, when the first set of his etchings, the 'French Set', was published, and he moved to London, while still maintaining his links with French art and artists.

Accepting the inevitable, Whistler's mother thereafter supported his decision to become an artist. She was looking forward to his return to the States:

Every season I practise more & more frugality, "practise makes perfect" you know dear boys, & I get so expert & neat ... in making & remoddling [sic] so fashionably for myself. Oh if you both were but under my care how comfortably I'd attend to your respectability.[6]

Her gentle respectability impressed Whistler's friends and patrons. When she visited England in 1860, the Secretary at the American Embassy, Benjamin Moran, described her as 'a pleasant old lady ... a woman of good sense'.[7] Three years later, she set up house with Whistler at 7 Lindsey Row, in Chelsea (see Fig.24), exerting a stabilising influence on his habits and household. However, it was not an entirely happy arrangement. She continually advised and pressurised Whistler to reform his life, accept Biblical teachings, join the church, and prepare in all ways for death and the afterlife. As far as can be judged, she had little effect except that Whistler could and did quote and misquote the Bible effectively throughout his life. Against a background of family disputes, Whistler found it difficult to work, and eventually barred his mother from the studio on the excuse of drawing from nude models.[8] In autumn 1869, he wrote to Thomas Winans, asking for a loan, and described the problems he was having with a painting, *The Three Girls*:

> I wiped it clean out, scraped it off the canvass and put it aside that I might perfect myself in certain knowledge that I should overcome imperfections I found in my work, and now I expect shortly to begin it all over again from the very beginning! ... The results of the education I have been giving myself these two years and more will show themselves in the time gained in my future work.[9]

During 'two years and more' in 1868 and 1869, Whistler exhibited nothing whatsoever, and the painting sent to the Royal Academy in 1870 – *Variations in Flesh-colour and Green: The Balcony* (Fig.28) – had been started six years previously. Anna had seen Whistler working on it: it showed oriental porcelain on lacquer trays from his collection, and women dressed in kimonos, looking over the River Thames.[10] The *Balcony* was quite well-received, but it marked no new departures: it was not enough to consolidate his promising debut of a decade earlier, when, in 1860, *At the Piano* – the portrait of his half-sister Deborah and niece Annie Haden (see Fig.48) – was exhibited at the Academy. It was not until 1872 that the portrait of his mother consolidated that early promise.

The occasion

In a letter to her sister Kate, on Friday 3 and Saturday 4 November 1871, after the completion of the portrait, Anna wrote that she had started to pose when another model did not turn up. The Glasgow MP, William Graham, a patron of the Pre-Raphaelites, had commissioned Whistler to paint a *Blue Girl* – possibly the painting now known as *Annabel Lee*.[11] He had promised to have the *Blue Girl* finished by August 1871, but failed to meet the deadline:

> Poor Jemie ... is never idle, his talent is too eager, if he fails in one attempt he tries another, so I was not surprised at his setting about preparing a large canvass late tho it was in the evening, but I was surprised when the next day he said to me: "Mother I want you to stand for me! it is what I have long intended & desired to do, to take your Portrait" ... if the youthful Maggie had not failed Jemie as a model for "The Girl in blue on the seashore["] which I trust he may yet finish for Mr. Grahame, he would have had no time for my Portrait ...[12]

It is not entirely clear when Whistler started the portrait. His mother was ill from May to June 1870 and stayed in London when Whistler visited the

Liverpool ship-owner F. R. Leyland and family at Speke Hall in August. He returned in November or December, and at that time she was still unwell. It may be that Whistler, deeply concerned for her, wished to record his mother's appearance before it was too late.

Mother and son remained in London for most of the following year. She wanted to be available for sittings and support: 'I refused all invitations to visiting relations here or friends, while I could be at home with Jemie, & even after he finished painting my Portrait such a success!'[13] According to Anna Whistler, her portrait was painted in 1871 and completed by October of that year; she implied that it had been painted over a period of about three months. This was, for Whistler, amazingly quick. He was notorious for the long and repeated sittings he demanded (the portrait of Cicely Alexander, painted two years later, required seventy sittings).[14] However, his mother was living in the same house, and available at all times of the week, Sundays excepted. 'You see ... that my Mother exerts her influence over me, and Sundays are "difficile"' as Whistler explained to William Grapel, a prospective patron who desired the *Blue Girl* already promised to Graham.[15] On any other day, 'the Mother would be delighted to receive you', said Whistler, hoping to tempt Grapel to buy a 'Nocturne' instead.[16] In letters to her sister, Anna Whistler mentioned Whistler's night scenes, *Variations in Violet and Green* and *Harmony in Blue-Green – Moonlight,* later called *Nocturne: Blue and Silver – Chelsea* (Fig.29), which also date from 1871, and, like her own portrait, mark a new departure in his work.[17] They were the first of the 'Nocturnes', with which Whistler's name became closely associated during the 1870s – a source of fame and controversy.

Anna Whistler also mentions in her letters Whistler's association with Walter and Harry Greaves, who were friends and neighbours when the portrait was being painted. Some fifty years later, Walter Greaves in his memoirs stated that 'Whistler thought this portrait of his Mother his finest work. Like the Leyland portrait, it was painted at No. 2 Lindsey Row, now Cheyne Walk.'[18] He also noted that while a portrait of F. R. Leyland had taken 'about a year and a half' (in fact it took at least twice that) the portrait of Whistler's mother 'went along much better'.[19] The portrait, he said, had been finished in two or three days. Unfortunately, as a witness, he is not entirely reliable. Greaves painted a couple of pictures showing Whistler apparently painting his mother, one dated, rather unconvincingly, 1869 (Fig.30).[20] Greaves painted many fine pictures of London and the Thames, and, from memory, portraits of Whistler and of the Scottish historian and philosopher, Thomas Carlyle, as well as these studies. Unfortunately, he added early dates in an effort to increase the historic and economic value of his works. His paintings of Whistler's studio were almost certainly painted much later – possibly after Whistler's death. Although they are charming concoctions, they cannot be considered historical records, but rather the record of a phenomenon: the growing fame of the artist and the painting after Whistler's death.

The dress

Years later, when planning the portrait of a rich American, Lois Cassatt (sister-in-law of the artist, Mary Cassatt), Whistler went through her entire wardrobe – glamorous clothes from New York and Paris – and rejected the lot.[21] He painted her instead in a black

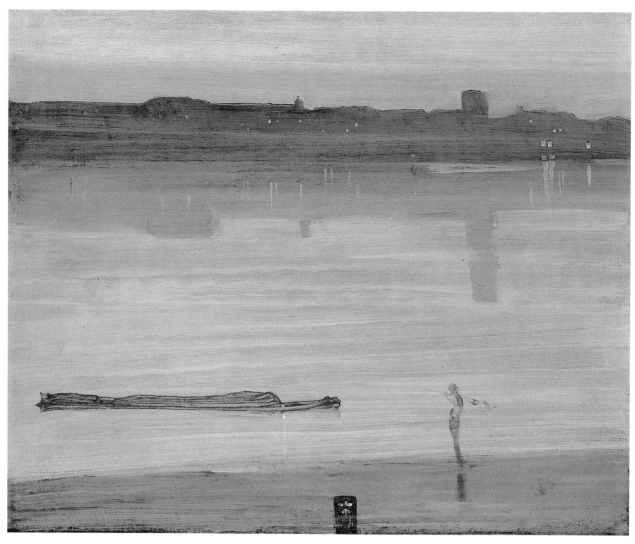

29 James McNeill Whistler

Nocturne: Blue and Silver – Chelsea 1871

Oil on canvas, 500 x 593 mm

Tate Britain

© Tate, London 2003

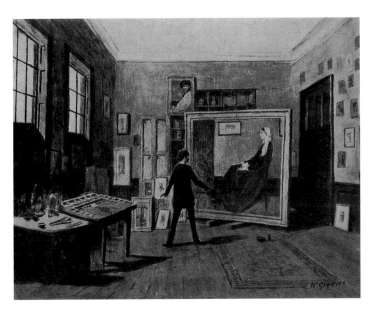

30 **Walter Greaves**
Whistler painting his Mother 1875/1910
Oil, reproduced in *The Sphere*, 27 April 1940
Glasgow University Library

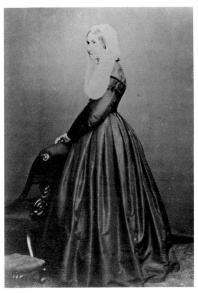

31 *Anna M. Whistler* 1870s
Photograph
Glasgow University Library

riding habit as an *Arrangement in Black, No. 8*, for which she never forgave him. In the case of his own mother, Whistler had no such lavish choice. His mother had gone into black on the death of her husband in St Petersburg in 1849 and dressed in deep mourning for the rest of her life. Since many middle-class women wore black for everyday wear, and high proportions of elderly women were, indeed, widows, this occasioned little comment.

Her dress was simple and practical. With the occasional help of a maid or seamstress and with her own skill in sewing and embroidering, she mended and updated her clothes. As she told Whistler, 'I have put my wardrobe in uncommonly neat array, old things remoddled [sic] but their St P dates will not affect their keeping to wear on occasions.'²² Photographs show a slight, slim figure, with carefully combed, straight thinning hair (Fig.31). She is neatly clad in a well-cut dress with long shoulder-line ending

in a little cap over the fitted sleeves; the neck and sleeves are trimmed with finely pleated muslin. She was aware of fashion, but avoided extremes, adopting neither the elaborate trimmings nor bright colours of fashionable dress (Fig.32).

Her white cap, made of extremely thin, see-through cotton, with large lappets like spaniel ears draping over her bodice, was the most striking element in her dress. Although the lappets could be tied up out of the way, they were intended to hang down decoratively, framing the face attractively. The cap was trimmed with ribbons and a narrow gathered border; it was impeccably clean, ironed and probably starched. It would be worn in the house, or under a heavier bonnet for outdoor wear. Such caps were decorative, impractical, labour intensive, and an assertion of status. There were an infinite number of ways for trimming these caps. When he was a child, Whistler drew his Aunt Alicia (Anna's elder half-sister) wearing

32 Jules David
'The Newest French Fashions'
Young Englishwoman, January 1867
Private collection

33 James McNeill Whistler
Portrait of Aunt Alicia McNeill
Graphite on cream wove paper, 117 x 93 mm
Cooper Hewitt National Design Museum, Smithsonian Institution
Gift of Mary E. Dreier from the estate of Katherine S. Dreier,
1953-186-17

a neat cap decorated with complex tucks and gathers (Fig.33). They could be trimmed grandly, with antique lace, or comparatively cheaply, with *broderie anglaise* (Fig.34). They could be gaudy with coloured ribbons, or as in Mrs Whistler's case, modest with white ruffled trim, and possibly a narrow white satin ribbon. There was a sort of conspicuous modesty in her outfit that gave a clear statement about Whistler's mother's age, position, income and housewifely skills (Figs 35–6).

Whistler, who was extremely sensitive to nuances of fashion, and to the meaning of dress, painted her costume with loving attention to the details of trim and the sensuous quality of the see-through cotton (Fig.37). He was as careful and focussed in the depiction of age and character, of the distinctive dress of the poor and of the respectable middle classes, as he was in depicting youthful beauties, the aristocracy and *nouveaux riches* in fashionable clothes.

The first composition

At first Whistler planned to paint his mother standing, but it seems from the account written to her sister Kate that Anna could not hold the pose long enough:

> *I was not as well then as I am now, but never distress Jemie by complaints, so I stood bravely, two or three days, whenever he was in the mood for studying me his pictures are* studies*, &* I so interested *stood as a statue! but realized it to be too great an effort, so my dear patient Artist who is gently patient as he is never wearying in his perseverance concluding to paint me sitting perfectly at my ease, ...*[23]

No trace of this portrait of her standing has survived, and presumably it was completely rubbed out. However, there is an etching of Anna Whistler, standing, nearly full face, which might have been done

NEW CAPS AND COIFFURES.

65. A DINNER CAP.

This cap is entirely made of guipure, trimmed with a ribbon bouillonné surrounding the top of the head. Loops of similar ribbon ornament the front. Guipure strings "à l'esclave" are loosely tied under the chin. Ribbon strings fastened in a bow behind.

66. "MATHILDE" CAP.

The "Mathilde" cap is composed of a round crown of Cluny guipure, and trimmed with ruching of muslin, edged on each side with narrow Cluny lace; another ruche is placed behind, forming a curtain. The long muslin strings are ornamented with insertion, and surrounded with Cluny lace.

66. "MATHILDE" CAP.

67. EVENING COIFFURE.

This charming coiffure is composed of three ribbon velvet torsades mounted on wire, and adorned with velvet leaves and long flowing ends. With the hair artistically arranged in the short curls, as shown in the engraving, nothing could be prettier than this simple head-dress.

65. DINNER CAP.

67. EVENING COIFFURE.

62–67. NEWEST PATTERNS FOR CAPS, HEADDRESS, AND MUSLIN BODICE.

No. 62. Morning Cap, of plain muslin, with a limp crown. The top of the cap is ornamented with three bouillonnés of muslin, divided by insertion, and surrounded with narrow lace. The front is trimmed with wide lace, arranged in large pleats, and finished off on each side by bows of muslin, edged with coloured ribbon; long flowing strings to match.

No. 63. Bodice of white pleated muslin, trimmed with ruchings of coloured ribbon and silk buttons, simulating a pointed bertha on the front, and fastened on each shoulder by a bow of wide ribbon, with long ends, terminated by aiguillettes. The neck is ornamented with insertion, placed

62. MORNING CAP.

between two bands of coloured ribbon, and fastened in front with ruching arranged in a trefoil. The sleeve is cut with a seam at the elbow, and trimmed to correspond. The waistband is of coloured gros grain silk, fastened on the right side by a large rosette.

63. MUSLIN BODICE.

64. "FANCHON" CAP.

64. "FANCHON" CAP.

This cap is made of muslin, with appliqué lace flowers on the crown and strings. It is entirely trimmed with wide lace, headed by coloured ribbon. Bows of the same ribbon ornament the left side.

34 'New Caps and Coiffures'
Young Englishwoman,
January 1867
Private collection

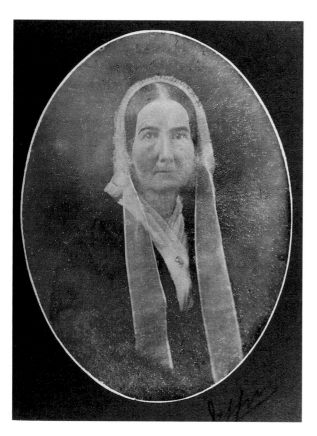

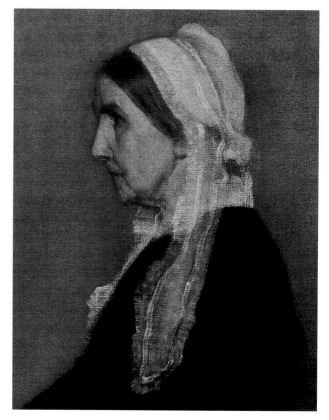

35 *Anna M. Whistler* 1870s
Photograph
Glasgow University Library

36 **James McNeill Whistler**
Arrangement in Grey and Black:
Portrait of the Painter's Mother 1871
Oil on canvas, detail of head
Musée d'Orsay, Paris
© Photo RMN – J.G. Berizzi

37 *Three cotton caps* 1865/75
Museum of Costume, Manchester
© Manchester Art Gallery

at this time (Fig.38).[24] Her dress was drawn in sharp, angular lines and the whole design had a confident simplicity. It was printed so that there was a skim of ink left on the plate, roughly rubbed so that this film of ink, rather than the etched lines, define the skirt. The print is in effect a monotype, and as such prefigures Whistler's exploration of the technique in his Venetian *Nocturnes* of 1880.[25] Anna Whistler's face is lively, rather quizzical, and she wears her cap well back on the hair. Her expression is less withdrawn and introspective than in the painting, showing that she is interacting with the artist – and revealing the fascination of watching him at work that is mentioned in the letter to her sister. Only one or two impressions were printed of this etching before it was cancelled, still very far from complete. It could well have related to the abortive attempt to paint her standing up. The etching would have taken only a short time – maybe a single session, or at most two – whereas a full-length oil painting could be expected to take many sessions of half an hour a time.

The portrait of Mrs Huth, wife of the collector Louis Huth, was being painted by 1872; entitled *Arrangement in Black No. 2*, it was completed by 31 January 1873. Two preparatory pastel sketches reveal that Mrs Huth's portrait (Fig.39), as originally conceived, had similarities to the planned portrait of Mrs Whistler.[26] Mrs Huth stands in profile, her dark hair arranged very simply, her black dress slim-fitting at the waist, with a graceful skirt ending in a train sweeping round to the front. The black is set off by a standing lace collar and lace cuffs, similar to those in Mrs Whistler's costume. Behind Mrs Huth hangs a dark backdrop with a stylised pattern. However, in the final painting Mrs Huth stands, dressed in black, against a dark background. Thus the pictures became entirely different both in composition and detail.

In the painting, the drapery hanging to the left behind Whistler's mother appears to be not a curtain, but a kimono, or fragment of a kimono. Journalists in 1872 varied in their interpretation of this: one called it a 'black lace curtain', another, 'a hanging of black Japanese crape, dashed with a meandering pattern in faint white and silver' and yet another, 'a piece of foldless, creaseless, Oriental flowered crape'.[27] Whistler had been collecting oriental artefacts and kimonos and incorporating them in his paintings for years. The kimono on the wall is similar to ones worn in two oriental subject pictures of the 1860s, by *La Princesse du pays de la porcelaine* (under a pink kimono) and by the standing model in *Variations in Flesh Colour and Green: The Balcony* (see Fig.28).[28] The Far Eastern drapes added an exotic element to the austere Western studio and the elderly woman in European mourning dress, with her beautifully trimmed and laundered cap. Thus two cultures, east and west, met in the Lindsey Row studio.

The canvas

If Whistler had painted his mother standing, on the canvas used for the final portrait, the figure would have been only a small full-length portrait. It may be that he prepared a canvas for a full-length, life-size, upright portrait, and then a second canvas when it became apparent that his mother could not stand for her portrait. The front of a canvas is usually smooth, and the back has a rougher, more irregular texture. When the young American painter Otto Bacher saw the portrait of Whistler's mother in 1883, he asked why it was painted on the back of such a canvas. Whistler replied, 'Isn't that a good surface?'[29] The rougher texture of the canvas was used to great

38 James McNeill Whistler

Whistler's Mother 1870/73
Etching and drypoint
252 x 153 mm
Freer Gallery of Art
Smithsonian Institution
Washington DC:
Gift of Charles Lang Freer,
F.1903.252

39 **James McNeill Whistler**
Study for Arrangement in Black No. 2:
Portrait of Mrs Louis Huth c.1872
Pastel on brown paper, 228 x 122 mm
Art Institute of Chicago,
Gift of Walter Stanton Brewster, 1933 (33.211)

advantage by Whistler, particularly in defining the textures of the drapery, cap, and handkerchief, and giving extra richness to the surface of the wall (Fig.40). Walter Greaves stressed the importance of the canvas: 'He painted this portrait with a lot of linseed oil and little colour, and on the back of the canvas so as to imitate the grain of the dress and of the handkerchief'.[30]

The canvas that Whistler prepared for the final portrait of his mother had apparently been used before, though whether for a version of the *Blue Girl*, a portrait, or another study, is unknown. The original, smooth, side apparently bore another painting that Whistler had abandoned and partially erased. Bacher thought he remembered seeing the portrait of a child there. He was writing in 1908, many years after the events described, and his memory conflicts with that of another young admirer of Whistler, the lithographic printer, Thomas R. Way, writing even later, in 1912. However, Way also thought the portrait was painted on the back of a canvas:

> *an ordinary white primed canvas; and on this, before he had reversed it, he had traced down a cartoon of the 'Three Girls', having pricked it through in the old manner, and then outlined the figures with a fine red line.*[31]

Such a technique was common academic practice, although rare in Whistler's work. However, in 1869, under the influence of his friend, the artist Albert Moore, he briefly returned to such traditional procedures: he made life studies, squared them for enlargement, and transferred the enlarged design from cartoon to canvas.[32] In this case, Whistler could have abandoned a study related to *Pink and Grey: Three Figures*, and painted his mother's portrait on the back of the canvas.

40 James McNeill Whistler
Arrangement in Grey and Black:
Portrait of the Painter's Mother 1871
Oil on canvas, detail of hands
Musée d'Orsay, Paris
© Photo RMN – J.G. Berizzi

Sources and influences

Whistler was reasonably familiar with classical art
(a studio he borrowed in the 1860s was opposite
the British Museum so that both classical funerary
statuary and the Elgin marbles were accessible). He
was particularly interested in Hellenistic art. Some
of his drawings of the late 1860s were inspired by
Tanagra figurines (Fig.41), the terracotta statuettes
of women (some authentic and some fakes) that
Whistler's patron Constantine Ionides brought back
from Greece at some time during that decade. They
fascinated Whistler and his friends. Both Thomas
Armstrong, in works like his *Music* of 1871, and Albert
Moore, in oil paintings like *A Musician*, exhibited at the
RA in 1867, included profile seated figures that relate
both to Whistler's studies and to their common
models.[33] However, Whistler became extremely worried
about the similarity between his work and Moore's.[34]
His conscious rejection of female figures in fluttering,
soft Tanagra-like draperies, in favour of more severe,
neo-classical models, occurred immediately before the
occasion arose to paint his mother.

To this antique source could be added such neo-
classical sources as Canova's sculpture, which Whistler
could have seen in Paris, in London, or in illustration.
Canova's, for instance, could have been known through
the illustrations of Etienne Achille Reveil; the solidity
of three-dimensional statuary was transformed in line
engraving into decorative outline.[35] This might explain
the simplicity of the figure painted by Whistler, which
has a massive presence and yet, except for the face and
hands, lacks depth.

Among the first critics to discuss Whistler's *Mother*, the
critic Philip Gilbert Hamerton, demonstrating his
classical education, wrote that 'The attitude of the

41 *Terracotta 'Tanagra' Figurine*
Photograph in album sent in 1894
by Aleco Ionides to Whistler
Hunterian Art Gallery
University of Glasgow
Birnie Philip Bequest

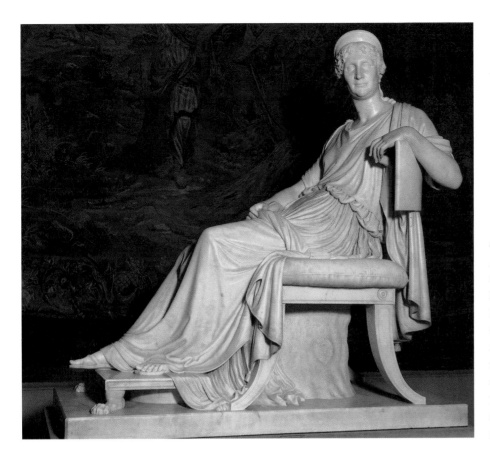

42 **Antonio Canova**
Letizia Ramolino Bonaparte
1804–07
Marble
Devonshire Collection,
Chatsworth
Reproduced by permission of
the Duke of Devonshire and the
Chatsworth Settlement Trustees
Photograph: Photographic
Survey, Courtauld Institute
of Art

figure, seated and in profile, seems to have been suggested by two famous statues – the portrait of Agrippina in the Capitol, and Canova's portrait of the mother of Napoleon I at Chatsworth' (Fig.42).[36] Although Canova strongly denied it, the antique statue of *Agrippina* in Rome may well have been *his* inspiration. It must be said that the figures of Agrippina and Napoleon's mother are not sitting looking straight ahead, but lean and turn, and look, and generally show a more complex and three-dimensional solidity than does Whistler's *Mother*. There is no proof that Whistler saw either statue, although they were extremely well known, and interesting for both visual and historical reasons. Indeed, there were two Agrippinas, one the mother of Nero and the other of Caligula, and one might

wonder whether Whistler equated his mother with those formidable ladies, or himself with either of their murderous sons.

The colour scheme and dress of Anna Whistler inevitably suggested death and mourning (though not murder) to viewers; the picture, wrote one art critic, conveyed 'a grave poetry of mourning'.[37] Whistler's (and Anna Whistler's) friend, the poet Algernon Swinburne was reminded of William Blake's illustration to Young's *Night Thoughts*: 'How, like a Widow in her Weeds, the Night, / Amid her glimmering Tapers, silent sits?' He saw this watercolour in July 1874, just after the *Mother* had been exhibited for the second time in London, and commented to William Michael Rossetti:

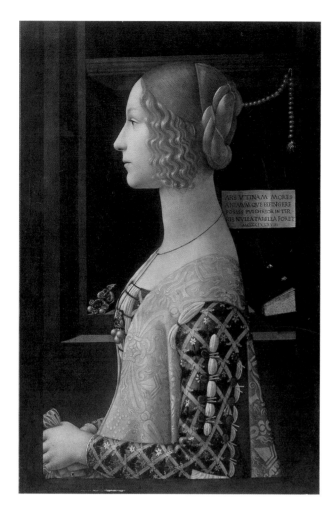

43 Domenico Ghirlandaio
Giovanna degli Albizzi Tornabuoni
Photograph in Whistler Collection
Glasgow University Library
Birnie Philip Gift

*I thought many good and interesting, a few very fine;
e.g. a widow by a monument in a vault with tapers
lighted, all in black and grey like a 'symphony' of
Whistler's; the attitude of the muffled figure struck
me as singularly successful and impressive.*[38]

Illustrations, prints and photographs are among
the possible sources for Whistler's composition. Over
the years, Whistler collected photographs of works by
other artists, and these came with his estate to the
University of Glasgow. Among these are photographs
that could have been acquired by others – by his wife,
for instance, or her family, the Birnie Philips. It
cannot be said with absolute certainty that Whistler
collected them, although they may provide clues to
his taste. They include numerous works in the grand
tradition of European portraiture, such as Velasquez'
paintings of Philip II of Spain, Van Eyck's portrait of
Margherita Van Eyck and Domenico Ghirlandaio's
superb and decorative profile portrait of Giovanna
degli Albizzi Tornabuoni (Fig.43).[39] The latter bears
a motto in Latin ('Could mind and behaviour be by art
expressed, this were of pictures all the loveliest'),
which many might find relevant to the portrait of
Whistler's *Mother*.[40] A journalist in 1872, for instance,
suggested that 'The attitude of mind of his sitter being
conceived, he [Whistler] has worked it out, selecting
the key of colour and the lines of composition so as
to enforce, as it were, rather the mental attitude than
the material facts.'[41] Ghirlandaio's portrait was in the
Henry Willet Collection in Brighton, before it was lent
to the Royal Academy in 1878: whether Whistler had
access to the picture in Brighton is unknown, as is the
date of the photograph.[42]

Photography itself, a new art when Whistler first
arrived in Britain, had quickly established its own
formulae for portraiture, limited at first by the

constraints of light and exposure times. When Whistler, as a child, visited Scotland with his mother in 1849, the calotypes of David Octavius Hill and Robert Adamson were opening up a new style of portraiture. Hill's sympathetic calotype of Mrs Anne Rigby (Fig.44) has been cited as a possible source for Whistler's composition.[43] The old lady in her black silk dress and white cap, seated in profile, her head very slightly bent in reflection, has a classic simplicity. Mrs Rigby's daughter, Elizabeth, Lady Eastlake, held her up as an example: 'Think of the moral charm exercised by such a face and figure ... the hallowing influence of one who, having performed all her active part in this world, now takes a passive, but a nobler one than many, and shows us *how to grow old*.'[44] It is quite possible that the young Whistler saw this image, and at a very impressionable age, when he was responding strongly to visual stimuli of all kinds.

Victorian audiences often expected to 'read' a picture or a photograph as if it was a book. The great exponent of genre photography was Henry Peach Robinson, whose melancholy masterpiece, *Fading Away* (Fig.45), was taken in 1858. It was no more a documentary record of the harrowing scene (a family watching a dying child) than a stage scene would be, but the 'reality' of photography gave it a strong emotional appeal. The figure on the left in Robinson's photograph is an elderly lady in black dress and white cap, seated in profile like Mrs Rigby and Mrs Whistler. The stiff lady-like posture, partly dictated by the boned corsets and dress of the time, was equated with respectable middle-class behaviour – physical uprightness being held to reflect moral rectitude. Whistler and McNeill family portraits and photographs may also have provided ideas. The earliest portrait of Anna Whistler was a simple and rather anonymous profile study, drawn in St Petersburg in 1845 (see

44 **David Octavius Hill and Robert Adamson**
Mrs Anne (Palgrave) Rigby 1844
Calotype photograph
Scottish National Photography Collection
Scottish National Portrait Gallery
Edinburgh

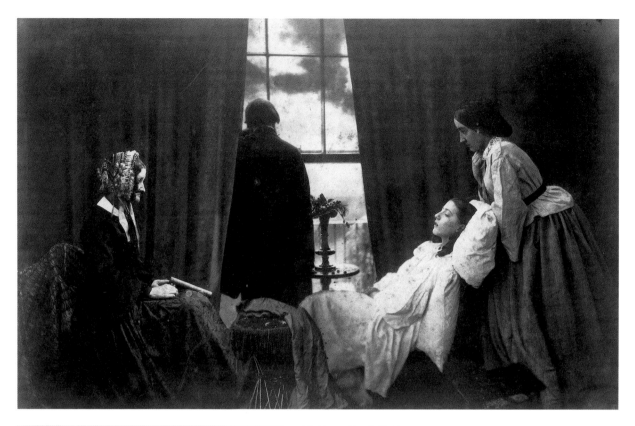

45 Henry Peach Robinson
Fading Away 1858
Copy of an albumen silver print
National Museum of Photography,
Film & Television Science & Society
Picture Library

46 James McNeill Whistler
La Vieille aux Locques 1858
Etching, 206 x 147 mm
Hunterian Art Gallery
University of Glasgow

47 **James McNeill Whistler**
Black Lion Wharf 1858
Etching, 152 x 226 mm
Hunterian Art Gallery
University of Glasgow

Fig.14); and the family photograph albums probably included the remarkable photograph of Maria Rodewald (see Fig.21), wearing a white dress, in a dramatic black and white composition.

Apart from portrait photography, there are a number of comparable compositions in Whistler's own work, as for example, in the etching, *La Vieille aux Locques* (Fig.46), where an old woman, in a cap with neatly pleated trim, sits working in a doorway. In another etching, *Black Lion Wharf* (Fig.47), a well-dressed young working man lounges comfortably on a Thames quayside. This is the etching that appears on the wall behind Whistler's mother, although only the initiated would have recognised it, since it was painted broadly, and without detail. It is, however, an interesting choice, complementing the figure of Whistler's mother, and defining the space as being in Whistler's studio by the Thames. It was also a reminder of Whistler's unquestioned superiority as an etcher, within a painting that was to assert his superiority as a painter.

Whistler's earlier portraits of his half-sister Deborah, both in etching (see Fig.25) and oil, show her in profile. The simplicity of the stage-like setting and

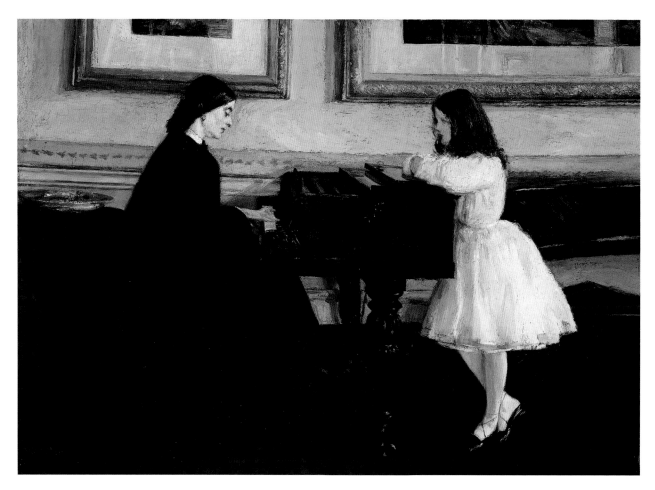

48 James McNeill Whistler

At the Piano 1858–59
Oil on canvas, 670 x 916 mm
Bequest of Louise Taft Semple,
Taft Museum of Art,
Cincinnati, Ohio (1962.7)

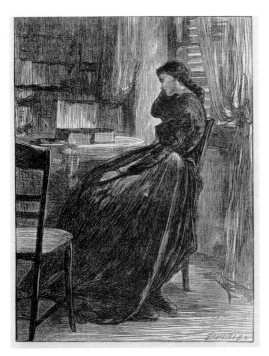

49 **After James McNeill Whistler**
Joanna Douglas in *The Trial Sermon* 1862
Wood engraving by Dalziel, 152 x 115 mm
Good Words for 1862
Glasgow University Library

50 **After John Everett Millais**
Mistress and Maid 1862
Wood engraving, 150 x 110 mm
Good Words for 1862
Glasgow University Library

the stark colour contrasts of white and grey suggest parallels between Whistler's *Mother* and *At the Piano* (Fig.48), which was painted in 1858–9, exhibited at the Royal Academy in 1860, and at the Salon in 1867.[45] In *At the Piano* Deborah, wearing black, in exact profile, is facing Annie: this imposes a central emphasis and interaction that is lacking in the *Mother*.[46] By contrast, his mother is not shown making contact with anyone within the visible space, nor with the artist or viewer, but in silent prayer or contemplation. Furthermore, in technique the two are totally different: the impasto of *At the Piano* has changed to a more fluid technique, with thinner paint and flowing brush strokes. It may be that Whistler turned to the most severe composition he had worked on in the past to escape the limitations of the style he had developed while

working on the *Blue Girl* and *The Three Girls* as part of the *'Six Projects'*.

The pose also has a superficial resemblance to several illustrations drawn by Whistler, such as *Joanna Douglas* in *The Trial Sermon* (Fig.49), published in *Good Words* in 1862, and *The Major's Daughter* in *Once a Week* in 1862.[47] However, the youthful beauty of the women and the flowing lines of Whistler's drawings emphasise the figures' languorous grace, in strong contrast to the stark simplicity of line and mass in Whistler's *Mother*. These drawings in their turn relate to contemporary illustrations such as the work of the Pre-Raphaelite J. E. Millais, in, for example, his *Mistress and Maid* (Fig.50), published as the frontispiece to *Good Words for 1862*. When the *Mother* was

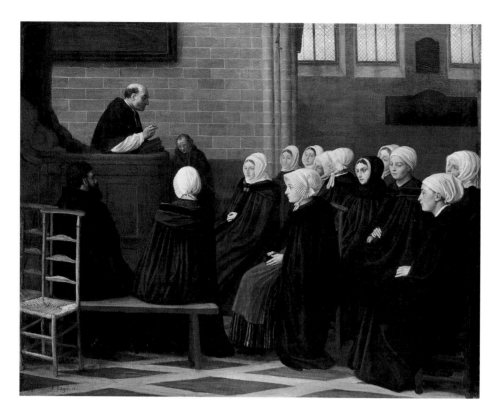

51 **Alphonse Legros**
The Sermon 1871
Oil on canvas, 750 x 940 mm
National Galleries of Scotland
Edinburgh

exhibited in 1872, *The Academy* compared Whistler unfavourably with Millais as a realistic painter, but praised the 'intellectual power' of his 'vision of the typical Huguenot interior'.[48]

The uncompromising Protestantism that was an inescapable part of Anna Whistler's character and is implicit in her appearance and surroundings can be compared with the explicit Catholicism expressed in the early paintings of Whistler's friend from student days, Alphonse Legros. Legros' most successful early paintings were religious subjects, with groups of people in peasant or clerical dress, influenced by early Flemish art. For instance, his painting *The Sermon* (Fig.51) contains a group of women in black wearing white caps, seated and kneeling, in profile or near-profile against a shadowy background. Whistler may well have shared Legros' interest in the late mediæval

and early Renaissance art of Northern Europe (an interest shared, moreover, with Whistler's neighbour and friend, D. G. Rossetti) as well as with more recent, explicitly Catholic religious paintings.[49] The photographs in Whistler's estate (whether collected by Whistler or not) include pictures of early Renaissance altarpieces, with black-clad donors in profile, kneeling reverently before Madonnas and Saints.[50] Were these religious icons the inspiration for Whistler's *Mother*, a secular icon?[51]

Anna Whistler's dress perhaps exaggerates the similarities of her portrait with Legros' paintings of women in peasant dress, and contemporary genre paintings of women in mourning. One such genre subject is a painting done by the Belgian artist, Alfred Stevens, *The Young Widow* of 1859, of which Whistler owned a photograph (Fig.52). It shows three young

52 **Alfred Stevens**
The Young Widow 1859
Oil. Photograph in
Whistler Collection
Glasgow University Library

women, including, on the right, a woman with head bowed wearing deep mourning. Stevens was known for his highly finished, flashy technique and bright colours but this painting, in keeping with its subject, is subdued.[52] When Whistler was a student in Paris, Stevens was already set on his successful career. However, he was interested in Whistler's work and even, so Fantin-Latour suggested in 1867, influenced by it.[53]

There were undoubtedly exchanges of ideas between Whistler and his French contemporaries, Fantin-Latour and Legros, Degas and Manet. Whistler was by no means alone in developing a particular strand of sober, sombre portraiture, or in the adoption of profile poses. In some portraits which have their subjects in profile or near-profile, Whistler and his friends can be seen experimenting, particularly in the 1860s, with

a new kind of portraiture influenced by Dutch art, depicting middle-class life, dress and surroundings. Degas' *La Famille Bellelli* (Fig.53), is in this category, as is Fantin-Latour's *Deux Sœurs*, a work 'whose surface serenity disguises underlying tensions'.[54] It is nearly contemporary with Whistler's *At the Piano* and like it, was rejected at the Salon in Paris in 1859.

Manet's portrait of *Emile Zola* (see Fig.63), exhibited at the Salon in 1868, is comparable in scale and design to the *Mother*. However, the solidity of the figure of the writer, his furniture, the variety of textures, colour and complexity of detail in Zola's surroundings (which include oriental prints and a reproduction of Manet's notorious painting of a prostitute, *Olympia*), are alien to it. Manet's portrait of his wife Suzanne, *Madame Manet au Piano*, painted 1867–8, is closer in feeling to the *Mother* as well being

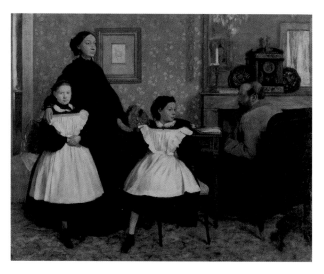

53 **Edgar Degas**
La Famille Bellelli 1858–60
Oil on canvas, 550 x 630 mm
Musée d'Orsay, Paris
© Photo RMN – Gérard Blot

54 **Claude Monet**
Madame Monet au Canapé 1871
Oil on canvas, 480 x 750 mm
Musée d'Orsay, Paris
© Photo RMN – H. Lewandowski

reminiscent of *At the Piano*. The figure, in absolute profile, dressed in grey and black, is set against a series of rectangles: panelling, the piano, a clock and reflections in a mirror. However, the figure is ruthlessly cropped, most of the skirt is hidden, so the woman appears at once more solid and less isolated than in Whistler's painting.[55] Manet's portrait stayed in his hands until 1894, when it was sold to Maurice Joyant of Goupil's in Paris – who had taken an active part in the sale of Whistler's *Mother* in 1892. Finally, Claude Monet's profile portrait of his wife, *Madame Monet au canapé* (Fig.54), which was painted in London in 1871 and exhibited in the *International*

Exhibition, South Kensington, in May 1871,[56] may have been partly inspired by the sparing decor of Whistler's house, and may, in its turn, have influenced the composition of Whistler's portrait.

From classic funerary statuary to Stevens' *Widow*; from Deborah Haden to *Madame Manet au piano*; from Hill's *Mrs Rigby* to family portraits, the possible influences on Whistler's portrait are many and complex. Tracing even a few of these possibilities is an inconclusive but fascinating exercise.

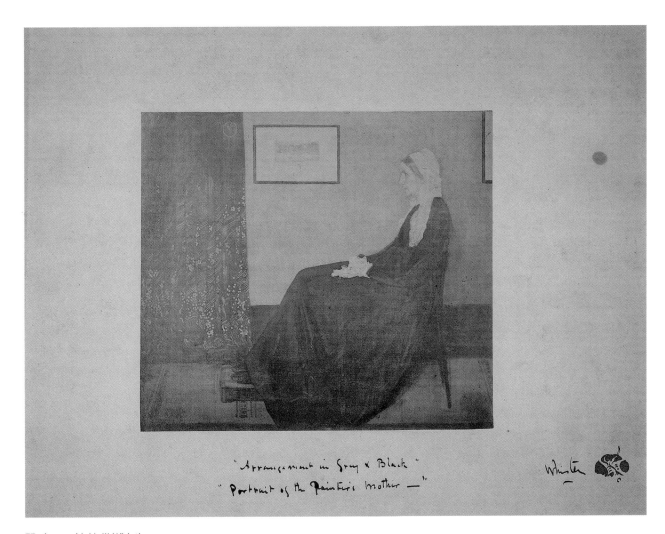

55 James McNeill Whistler
Arrangement in Grey and Black:
Portrait of the Painter's Mother 1871
Photograph, 1872
Signed by Whistler, *c.*1878
Glasgow University Library

Arranging the composition

Anna Whistler described sittings for her portrait to her sister Kate Palmer on 3 November 1871, shortly after the event:

> Jemie had no nervous fears in painting his Mothers portrait for it was to please himself & not to be paid for in other coin, only at one or two difficult points when I heard him ejaculate "No! I can't get it right! it is impossible to do it as it ought to be done perfectly!" I silently lifted my heart, that it might be as the Net cast down in the Lake at the Lords will, as I observed him trying again, and oh my grateful rejoicing in spirit as suddenly my dear Son would exclaim, "Oh Mother it is mastered, it is beautiful!" and he would kiss me for it![57]

The difficulties that Whistler encountered can be deduced from the alterations that he made to the composition while he was painting it, varying the position and outline of the figure and its surroundings.

The figure was originally painted several inches higher on the canvas, or at least with the legs rather higher. The original outline, just visible under the thick creamy grey paint of the wall, is about 1¼ in (30 mm) outside the final outline, and runs from the head all the way down the front of the figure to the footstool. There are two distinctly separate outlines of the knees above their present position, and one a little lower. There are some thick strokes of paint to the left of the hands and a faint outline below, suggesting they were moved up and to the right. Under raking light, minor alterations are visible, for instance to the outline of the arm, which was originally painted lower, and hanging down more. The figure may have been set further back in space within the picture frame, with the skirt entirely visible. Below her knee, the original line of the legs is visible. The black of the skirt, which does not quite merge with the dado, can be seen until it reaches the curtain, at ankle level. At that point, the curtain is painted over it.

Early photographs of Whistler's *Mother* (Fig.55) show the state of the picture in 1872. At that time Whistler's butterfly signature, the folds of the skirt, and pattern on the rug and kimono, were brighter.[58] It shows the earlier position of the footstool, which was higher up, and the pattern of stripes and checks on the rug. There are also indistinct traces of work to the right of the figure, suggesting that something, possibly a wall or another curtain, divided in half the space between the chair and the edge of the picture. The chair itself was originally painted in a lighter shade, and had a shorter, curved back.[59]

Other minor changes in the outline of the figure, the head, and the wall, do not materially affect the composition. However, the hanging drapery extended further to the right, and the picture frame was originally more than an inch nearer the figure to its right. Since the figure was positioned higher up and extended further to the left, it must have appeared much more closely confined in the picture space.

There may well have been long intervals between sittings, when Whistler's original conception of the painting was radically changed. The technical and compositional changes show that it must have taken several weeks, at the very least, to complete.

Whistler's neighbour, Mme Emilie Venturi, brought Thomas Carlyle to see the completed portrait, and he was persuaded to pose. The portrait (Fig.56) was started in 1872 and exhibited (with the portrait of

Whistler's mother) in 1874. This was the only time that Whistler employed a similar composition. The portrait of Carlyle is marginally larger than the portrait of Mrs Whistler. It is an upright, and the composition is, if anything, even more simple and austere. There are two pictures above the dado behind Carlyle, the studio chair on which he sits, and nothing else. The coat over his knees falls in heavier folds than her dress, and the coat front and high hat make the silhouette slightly less severe than Mrs Whistler's. In his male version of the portrait, Whistler adapted his technique, making it rather broader and richer. Carlyle himself remarked on 'a certain massive originality about the whole thing, which was rather impressive'.[60] The head is very slightly tilted, and it is a remarkable face: weary and troubled. Whistler's portrait of Carlyle is as sympathetic as is his portrait of his mother, but it has a psychological intensity that reflects the disturbed and troubled nature of the ageing historian.

Colour and technique

Walter Greaves gave Whistler's biographers, Elizabeth and Joseph Pennell, some technical details about the painting of Whistler's mother, which correspond to its current appearance. He emphasised the sparse use of paint: 'the canvas being simply rubbed over to get the dress, and, as at first the dado had been painted all across the canvas, it even now shows through the black of the skirt'. Greaves said that the handkerchief was 'nothing but a bit of white and oil'.[61]

The wall dominates the colour of the picture. It is broadly treated, the brushstrokes going in all directions, building up several shades of greys and creams. In this Whistler recreated the decor of his own house. The subtle balance of his colour schemes was achieved with careful balancing of washes, as revealed in a letter to his sister-in-law, who had failed to carry out his precise instructions for her house:

why on earth should the workmen think for themselves that after all two coats of the yellow upon white would do just as well as one coat of yellow on grey! – This was so ordered by me because in my experience the result would have been fair and at the same time soft and sweet ...[62]

Against a wall colour, 'fair and at the same time soft and sweet', Anna Whistler's face and hands have an unexpected richness (see Figs 37, 40). The hands were created with brushstrokes of pale golden yellow, cream and pink, carefully applied with a small brush. The white of the lace and the handkerchief is laid on rather dry, contrasting with the white of the picture mount on the wall, which is painted thickly and yet still shows the earlier working underneath. On the face, the white highlights on nostrils and eyebrows are applied with small strokes. The glowing flesh colours, and also the yellow of the footstool, are painted with rather liquid paint. It no longer retains the brush mark, but it is not yet a wash. The colour is built up with layers of thin paint boldly applied, but with rather small rounded brushes (Fig.57).

The skirt is thinly painted with little variation in tone, or definition of drapery. The dark grey wall hanging is painted quite thinly, with a pattern, painted vigorously in several colours, defining its structure. Most of the pattern is applied with a round bristle brush, over 1/4 in (8 mm) wide, with thin paint. Occasionally there is a highlight, a thick dab of yellow paint, not a pure colour, but partly combined with a touch of white. In addition, a subdued pattern is

56 James McNeill Whistler

Arrangement in Grey and Black, No. 2:
Portrait of Thomas Carlyle 1873
Oil on canvas, 1710 x 1435 mm
Glasgow Museums:
Art Gallery and Museum, Kelvingrove

*57 Five of Whistler's brushes
and his mahlstick* 1890s
Hunterian Art Gallery
University of Glasgow
Birnie Philip Bequest

painted by a small (3 mm) round brush, in a grey not much lighter than the curtain itself. The long lines in the pattern are painted freely, mostly with a larger (4 mm) brush, and paint as thin as watercolour, but some with a broader, square ended brush (6 mm).

The yellow in the kimono picks up the colour of the handkerchief and the footstool. The colour of the rug is subdued, the pattern tinged with a deeper shade of yellow ochre. Both the rug and footstool appear rather richer in colour than the rest of the picture, partly because the rug is painted over darker brown under-paint, whereas further up, the dark dado in front of the figure is apparently painted straight on the white priming. When the picture was exhibited, a critic commented, 'It is astonishing how much Mr Whistler has here accomplished with two colours, aided, however, by touches of red on the face and hands, and of yellow in the carpet, footstool, and cardboard of the drawing on the wall.'[63]

In 1868 Whistler had told Fantin-Latour that he thought colours should be repeated throughout a painting to create a harmonious pattern:

> les couleurs doivent être pour ainsi dire brodées là dessus – c'est à dire la même couleur reparaitre continuellement ça et là comme le même fil dans une broderie – et ainsi avec les autres – plus ou moins selon leur importance – le tout formant de cette façon un patron harmonieux – Regardes les Japonais comme ils comprennent ça! – Ce n'est jamais le contraste qu'ils cherchent, mais au contraire la répétition.[64]

He continued to experiment and develop this idea, which he called 'the science of colour'. Shortly after completing the portrait, Whistler wrote again to Fantin-Latour:

> Si j'ai fait des progrés c'est dans la science de la couleur que je crois avoir presque entièrement aprofondi et réduite à un système – Mais je me tourmente beaucoup – et je voudrais bien te causer ... Le portrait de ma mère, je ferai photographier et je t'en enverrai une épreuve – Aussi je pense peutêtre envoyer la toile à Paris pour le Salon prochain.[65]

The 'science of colour' in this letter was not used in reference specifically to the portrait of his mother, but the association of ideas is interesting. The title, *Arrangement in Grey and Black*, stresses a sombre and limited range of colour. In practice, warmer shades of cream, beige, yellow and pink soften the cooler shades of ivory, silver grey and black, and subtle textures and the rich variety of brushstrokes enrich the surface, creating a controlled resonance. By carefully arranging and controlling the colours, Whistler felt that he had arrived at a more realistic scientific truth than if he had increased and exaggerated the colours. The result is a subtle harmony that makes an enormous impact on the viewer.

Titles

Whistler had first exhibited a painting with a musical title in 1867 (*Symphony in White, No. 3*), and gradually adopted musical titles: 'Harmony' could cover a broad range of subjects, figure compositions were 'Symphonies', portraits were 'Arrangements' and his 'Moonlights' became 'Nocturnes'. 'Art for Art's Sake' was the rallying cry of Whistler and other leaders of the Aesthetic movement. His titles emphasised colour harmonies as being more important than the subject of the painting, even when that subject was his much beloved and highly respected mother.

When the portrait was exhibited, one journalist objected that the title was confusing, and the stiffness of the composition distracted from 'the real nature of his strength as a painter, which consists in the subtlety of distinction between hues and tones'.[66] The *Graphic* felt that the restricted range of colour, demonstrating Whistler's 'ingenuity', was 'needless and voluntarily imposed'; however, it is possible that Whistler wanted to demonstrate that he was not only a colourist, but capable of intellectual force and psychological depth.[67] A bravura *tour de force* of vigorous brushwork, strong contrasts, and a wide range of colour would have shown off his undoubted skills as a painter but detracted from the subtlety of his portrait.

Exhibition

In the Autumn of 1871 Whistler's friends were able to see the completed painting. His lawyer, Anderson Rose, 'was charmed & came four times', and Dante Gabriel Rossetti wrote to Whistler: 'such a picture as you have now finished of your Mother, must make you happy for life, & ought to do good to the time we are now living in'.[68] Whistler's half-sister Deborah thought it was very like her stepmother and it reminded her also of pictures of Anna Whistler's mother and brother (see Figs 7, 8).

Whistler took the completed portrait to show the Leylands at Speke Hall in October 1871. Both he and his mother had visited Speke before; Whistler had drawn portraits of various members of the family there and in the summer Mr and Mrs Leyland came to pose in his London studio. He had just started a painting of Mrs Leyland, as Mrs Whistler told her sister:

Mrs. Leyland writes to me that she thinks the full length Portrait he has begun of herself will be as lifelike as she is sure mine is! Jemie sent me a sketch of mine as the centre Mr. Leylands Portrait & a painting of Velasquez the two on either side of mine covering the wall one whole side of the great dining room called the banquetting hall, & that the two Portraits bore the comparison with the painting of the famous Spanish Artist to his satisfaction![69]

A drawing of Mrs Leyland (Fig.58) shows her in profile, fashionably dressed and rather mournfully thoughtful: but for her full-length portrait (Fig.59) Whistler designed a shimmering, flowing, gauzy dress, an ethereal escape from reality.

Harsh reality nearly overtook the portrait of Whistler's mother on its way back to London, when it narrowly escaped destruction, as she reported:

the 3 cases of Portraits were preserved from fire on the RR train coming back from Speke Hall ... the Case in which my Portrait was, the flames had reached but in time discovered. the lid so burnt, a side of the frame was scorched! & yet the painting uninjured. you will know my thankfulness for the Interposition that my dear Jemie was spared the loss of his favorite work, I hope it is a favorable omen that it may be hung properly in the Royal Academy Exhibition.[70]

It was sent to the Royal Academy on the first or second of April 1872. Neither Whistler nor his friends seem to have anticipated that it would have the slightest trouble in being accepted.[71] However, it was very nearly excluded, which now seems extraordinary. Sir William Boxall – an Academician and an old friend of the Whistler family – threatened to resign if it was rejected, and so it was grudgingly admitted.[72] Whistler

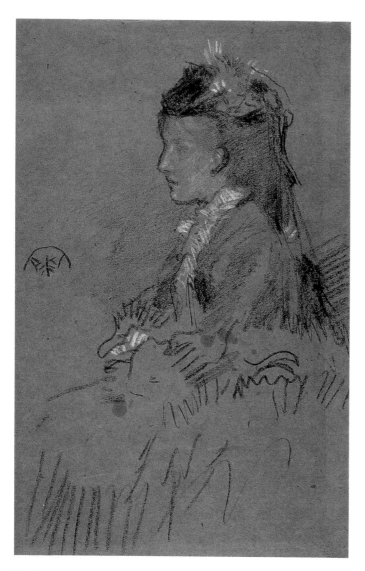

58 James McNeill Whistler

Mrs Leyland seated 1873/75
Chalk and pastel on brown paper,
279 x 180 mm
Hunterian Art Gallery
University of Glasgow
Birnie Philip Gift

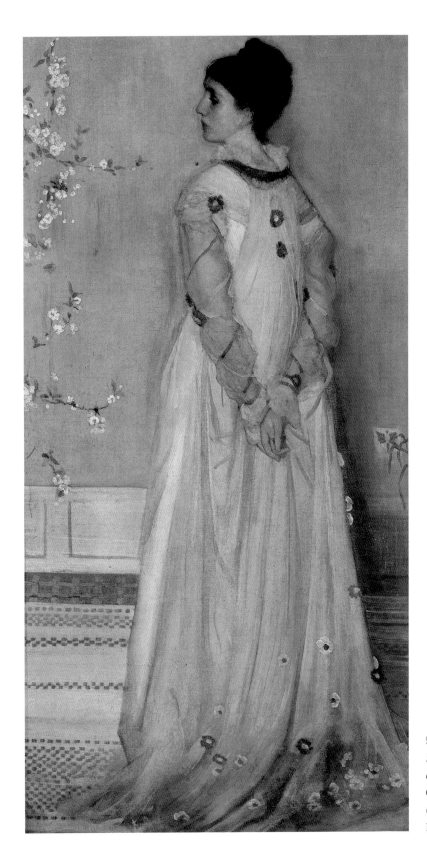

59 James McNeill Whistler
Symphony in Flesh Colour and Pink: Portrait
of Mrs Frances Leyland 1871–74
Oil on canvas, 1959 x 1022 mm
© The Frick Collection
New York

was disillusioned, and never submitted his paintings to the Academy again.

Although it was not hung 'on the line' – that is, at eye level – it was accorded a 'place of honour', which, said the *Daily Telegraph*, was unjustified: 'the salons of the Royal Academy are not the place for the trial of the experiments of eccentrics'.[73] It was not extensively reviewed, and reviews varied from the misleading ('a large drawing in monochrome'), to the ecstatic ('wholly exceptional').[74] It immediately attracted the attention of a caricaturist: the first in a long line of cartoons involving the picture (see Fig.2). The influential London *Times* found it 'Far removed from the commonplace ... The floor and the walls are subdued, softened, and fused to a level which might have become monotonous in any other hands.' Nevertheless, the critic was rather condescending and free with his advice: 'An artist who could deal with large masses so grandly might have shown a little less severity, and thrown in a few details of interest without offence.' Looking over these press cuttings, some time later, Whistler suggested to the artist Walter Sickert that suitable details might be 'a glass of sherry & the Bible'![75]

The title that inspired reservations (because of its stress on abstract qualities of colour and composition) also brought sympathy (because the sitter was identified as the artist's mother). In civilised Victorian society, it was considered impolite to be extremely rude about someone's mother. It was, however, perfectly all right to wax sentimental. Reviewers responded to the emotional appeal of the picture, 'it tells the story of a life as pen and ink could not tell it. ... All the storms, all the fears, all the anxieties, all the burdens have gone from her life ... and left her a pure embodiment of spirit, of patient waiting.'[76]

The *Examiner* noted politely, 'The lines of the face are beautifully drawn, ... We should think that the likeness, both of the room and the lady, is true and intimate.'[77] Another thought it 'a piece of fine art ... an elderly lady in mourning robes ... a beautiful example of its kind, a kind rare and valuable in England at least'.[78] The qualifying words ('of its kind' and 'in England at least') made it rather difficult to make out exactly what the critic meant. Whistler mocked such critics for their carelessness, inaccuracies, and, basically, for not admiring his work unconditionally.

Afterwords

His mother wrote immediately after the portrait was painted that Whistler considered it his 'favorite work'.[79] Personal relationships and artistic problems were resolved in the painting, enabling him to create new masterpieces in the 1870s: the portraits of Carlyle, Mrs Leyland, Cicely Alexander, and Maud Franklin. As he wrote to his mother in 1876:

> *The reward ... I now feel dawning upon me, and ... I believe I shall have established for myself a proud reputation, in which you will rejoice with me, not because of the worldly glory alone, but because of the joy that you will see in me, as I produce lovely works, one after the other without any more of the old agony of doubt ... never have I done such painting as I am now executing.*[80]

Although he thought it a great work, in later years, Whistler did not like the portrait of his mother to be praised at the expense of more recent work, such as his portrait of the violinist Pablo de Sarasate: 'Wait until the Sarasate is as old as the Mother, with a skin

of varnish upon it that has mellowed, – then you will call that my chef d'œuvre!' he wrote.[81] He undoubtedly valued the picture and the sitter highly, and as he told one friend, years later, 'Yes – one does like to make one's mummy just as nice as possible!'[82] The portrait had great personal significance for both Whistler and his mother, as the record of a fruitful collaboration between artist and model, a token of love and respect, and a memorial of her life.

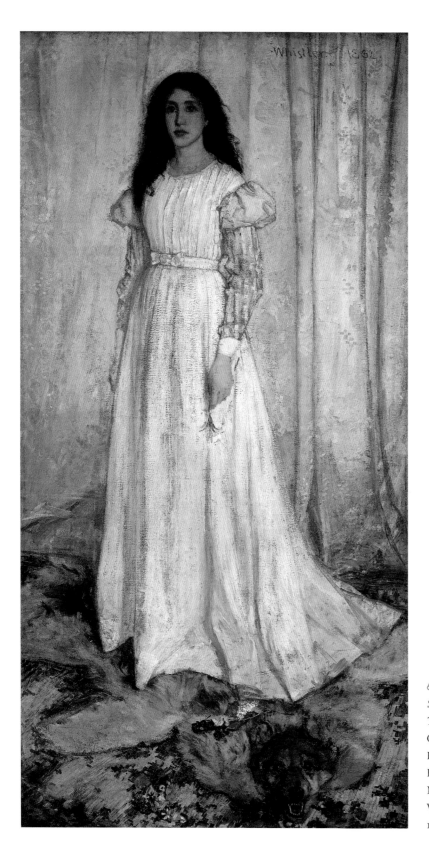

60 **James McNeill Whistler**
Symphony in White No. 1:
The White Girl 1861
Oil on canvas, 2146 x 1080 mm
Harris Whittemore Collection
Photograph © 2002 Board of Trustees
National Gallery of Art
Washington DC
1943.6.2(750)/PA

Chapter 3 The selling of Whistler's *Mother*

Margaret F. MacDonald and Joy Newton

How can it ever have been supposed that I offered the picture of my Mother for sale! ... I had understood ... that it had been especially asked for – chosen because of its having been so much talked of in Paris after its exhibition in the Salon – therefore I made Messrs. Graves forward it to Dublin – but certainly I should never dream of disposing of it ...

James McNeill Whistler [1]

Whistler's mother died in 1881, and he was not prepared to sell her portrait – for a while. But ten years after her death, it was a different matter. He was delighted to sell the painting to the French government, thus ensuring immortality for mother and son alike. This was a little difficult to explain to his brother, so he stressed that this was a matter of family pride, but it was clearly his own pride that came first:

Just think – To go and look at one's own picture hanging on the walls of the Luxembourg – remembering how it was treated in England – to be met every where with deference and treated with respect ... and to know that all this is ... a tremendous slap in the face to the Academy and the rest! Really it is like a dream! [2]

The picture was no longer just the portrait of their revered mother: it was the guarantee of *his* position and reputation.

Art as investment

The history of the portrait between its creation in 1871 and its sale in 1891 reflects the vicissitudes of J. McN. Whistler's career. After being shown at the Royal Academy in 1872 it was photographed (see Fig.55), but sales of the photograph were slow, and the picture remained comparatively little known. It was shown at Whistler's first one-man exhibition at a Pall Mall gallery in June 1874, having narrowly escaped being seized by his brother's creditors in the spring. [3] The Whistler family fortunes were in some disarray, and the painting was next used in an attempt to fend off Whistler's own creditors. On 9 September 1878 a friend, the ingenious entrepreneur Charles Augustus Howell, deposited the *Mother* and two Nocturnes with the print dealers Messrs Graves and Co. as security for an advance of £100. [4] Later more money was advanced on the security of the *Mother* alone. Howell commissioned a mezzotint engraving of the painting by Richard Josey (see Fig.87), but before this was complete, Whistler filed for bankruptcy. [5] On 7 May 1879 the portrait was declared as one of Whistler's assets: 'A portrait of my mother painted by

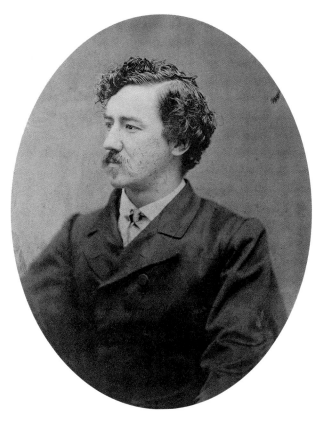

61 *James McNeill Whistler* 1870s
Photograph
Centre for Whistler Studies
University of Glasgow

me now in the hands of Mr. Josey of Shepherds Bush for the purpose of engraving £500.0.0'.[6] Howell attempted to claim the portrait as security for debts but fortunately for Whistler was declared an unsecured creditor.[7] After Howell's death the copyright in Josey's engraving was bought by Messrs Graves, who still retained the portrait. They relinquished their rights at Whistler's request in January 1892 when Thomas R. Way wanted to make a lithographic copy of the portrait.[8] The marketing of photographs, mezzotints, and lithographs, though complicated by Whistler's economic insecurity, nevertheless meant that connoisseurs became increasingly familiar with the image.

Early in 1881 Whistler was able to pay back £50 of the £200 then owing on the *Mother*, but since he had borrowed £300 on his portrait of Carlyle (see Fig.56), he was still heavily in debt.[9] So when Whistler's *Mother* was sent to exhibition – in Philadelphia, New York, Paris, Dublin, London, Amsterdam and Glasgow – the artist had to borrow it from Graves. The firm was infinitely patient in awaiting repayment. Whistler raised the price for the portrait of Carlyle from 400 to 1000 guineas, and sold it to the City of Glasgow for that price in 1891.[10] He had a strong core of support in Glasgow among students, artists and collectors, and both he and his work were regarded with affectionate pride (Figs.61–2). (He added 'McNeill' to his name, after his mother's death, as a reminder of his Scottish ancestry.) It was the first of Whistler's works to be acquired by a public collection, and the acquisition augured well for his future prospects.

Meanwhile, Whistler's *Mother* was valued modestly at 300 guineas.[11] He settled Graves's account on 11 December 1888 and immediately deposited the portrait with the theatrical impresario, Richard D'Oyly

Carte, with two other paintings, as security for £500, which was paid on 1 February 1887. This he in turn lent to the Society of British Artists, during his brief presidency of that society.[12] D'Oyly Carte was complaisance itself, though somewhat overwhelmed by having the portraits of Carlyle and of Whistler's mother stacked against the wall. He even let Whistler exhibit the *Mother* in his own name. When Whistler was forced to resign from his presidency he recalled the loan and was repaid by July 1888.[13] In turn, he repaid D'Oyly Carte, and acquired complete possession of the portrait for the first time in ten years. At this point he seriously began to consider selling it.

62 'Madge Wildfire', 'Studies of Students in Black and White. No. III, Types from St Margaret's' *Glasgow University Magazine*, III, No. 5, 14 January 1891 Glasgow University Library

Reputation

Whistler, like Fantin-Latour and Legros, had sought fame and fortune at the prestigious marketplace of French art: the Salon. He was thwarted initially, when *At the Piano* was rejected in 1859 (it hung at the Royal Academy in 1860, and in Paris six years later). Similarly, when *Symphony in White, No. 1: The White Girl* (Fig.60) was rejected by the Academy, he sent it to the Salon in 1863, only to have it rejected again. There was such a furore over the number of paintings rejected (2783 out of 5000 submitted) that a *Salon des Refusés* was established, where *The White Girl* enjoyed a *succès de scandale* with Manet's *Le déjeuner sur l'herbe*.[14] *Le Boulevard* reported *The White Girl*'s mixed reception: 'Un morceau de peinture d'une incontestable beauté ... Que d'élégance, que d'habileté, quelle grâce dans cette toile qui fait rire les sots!'[15] It delighted his fellow artists – Courbet, Manet, Legros and Bracquemond. Fantin-Latour wrote that 'Baudelaire trouve cela charmant, charmant, Exquise

délicatesse'.[16] Arsène Houssaye was interested in buying the picture, and Emile Zola (Fig.63) singled out for praise: 'la Dame en blanc, très curieuse vision d'un œil de grand artiste ...'[17]

Although it was bought in 1866 by his half-brother, George (see Fig.19) Whistler continued to exhibit *The White Girl*, and only sent it to George's family in America in 1875. For thirty years Whistler's name was associated with *The White Girl* in France.[18] He appreciated the publicity, but found it difficult to maintain momentum. He sent some pictures to the Salon, and a few works to the Paris *Exposition universelle* in 1867; the press was less sympathetic, although the American papers began to take notice of his work, and, as he wrote to an American friend, the dealer George A. Lucas, 'I am there a discussed man!'[19] Five years later he sent works to Durand-Ruel's gallery, explaining to Lucas: 'This exhibition ...

63 **Edmund Manet**
Portrait of Emile Zola 1868
Oil on canvas, 1460 x 1140 mm
Musée d'Orsay, Paris
© Photo RMN – H. Lewandowski

64 'Pauvre Dame! –
pourquoi l'avoir fait pose dans un sac à charbon'
Le Salon pour rire, 20 May 1883
Glasgow University Library

65 'Protestation contre les brouillards de l'Angleterre'
La Caricature, 1883, from Whistler's press-cutting album
Glasgow University Library

is especially intended to assert myself to the painters ... to register among them in Paris as I have done here, my work. Therefore I have not waited for the Salon ... This is an "overture"!'[20] The main event, however, did not follow for ten years – until, in fact, his *Mother* (under the simple title, *Portrait de ma mère*) arrived at the Salon, under the care of the young artist Walter Sickert, in 1883. The art critic, collector and connoisseur, Théodore Duret, considered that it was this exhibition that awakened the French to his importance.[21] Duret was introduced to Whistler by Manet and wrote a perceptive article on Whistler's work for the *Gazette des Beaux-Arts*[22] just when he was in acute need of rehabilitation after the ups and downs of the 1870s – artistic success and economic disaster. Duret was one of the few Frenchmen – or women – ever to pose for Whistler. *Arrangement en couleur chair et noir: Portrait de Théodore Duret*, showed him in evening dress, looking pink, plump and

prosperous, but many critics felt that Whistler had not done him justice.[23]

However, not everyone admired the *Portrait de ma mère* in 1883; some journalists treated it with contempt. *L'Union Médicale* thought the portrait showed the mother 'après sa mort', and it provoked a series of caricatures involving coal sacks, fog and smoke (Figs 3, 64–5).[24] *Le Rappel* considered both the fog and décor very English, and admired the subtlety of the portrait: 'Cette peinture délicate, pleine de subtilités, dans des gris d'une finesse extrême, donne une note nouvelle et des plus attrayantes.'[25] The *Gazette des Beaux-Arts* also appreciated the originality of Whistler's work, the harmony between colour and subject, the truth and realism of the portrait, the peaceful impression conveyed by the pose and composition, and the integrity of the artist.[26] *Le Jour* perceived that Whistler was interested in the abstract

arrangement of colours and forms, comparing his limited palette to that of Puvis de Chavannes, 'Du blanc, du noir, quelques jaunes, des rouges et c'est tout. Mais quelle poésie dans le jeu de ces quatre tons où les premiers dominent avec une saveur étrange.'[27] The *Nancy Artiste*, on the other hand, while appreciating the subtle colouring, saw it as anecdotal, and reacted sentimentally: 'Sa pensée est avec son fils ... songeant qu'il est sans doute heureux, qu'il travaille et que la gloire viendra couronner ses efforts ... Je pense à la mère de Washington.'[28] The journalist was actually rather close to divining the sitter's thoughts, for she wrote: 'it was a Mother's unceasing prayer while being the painters model gave the expression which makes the attractive charm'.[29]

On the whole the critics admired the painting. *Le Progrès artistique* thought the work of Whistler and Sargent far more interesting than that of local artists.[30] *Le Figaro* suggested it was about time he was properly rewarded for his work.[31] The portrait was in fact awarded a third-class gold medal. Five years later, in 1888, Munich *Internationale Kunst-Austellung* awarded *Der Künstlers Mutter* a second-class gold medal, and the artist wrote thanking them for the 'second-class compliment'.[32] Throughout this period, Whistler was cultivating his reputation throughout Europe and America, with increasing success – and the Munich authorities, realising their mistake, responded by awarding him the Cross of St Michael of Bavaria.

Following the portrait of his mother, in 1884 Whistler sent two great portraits – those of Cicely Alexander and Thomas Carlyle – to the Salon. Both had first been exhibited in England ten years previously – ten years that had undoubtedly increased public under-standing of his work. *Le Figaro* described Whistler as

'Un Américain. Un original. Beaucoup de talent', a much discussed artist, who employed bizarre titles.[33] Roger Marx, who was to be active in arranging the purchase of the *Mother* for the State, thought Whistler deserved more recognition: 'M. Whistler est une des individualités les plus étonnantes de l'art moderne. Ses portraits sont le fait d'un practicien hors de pair et décèlent en plus une étrange et profonde pénétration de la pensée.'[34] In spite of the growing interest in Whistler's work none of his major works had yet been bought by a public collection. Yet Whistler was well aware of the advantages of having work in a national collection. He wrote to one patron:

> when a picture is purchased by the Louvre or the National Gallery, all can come & see it on the walls, but when a painting is bought by a private gentleman, it is ... withdrawn from circulation, and for public fame is missing from the story of the painter's reputation.[35]

In 1885 Whistler's main contribution to the Salon was Duret's portrait, which was skied.[36] Undeterred, Whistler sent over *Arrangement in Black: Portrait of Señor Pablo de Sarasate* in 1886. Sarasate was a famous violinist and his portrait, like Duret's, was calculated to appeal to a French audience. *La Réforme*, while criticising practically everything – colour, proportions, the mannerism of the pose – admitted that the effect was fascinating: 'Ces étrangetés créent une figure insaisissable d'une élégance toute particulière.'[37] Over subsequent years, Whistler exhibited with dealers, and at the Salons of 1890 and 1891; he sent many recent works to the *Exposition Internationale* at Petit's in 1887. The artist Camille Pissarro described them as 'très jolis petits bouts d'études peintes',[38] but preferred Whistler's etchings – and indeed these were consistently rated more highly than his paintings by

press and public. Pissarro thought his approach to etching 'même bien supérieur, c'est même lumineux, chose étrange pour un artist qui n'en veut pas dans ses colorations'.[39] The journalist Octave Mirbeau, whose support would be of great practical importance to Whistler in the sale of the *Mother*, received the work of Monet and Whistler with equal enthusiasm. The etchings were 'incomparable', the paintings, often compared to Velasquez, unique: 'M. Whistler ne ressemble à personne. Son art, originel et raffiné, qui cache une pensée aiguë sous des grâces de dandy, lui appartient absolument.'[40] Whistler's contribution to Durand-Ruel's *Exposition* in 1888 was smaller, but Berthe Morisot thought that it was only Whistler and Renoir that saved the exhibition from total disaster.[41] Most papers did not get round to reviewing the exhibition at all, being full of the death and funeral of Frederick III.

In 1889 *Arrangement in Black: La Dame au Brodequin Jaune: Portrait of Lady Archibald Campbell* was awarded a gold medal at the *Exposition universelle* in Paris;[42] it was clear from then on that there would be little serious adverse criticism of Whistler's work. Thus, when *Arrangement in Brown and Black: Portrait of Miss Rosa Corder* (Fig.66) was shown at the Salon in 1891, *Gil Blas* expressed a widespread feeling that it would constitute 'le trésor d'un musée'.[43] With the *Rosa Corder*, painted in 1876, Whistler exhibited a seascape painted ten years earlier: *Crepuscule in Flesh-Colour and Green: Valparaiso*.[44] *Le Gaulois* praised both: 'une des plus nobles figures féminines qu'on puisse rencontrer … la marine délicieuse … je voudrais voir ce paysage au musée du Luxembourg.'[45] The time was clearly ripe for the acquisition of a Whistler painting – though not, as it turned out, either of those exhibited in 1891 – and for the writer Gustave Geffroy to launch a pro-Whistler campaign. He had met Whistler in London

the previous winter through Duret.[46] In *La Justice* he devoted his seventh article on the Salon to a survey of Whistler's work. Like Duret, he set out to explain that Whistler's paintings, particularly his Nocturnes, were both realistic and impressionistic views of nature, scenes more conjectured than seen, 'le portrait prodigieux de l'Obscurité'.[47] Whistler's portraits, he said, combined contemporary realism with a timeless quality. Geffroy's support was crucial in consolidating Whistler's position, and in educating the French press and public.

Paris in the 1890s

Other new contacts were equally important. In 1885, Henry James introduced Whistler to Comte Robert de Montesquiou-Fezensac,[48] and in 1886 or 1887 he met the poet Stéphane Mallarmé. Twenty years younger than Whistler, Montesquiou became an ardent admirer. He overwhelmed Whistler with attentions, wrote poems inspired by his work, and introduced him into high society. Within his circle Montesquiou was considered the arbiter of taste for 'le tout Paris'. With his cousin Elizabeth, Comtesse Greffulhe, he was instrumental in encouraging and supporting such artists as Moreau, Helleu, Boldini, Lalique and Gallé. He commissioned Whistler to paint his portrait, *Arrangement in Black and Gold: Comte Robert de Montesquiou-Fezensac* (Fig.67), early in 1891. He posed with weary elegance: '"soixante séances" c'est beaucoup, mais ce n'est pas assez!' said Whistler; it took a hundred sittings to complete it to his satisfaction, to produce an image of Montesquiou's effete elegance.[49]

66 **James McNeill Whistler**
Arrangement in Brown and Black:
Portrait of Miss Rosa Corder 1876
Oil on canvas, 1924 x 924 mm
© The Frick Collection
New York

67 **James McNeill Whistler**
Arrangement in Black and Gold:
Comte Robert de Montesquiou-Fezensac 1892
Oil on canvas, 2086 x 918 mm
© The Frick Collection
New York

68 **James McNeill Whistler**

Stéphane Mallarmé 1892
Lithograph, 97 x 70 mm
Hunterian Art Gallery
University of Glasgow
Birnie Philip Bequest

Mallarmé translated Whistler's 'Ten O'Clock' lecture into French in 1888, and their acquaintance blossomed into a friendship that lasted until Mallarmé's death in 1898.[50] Whistler made an etching of Mallarmé, a drypoint, and a portrait lithograph (Fig.68) that was published as the frontispiece to Mallarmé's *Vers et Prose* in 1893.[51] Whistler described him as 'the most charming and raffiné of men, and the truest and fondest of friends'.[52] Mallarmé's influence was wide-reaching. He brought Whistler into closer contact with a circle that included Monet, Duret, Mirbeau and Huysmans, and made Whistler's work known to his friends and followers, including Henri de Régnier and André Gide. In his turn he influenced Whistler's ideas about aesthetics, so that he increasingly explored themes reflecting Symbolist ideas.[53] By 1891, Whistler's name was associated with Symbolism in France: 'Whistler est une manière de symboliste qui emprunte à la nature des effets exacts, des visions réelles pour en déduire des harmonies de colorations ou des discordances de tons.'[54]

Whistler had been regularly travelling back and forth between London and Paris; he and his wife Beatrice honeymooned in France in 1888. Consolidating his contacts there provided a basis for one of the most important steps in his career – the purchase of *Arrangement in Grey and Black: Portrait of the Painter's Mother* by the French government.

Olympia, Carlyle and Whistler's *Mother*

Manet's *Olympia* was bought – after the painter's death – for the Musée du Luxembourg in 1890, for a little under 20,000 francs; the purchase was instigated by Monet and the money raised by subscription.[55]

Similarly when the Corporation of Glasgow bought Whistler's portrait of *Thomas Carlyle* in April 1891 for 1000 guineas it was as the result of pressure from local artists led by E. A. Walton and James Guthrie.[56] Whistler's new campaign involved not only artists, but dealers, and friends in society and literary circles, in an immensely effective network of contacts.

David Croal Thomson of Goupil's in London was an astute businessman and organiser, and an admirer of Whistler's work. He was the first to suggest that the portrait should be offered to the Musée du Luxembourg. Whistler authorised him to make enquiries about the possibility through Goupil's Paris branch, Boussod Valadon & Cie. On 13 October 1891 the Manager, M. Joyant replied:

> *Il est certain que l'idée de faire entrer au Luxembourg un tableau de Mr. Whistler et surtout celui dont vous nous parlez est une idée excellente, et qu'il se trouverait beaucoup de personnes pour l'appuyer; car les sympathies de tous les artistes et amateurs sont déjà depuis longtemps avec Mr. Whistler.*[57]

The picture was sent to Paris and put discreetly on exhibition. Whistler returned to Paris at the end of October and found affairs progressing satisfactorily. It was essential to make the correct approach to the *Département des Beaux-Arts* and to mount a press campaign. Whistler was experienced with the press, but ignorant of local politics. He wrote to his wife on arrival:

> *seated at this café with Mallarmé who sends messages wrapped in the latest rose leaves, I send you two words ... I have been – both of us together, Mallarmé and I, to the Goupils and I am to see Geoffroy [sic] tomorrow – The Luxembourg is I believe not so far off – for*

> *Proust is no longer the Ministre des Beaux Arts, but an intimate friend of Mallarmé holds that post! – and the matter will be seen to at once! ... I am going with him to dine and Madame Méry where I am to meet Huysmans also ...*[58]

Geffroy's next contribution to the campaign was an article in *Le Gaulois* on 4 November 1891.[59] He stressed the importance of having a Whistler painting in the museum, and suggested that if there was no alternative it should be bought by public subscription, like Manet's *Olympia*. Whistler had left Paris just before the article appeared; he was perturbed by Geffroy's emotional journalism, and wanted to make clear to Mallarmé's contact at the Ministry, Henri Roujon, that he was quite prepared to go through normal official channels. He feared that an appeal to popular demand might deter the public body responsible for purchases. Mallarmé was concerned about the timing of the campaign. The portrait was still on show at Goupil's, and Mallarmé was gratified by the reactions of his friends, canvassed at his Tuesday soirée, the meeting place of the Symbolist circle, including, on this occasion, Oscar Wilde: 'Les "disciples", qui avaient été chez Goupil, se sont, votre nom lancé haut par moi, répandus en leur admiration, à laquelle a fait écho M. O. Wilde: et ce furent les éclats de ce Mardi.'[60]

Joyant at Boussod, Valadon & Cie reported on 18 November that: 'Le monde continue de venir, les reporters aussi.'[61] Then Henri Roujon inopportunely fell ill and went south to recuperate; since nothing could be done until his return, they removed the picture from exhibition. Meanwhile Mallarmé sent Roujon an article by Duret on Whistler containing a reproduction and evaluation of the portrait: 'on a eu sur la toile des êtres d'une vie intense, dont le

caractère et la manière d'être saisissent les regards. Sa mère et Carlyle ont été peints de profil, assis sur une chaise, dans une pose à la fois sévère et pleine d'abandon.'[62]

Whistler remained in constant touch with Montesquiou and Duret, who was so excited that Whistler begged Mallarmé to restrain him.[63] Duret thought of contacting Roger Marx, *Inspecteur Principal des Musées*, and advocated a public subscription, despite the danger that this might not raise enough money. Another idea, potentially more prestigious, was to have it purchased by a 'comité illustre'. On 10 November 1891 Mallarmé was approached by Alidor Delzant, who admired Whistler's work, and Mathias Morhardt, editor of *Le Temps*.[64] They favoured the formation of a group of collectors, possibly headed by Antonin Proust, to buy the picture and present it to the nation. The committee considered a comparable price to that paid for Whistler's portrait of Carlyle – that is, 25,000 francs, or about £1000. A similar committee and methods were involved in buying Manet's *Olympia*. However, this did not suit Whistler's ideas; possibly he remembered the protracted negotiations over the sale of other portraits. He begged Mallarmé to keep his supporters under control and was anxious to complete negotiations as soon as possible. Meanwhile Joyant tried to interest the government in purchasing the picture directly. Whistler was prepared to accept much less money – around 5000 francs was suggested – if he could be sure the picture would go to the Musée du Luxembourg. Joyant reported that the Minister would visit the gallery on Friday, accompanied by the radical deputy Georges Clemenceau, political editor of *La Justice*.[65] Later Mallarmé wrote, 'c'est beaucoup l'influence de Clemenceau qui a tout hâté.'[66]

Duret assured Whistler that as soon as the picture had been acquired by the Luxembourg, those who had nominated Whistler *Chevalier de la Légion d'Honneur* in 1889 would propose his promotion to the rank of *Officier* as a reward for his contribution to the Fine Arts. Duret was supremely confident that there would be no problem in arranging this: 'Nous sommes tous heureux de voir la bonne tournure que prend l'affaire.'[67] Whistler was a passionately serious artist and a manipulative and ambitious man; minor economic gains would be more than balanced by the social gains to be reaped from this honour.

On 19 November the minister, Léon Bourgeois, wrote asking officially if Whistler was prepared to sell the portrait, 'l'une de vos toiles que la critique et le public ont le plus justement remarquée', and under what conditions.[68] Mallarmé was also curious about this point: would Whistler insist on the portrait going to the Louvre, even though that could not happen until ten years after Whistler's death, and meanwhile it would hang in the Musée du Luxembourg. Whistler was more interested in present fame; he replied that he would not allow any considerations to stand in the way of the acquisition, and he agreed to a price of 4000 francs.[69] On 27 November Duret wrote, enclosing a letter from Roger Marx who was in charge of the final formalities: 'le Ministre signera ce soir l'arrêté qui achète moyennant la somme de quatre mille francs le Portrait de ma mère pour le Musée du Luxembourg.'[70] Marx then told Mallarmé what had transpired, and Mallarmé, like Duret, wrote to Whistler that everything was settled, and he was well satisfied: 'Oui, c'est bien pour le Louvre, cela va de soi, le Luxembourg n'en est que l'antichambre.'[71]

The Luxembourg

That same day *Le Figaro* announced the purchase with a front-page spread.[72] They called Whistler a great artist and congratulated the Museum on acquiring their first example of the work of 'la si curieuse école anglaise contemporaine'. Although the writer thought the average visitor would not understand the picture, he congratulated Whistler on triumphantly overcoming the banality of his subject matter. Mallarmé was horrified.[73] The article was crammed with inaccuracies, as *Le Gaulois* pointed out when announcing the purchase on its front page.[74] *Le Gaulois* was in a self-congratulatory mood over the success of the movement initiated by Geffroy in its pages. *La Justice*, which had, through Clemenceau, taken an interest, was also quick to announce its successful conclusion: 'M. Whistler ... avec infiniment de gracieuseté et de désintéressement, a vendu, – on peut dire offert – son tableau à l'Etat. Il faut se réjouir de cette heureuse solution.'[75] Arsène Alexandre, writing in *Le Paris*, while admiring the *Mother*, 'une oeuvre précieuse', and realising that it would stand up very well to the company of *Olympia*, complained that the State had now very little excuse for ignoring the work of great French artists, like Pissarro and Renoir.[76] Monet and Whistler were among the few artists to achieve such success in their own lifetime. Alexandre found it difficult for those who admired the work of certain painters to make any impact either on the public or the State: 'L'Etat ... fait signe à Whistler quand on a chanté sur tous les tons sa finesse et sa surprenante distinction.'[77] Apart from this, there was not much press coverage of the purchase: its news value was overshadowed by the flu epidemic in London and Paris.

The final arrangements were soon made. By 30 November everything was signed and sealed. Joyant wrote to Whistler for permission to effect the official transference of the painting to the state: 'L'affaire est bien terminée, n'est-ce pas?'[78] and Whistler replied warmly: 'je suis bien sensible à tout ce que vous avez déployé, de bonne volonté, d'énergie et de tact, à mon égard, dans cette occasion, où votre grande appréciation artistique a tant activé le résultat.'[79] The picture was transferred immediately to the Luxembourg. Whistler waited for his wife to arrive before visiting the museum; but Montesquiou went in to report the effect. The portrait was displayed by itself, on a stand, and he was pleased to find one of his noble relations there, and 'the rest standing about were "respectueux" and becoming in their demeanour!'[80] The Comte had been so sure of success that he held a soirée in Whistler's honour on 25 November, long before everything was settled. At the soirée Montesquiou read his poem *Moth*, composed for the occasion, ending with a verse on Whistler's portrait, which moved the artist to tears:

> *Et ce plus grand encore, noble Mère du peintre:*
> *Oui, le plus grand de tous, et de ceux qui sont tels,*
> *Et qu'il me plaît ici de suspendre en son cintre,*
> *Pour lui rendre l'hommage aimée des immortels!*[81]

Duret thought that the acquisition of the portrait by the State had 'le caractère d'une victoire artistique et lui vaudrait, auprès des Américains et des Anglais, une vraie consécration'.[82] Whistler was jubilant, and ensured that no one missed the news or the significance of his achievement. The arrival of a painting by an American of an American in the Musée du Luxembourg naturally impressed Whistler's compatriots. His major patron, the Detroit manufacturer Charles L. Freer, showed a

naive pleasure at Whistler's success and wrote to Beatrice Whistler that 'although of universal interest, it is ... peculiarly gratifying to all good Americans'.[83] Another collector, John Chandler Bancroft, who was in Paris at the time, wrote jealously:

I was pleased to read the other day that your ... great portrait goes to the Luxemb[o]urg – I wish it was to our poor Museum in Boston: not so noble a resting place at present certainly nor perhaps ever. But one where it would may be do more good in the long run.[84]

A stronger protest came from Thomas R. Way, who had made the lithograph of Whistler's *Mother*. Whistler responded that 'he had been very much hurt by the deeply slighting treatment he had received here ... the French authorities had approached him as only Frenchmen could', and eventually the picture would hang in the Louvre, 'a fit home for his Mother'.[85]

La Légion d'honneur

Gil Blas expressed 'très vif plaisir' when, only a month after the purchase, Whistler was promoted to *Officier de la Légion d'Honneur*.[86] *Le Temps*, and Mallarmé, and Whistler's old friend the sculptor Drouet were all planning dinners to celebrate the award. Whistler wrote to his wife: 'I am of course frightened to death! – What shall I say?' Drouet, 'an amazing incarnation of pure unselfishness', had explained to Whistler the importance of being *Officier* rather than *Chevalier*: 'you cannot exaggerate the high esteem in which in France this honour conferred upon you is held – ... it means la fortune!'[87] Drouet scheduled his dinner for 30 January, inviting several newly promoted *Chevaliers*. However, on the previous day Whistler had not received confirmation and was not sure whether to plead illness or go as a *Chevalier* like the others. Fortunately, at the last moment Mallarmé brought 'the first bright little Rosette!!' – and the official letter. Henri Roujon had sent it to Mallarmé – 'he had reserved for him the pleasure of being the first to bring the news "au grand Whistler"' – so Whistler arrived triumphantly, albeit late, and Drouet 'on seeing the real reason in the round red button already in its place ... was simply overwhelmed with delight and filled out with pride! all his own'.[88]

Another old friend – Fantin-Latour – was less enthusiastic. Montesquiou described their meeting: 'Fantin s'approche de lui et lui dit, en touchant le ruban rouge fraîchement éclos à la boutonnière de l'illustre auteur du "Gentle Art": "C'est pour cela que tu as vendu ta mère!"'[89] On the other hand, Whistler himself described meeting Pierre-Victor Galland, a decorative painter and Director of the Gobelins:

"What!" he said, and so you have our décoration! Vous êtes alors Français, and it is only just that one who has exercised so great an influence upon the French school should have this recognition – whereupon without more ado, he put his arm round my should[er] and kissed me twice![90]

Aftermath

Official recognition was reassuring to patrons and dealers, and Whistler made the most of it. Goupil's in London, who had been so active in the sale, were keen to have a big retrospective exhibition. It was organised by D. C. Thomson, and was immensely popular, as Thomson told Beatrice Whistler:

Today the public are crowding in ... willing to admire and mostly doing so – Mr. Whistler is becoming the fashion at least it is becoming the correct thing to pretend to admire him. What a dreadful thing it is that people <u>cannot</u> learn more quickly.[91]

There was even talk of getting the National Gallery to follow the example of the Luxembourg, while Munich and several big American galleries were making tentative enquiries.[92] Furthermore, by exploiting his position as outsider and expatriate, he now found himself claimed by several countries at once as an artist of major importance, as *Le Moniteur des Arts* reported with amusement:

M. Whistler, incompris au début, est reconnu aujourd'hui comme un maître anglais, et il a fallu que ce soit la France, suprême arbitre en matière artistique, qui consacre définitivement la gloire du peintre. Mais M. Whistler n'est pas Anglais, il est Américain, ou plutôt il est Français; les Anglais le réclament à présent, ils ont raison. Mais il n'en demeure pas moins Français. La croix d'Officier de la Légion d'honneur qu'il porte très ostensiblement prouve ses sentiments, et je lui sais gré de la fierté, de la joie qu'il témoigne d'avoir reçu cette haute distinction si bien due.[93]

Whistler was sure that the French appreciated him more than the English, and, encouraged by Mallarmé and Montesquiou, the Whistlers moved to Paris in 1892; by the end of the year they were ensconced at 110 rue du Bac, with a studio in the rue Notre Dame des Champs. Whistler said jubilantly that one painting could have been sold several times over in Paris, and a pastel was sold at George Petit's for 3000 francs: 'pretty big price for Paris – what?'[94] However, the print-dealer Edward G. Kennedy insisted that Whistler's real market was in the States:

you are always telling me how superior the French are as patrons of Art, ... though I notice that most of the painters in Paris depend on the foreign markets, the disliked English or the derided American being especially desirable ... "French me no Frenchs" ... This French 'appreciation' has rather a wearying effect after a while. Appreciation in the form of $ and c. is more practical.[95]

Dollars indeed poured in, tempting his early patrons to sell their pictures; Whistler approved the prices but deplored the inconstancy of collectors. Years later he wrote to Charles L. Freer:

You see the Englishmen <u>have all</u> sold ... whatever paintings of mine they possessed! directly they were hallmarked by the French Government, and established as of value – turning over, under my very eyes, literally for thousands what they had gotten for odd pounds![96]

However, the sale of his *Mother* brought undoubted benefits in sales, commissions and income, and raised Whistler's social and artistic profile. Thus, the expatriate American achieved international recognition in his lifetime, with the portrait of his *Mother* hanging among the great masterpieces of the Musée du Luxembourg (and later in the Louvre, until it was transferred to the Musée d'Orsay with other great works of the nineteenth century); it became, over the next century, the best-known and much loved expatriate icon of American art.

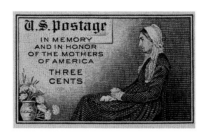

69 Adaptation of Whistler's
Arrangement in Grey and Black:
Portrait of the Painter's Mother
Mothers of America Issue
US Postage Stamp, 1934
Glasgow University Library

Chapter 4 Pleasant dreams: Whistler's *Mother* on tour in America, 1932–4

Kevin Sharp

Can it be that in moments of crisis all we want, all we really need are our mothers? Certainly in 1932, after months of sleepless nights, Alfred H. Barr, Jr (Fig.70), the thirty-year-old founding director of the Museum of Modern Art in New York, sought a mother to answer doubts about his leadership and to quell his lingering insomnia. His fledgling museum needed a mother to push visitors through its doors, evidence of legitimacy to Park Avenue constituents and of solvency to its trustees. And in 1932, the United States pined for a reassuring mother figure to guide it through the dire days and nights of the Great Depression. Few could have guessed, however, that the mother who would console them all was no flesh and blood, no womb and succouring breast, but rather oil paint on canvas: James McNeill Whistler's 1871 *Arrangement in Grey and Black: Portrait of the Painter's Mother*, better known then as now by her affectionate nickname: Whistler's *Mother*.

As bad luck would have it, the Museum of Modern Art opened its doors for the first time on 7 November 1929, just ten days after the most catastrophic plunge in the history of the American stock market. Alfred Barr may have felt well insulated against any economic hardship with the backing of such financially solid supporters as MoMA co-founders, Abby Rockefeller, Lizzie Bliss and Mary Quinn Sullivan.[1] But three years later, the Museum of Modern Art was in financial peril.[2] The trustees were looking for ways to trim the museum's operating budget. MoMA's first president, A. Conger Goodyear, suggested that the museum shave operating expenses by closing during the traditionally slow month of August. Barr fought to defeat the proposal; shutting down even for one month was a dangerous precedent, and perhaps the first clumsy step toward complete collapse.[3]

Even opportunities for the museum came with tremendous pressures for Barr. Upon her death in 1931, Lizzie Bliss left an extraordinary collection of modern art to MoMA. But her bequest arrived encumbered by a condition; the institution had to build a one million dollar endowment as evidence of its permanency. If Barr and MoMA's trustees failed to answer the provision, the donation would be transferred to the Metropolitan Museum of Art. The campaign to meet Lizzie Bliss's stipulation was more than an effort to retain a co-founder's collection. It was a line drawn in the sand to determine whether MoMA ultimately would succeed or fail. And in 1932, the worst year of the Great Depression, MoMA was much nearer to failure than to raising one million dollars.[4] As Barr pondered his future and the future of MoMA, he realised that what he needed most was a smash exhibition, a popular draw that would line up the public all the way to Fifth Avenue and set the critics' pens to twitching. A well-received show would not only improve the gate and enhance MoMA's chances of picking up a new donor or two, it just might

70 *Alfred Barr*
Digital Image
© The Museum of Modern Art/
Licensed by SCALA/Art Resource, NY.

reinvigorate existing trustees, who at the moment needed a good prodding. It was perhaps on one of those sleepless nights, tossing and turning, that Barr envisioned bringing Whistler's *Mother* to MoMA.

By 8 April 1932, Barr had drafted letters to Jean Guiffrey, the chief curator of the Musée du Louvre and to Henri Verne, director of Les Musées Nationaux de France, seeking the loan of Whistler's *Mother*. Barr knew that his request was extraordinary; the Louvre had never allowed a painting in its collection to leave France, let alone travel to an American museum. Determined to marshal all of MoMA's institutional force behind the request, Barr urged Goodyear to write to the French museum officials and called upon his most persuasive ally, Abby Rockefeller, to make a personal plea for the painting as well. He sent her copies of his own letters to Guiffrey and Verne along with the encouragement that Verne 'remembers you with special regard'.[5]

In May 1932, as he awaited word from Paris, Barr's insomnia worsened. The pressures of keeping MoMA solvent combined with a disastrous spring exhibition of contemporary American murals had virtually fused Barr's eyelids into the open position.[6] By early June, he was exhausted and out of options, except to petition MoMA's board for a leave of absence. Abby Rockefeller's own physician insisted that nothing less than a year of complete rest would restore normal sleep patterns, and the trustees reluctantly agreed.[7] Barr decamped New York in mid-July for his family's retreat in Vermont, where he hoped quiet days and cool nights would soothe his ragged nerves, but he continued to administer MoMA's affairs *in absentia*. Less than three weeks into his young colleague's sabbatical, Goodyear reminded Barr that: 'There will be a good many things to come up that you will be

eager to work on, but I feel that it is a great mistake for you to do so.' The weary director's dispatches to MoMA came to an abrupt halt, but his silence may have resulted less from Goodyear's thoughtful advice than the news in the same letter that Barr's temporary replacement (but not his preferred choice), interim director, Holger Cahill, was spending mornings at the museum.[8] Together with Goodyear, Cahill was at work on the fall exhibition of American art that was to feature Whistler's *Mother* – drafting a checklist, pursuing loans and outlining a catalogue. Barr tinkered with plans to continue his leave in Europe. The summer passed, but still there was no answer from the French.

With Brentano's scouring the city on his behalf for a second-hand copy of *Sleep and Sleeplessness*, Barr boarded a ship for Naples on 17 September.[9] He sailed knowing that Cahill had made steady, if unspectacular, progress on the American show, and that the approaching 2 November opening date left little hope that Whistler's *Mother* would come to MoMA. Although he was devoted to the museum and its programmes, Barr was less concerned about smash exhibitions and long lines of visitors than he had been the previous April; he was not eager for Cahill, or anyone else, to become too comfortable at his desk. A competent but unremarkable American exhibition (to Barr's thinking, all one could expect of American art) probably suited him fine.[10] But if Barr believed that the question of Whistler's *Mother* had been answered by the silence of the French, he underestimated the resources he had already committed to the request. In eliciting the support of Abby Rockefeller and Conger Goodyear, Barr had chosen more wisely (or unwisely) than he realised.

The personal appeal Barr had coaxed from Abby Rockefeller the previous April was more than a polite plea from a Park Avenue society dame. The Rockefellers were major contributors to cultural projects worldwide, including the restorations of the Bibliothèque Nationale in Paris, the Palace of Versailles and Rheims Cathedral. In 1933, at the opening of an international exhibition of modern art at Rockefeller Center, the French writer and ambassador to the United States, Paul Claudel, offered Abby Rockefeller his nation's thanks for her commitment to French history and culture. Later that year, John D. Rockefeller, Jr was named a *Grand Officier* and Abby Rockefeller a *Croix d'Officier* of the French *Légion d'honneur*.[11] A warm note on Abby Rockefeller's stationery, seeking consideration in the matter of Whistler's *Mother* would not have failed to catch the attention of Guiffrey, Verne or any other government employee in France with a pension to protect. They might not respond promptly, but they would respond.

If Rockefeller seduced the French with charm backed by economic might, Goodyear overwhelmed them with blustery insistence. Determined to make one final push for Whistler's *Mother*, Goodyear veered from his European vacation into Jean Guiffrey's office at the Louvre during the first week of October 1932, less than a month before MoMA's American exhibition was to open. Goodyear's direct appeal for the painting could not have been better timed. The autumn of 1932 was a pivotal moment in Franco-American relations, and that made all the difference.

It was a presidential election year in the United States, and the Republican incumbent, Herbert Hoover, and his Democratic challenger, Franklin D. Roosevelt, saw their polls rise each time they blamed American economic misery on the fiscal irresponsibility of

Europe. France was favourite target of both candidates. German delegates had just walked out of the Lausanne War Debt conference, shouting threats to rearm, and placing the French premier, Edouard Herriot, in a nearly untenable position. On the one hand, Herriot was under intense internal pressure to seek a deferment of France's next war debt payment (still lingering from the Great War) to the United States. His cabinet and military advisors urged him to salt away France's cash reserves to finance a military build-up made necessary by aggressive German rhetoric. On the other hand, cultivating better relations with the United States was essential if Herriot was to extract an American intervention pledge should France's borders be invaded, which seemed more likely with each passing day. The French premier understood that in the few remaining weeks before the November election, Hoover was not about to enter into substantial diplomatic discussions, much less support a consultative pact that might lead the United States to war. The most Herriot could hope to accomplish diplomatically in the autumn of 1932 was to improve the flagging perception of France in American public opinion, and he was eager to make any reconciling gesture available to him. Herriot and his staff were considering their options when Goodyear wandered into Guiffrey's office. Within days, Louvre art handlers marched into the *Salle des Etats* and packed Whistler's *Mother* for shipment to New York.[12]

'Whistler's *Mother* comes home'

Goodyear returned to New York on 9 October, and began stoking MoMA's public relations machinery. Any loan from the Louvre was news, and by Wednesday, 12 October, Goodyear was seated before

the press, describing his negotiations with the French museum officials. The slender column that appeared in the following day's *New York Times*, FRANCE TO LEND US WHISTLER'S 'MOTHER', offered little indication of the media barrage to come. But the short announcement did note Goodyear's victory in the face of insurmountable odds, reminding readers that it had been fifty years since Whistler's *Mother* was last seen in America, and that the Louvre had made an unprecedented exception to its conservative loan policy. In his statement to the press, Goodyear emphasised France's objective in making the loan: 'The return of the painting at this time is an act of international goodwill on the part of the French Government and a reaffirmation of the artistic solidarity of France and the United States.'[13] Goodyear delighted in MoMA's contribution to international diplomacy.

Barr was among the first to learn of Goodyear's coup, and the news was more than he could bear in silence. Suddenly, Goodyear and Cahill's exhibition had a centrepiece that charmed it for triumph. Although angling for Whistler's *Mother* had been Barr's idea, he knew that credit would go to whoever was standing next to the painting when the reporters and photographers arrived. Asserting his proprietary interest in the project, Barr set down a list of paintings that he thought would further enhance the American show and sent it to Holger Cahill. It was the desperate action of a sleepless man, hoping not to be lost in the shuffle, but his suggestions arrived too late. The (seemingly) always cheerful Cahill wrote back 'I am sorry I did not get your letter sooner for our catalogue is already on the press', before adding, 'the American show is coming on nicely. I do nothing but work, eat, dream, and sleep it.'[14]

A week before the opening, on 23 October 1932, H. I. Brock published in *The New York Times Magazine* the first feature article on the return of Whistler's *Mother* to America. A large reproduction of the painting was framed between the headline WHISTLER'S 'MOTHER' COMES HOME AGAIN, and the caption 'Symbol of the dignity and patience of motherhood', the first of hundreds of references to the painting's stature as an icon.[15] News of Whistler's *Mother*'s arrival in New York and imminent exhibition at MoMA spread quickly. Four days later, the syndicated story 'MOTHER ... BY WHISTLER' was picked off the wire by dozens of small town papers across the country. No doubt responding to Goodyear's internationalist take on the loan, the article praised Whistler for creating a 'symbol of mother of all ages and in all lands'. Such an expansive, global understanding of Whistler's *Mother*'s iconic reach would not last long, however. By the time the painting landed on the walls of MoMA, the press had refined its interpretation considerably, transforming Whistler's *Mother* into a symbol of American motherhood.[16]

Whistler's *Mother* at MoMa

Seventy Years of American Painting and Sculpture, 1862–1932 and its main attraction opened to MoMA's trustees and members on 31 October; the press preview was 1 November, and an eager public received its first glimpse of Whistler's *Mother* on 2 November.[17] Edward Alden Jewell of *The New York Times* called the show a 'brilliant success ... that very eloquently states the case for American art', before devoting five paragraphs to Whistler's *Mother*, the painting in 'the position of honor'.[18] The exhibition also received high marks from Royal Cortissoz in *The New York Herald-Tribune*, Malcolm Vaughan in *The New York American*, Henry McBride in *The New York Sun* and Marguerite Breunning in *The New York Post*, but every review singled out Whistler's *Mother* as the show's central work.[19] *The Art News*, *The Art Digest*, *Creative Art*, *Arts and Decoration* and *Parnassus* all favourably noticed the exhibition, while such national news magazines as *Literary Digest*, *Time*, *The New Yorker*, and *Scholastic Magazine* discussed the show as a pretence to comment on the triumphant return of Whistler's *Mother*.[20]

Holger Cahill was pleased enough with the early response that he wired Barr in Rome on 1 November, the day of the press preview, 'American show appears to be a success ... you and the trustees are to be congratulated.' Goodyear wrote to Barr the same day, folding the *Times* and *Tribune* reviews into a gushing letter full of praise for Cahill and his work on the American show.[21] Barr wrote to Goodyear, three weeks later, congratulating him and the trustees, before adding half begrudgingly, 'I think, too, that Cahill did a difficult job very well,' and almost sulking, 'I'm glad you found him agreeable to work with.' Barr had been relaxed enough in early November but his insomnia came roaring back before the end of the month coinciding with the stir Whistler's *Mother* was causing in New York without him. He wrote to his secretary at MoMA, Alice Malette, to see if Brentano's had delivered *Sleep and Sleeplessness*. They had.[22]

By 12 December, six weeks into the MoMA exhibition, more than a dozen American museum directors had written to Goodyear, asking whether Whistler's *Mother* might travel beyond New York. *Seventy Years of American Painting and Sculpture* and 'the most popular painting in the exhibition' had already attracted 50,000 visitors, and Goodyear was determined to

make the most of the desirable position MoMA now occupied. Sometime in December and certainly well before Christmas, he petitioned the Louvre to extend the loan period to one year, which would allow Whistler's *Mother* to travel to a handful of venues in the United States. Once again, Goodyear's timing was far from strategic but utterly impeccable. On 15 December, over the objection and resignation of Herriot, France defaulted on its war debt payment to the United States. Even more than the previous October, France needed to shore up its relations with the United States, and to offer up some gesture of conciliation to its newly elected president, Franklin D. Roosevelt.[23]

There was no word of the Louvre's decision in the New York press during the holidays, but on 29 December 1932, *The Chicago Daily News* breathlessly announced that Whistler's *Mother* would appear the following summer at the *Century of Progress* World's Fair. The source, Art Institute of Chicago director Robert B. Harshe, was reliable and the information may have been accurate, but if the Louvre had consented, MoMA, Goodyear and the New York press remained inexplicably silent. It was the first but certainly not the last time that Chicago Fair publicists would irritate MoMA's leadership. After an almost month-long dramatic pause, on 22 January 1933, *The New York Times* finally announced that the French government had agreed to extend the loan period until November. Whistler's *Mother* would be exhibited in San Francisco, St Louis, Columbus (Ohio), and, as readers of *The Chicago Daily News* were already aware, at the *Century of Progress* World's Fair in Chicago.[24]

Barr, meanwhile, was trying to put aside his anxieties about MoMA, Whistler's *Mother* and Holger Cahill to relax and to concentrate exclusively on his health.

While skiing in Austria, he fell into conversation with a certain Frau Jacob, a German woman to whom he confided the reason for his extended sabbatical. Frau Jacob insisted that Barr contact a Stuttgart psychiatrist named Dr Otto Garthe. Halfway through his furlough and desperate for some relief, Barr exchanged letters with Dr Garthe, and within two weeks, before the end of January 1933, he was settled in Stuttgart. But of all the places and times to seek treatment for an anxiety-induced sleep disorder, Barr found himself in southern Germany at the precise moment that Adolf Hitler was named chancellor. From a boarding-house in Stuttgart, Barr witnessed firsthand the startlingly swift and belligerent tactics of Württemberg's National Socialist German Workers' Party. He was deeply troubled by what we saw there, but remarkably, his insomnia improved.[25]

The *Mother* goes on tour

MoMA had attracted 102,000 visitors by the time *Seventy Years of American Painting and Sculpture* closed on 5 February, 'more than doubling any previous attendance for a corresponding period'.[26] The museum continued to receive a steady flow of requests to borrow Whistler's *Mother*, and rather than bask in his unqualified success, the intrepid Goodyear went back to the Louvre for yet another extension. On 14 February 1933, he learned that the French had once again consented, allowing Whistler's *Mother* to remain in the United States until June (actually May) 1934.[27] After leaving the World's Fair in Chicago at the end of October 1933, the painting would appear in Cleveland, Kansas City, Baltimore, Toledo, Dayton and Boston. Los Angeles was also added to the itinerary, shoehorned between the San Francisco and St Louis

venues.[28] Eight cities would exhibit the painting for approximately thirty days; Chicago would enjoy a five-month run, and Columbus and Boston would each show Whistler's *Mother* for two weeks. The eleven museums divided the insurance bill, with each share coming to $581.25; their only other expense was the cost of shipping the painting to the next venue. Chicago paid a larger percentage of the insurance cost and Columbus and Boston were charged a bit less, but everyone, everyone paid up gratefully.[29]

When word of the Louvre's second extension reached American newspapers, Whistler's *Mother* was already drawing record crowds in San Francisco's California Palace of the Legion of Honour. Alexander Fried reported in *The San Francisco Chronicle* that 'all day long, cars were packed thickly in the plaza before the Palace', and that 'the large canvas was studied from morning until night by an ever-changing but never diminished throng of reverent visitors'.[30] By Sunday, 19 February, the attendance tally turned into a friendly competition between San Francisco and New York. Under the headline, SAN FRANCISCO PAYS ATTENTION, the *Chronicle* reported that 15,000 visitors had already seen Whistler's *Mother*, and that 'San Francisco does not propose to take a back seat to New York'. The article continued:

> *This, for a one-day count is a good start on the New York record of 100,000 persons who saw the painting while it hung for three months in the Museum of Modern Art in that city. At this rate the New York record will be broken by San Francisco, without any consideration of the proportion between the two cities.[31]*

San Francisco drew 145,700 'reverent visitors' in only twenty-nine days, well surpassing New York's attendance record. More than 25,000 guests of the museum (roughly, one per second) marched before the canvas on the final day of the show.[32]

A note of cynicism occasionally seeped into the press's discussion of attendance figures. Some writers characterised the enormous crowds as little more than curiosity seekers attracted to Whistler's *Mother*'s staggering commercial value, reported to be $500,000.[33] But whether inquisitive spectators or reverent multitudes (*The San Francisco Chronicle* described it as 'beloved of every American'),[34] it was difficult not to be impressed by the painting's immense value in an otherwise depressed marketplace.

Newspaper writers added poignancy to the half-million-dollar figure by repeatedly, if unfairly, chiding American museums for failing to snatch Whistler's *Mother* in 1881, when it was offered for the bargain sum of one thousand dollars.[35] Transformed by American journalists into a Depression-era trope, Whistler's *Mother* became – like the once bullish stock market, like formerly steady employment statistics, like the evaporated prosperity of the 1920s – yet another good deal that got away. Who wouldn't take a second glance at a golden opportunity squandered? Moreover, the painting's commercial value seemed to climb as it crisscrossed the country. When Whistler's *Mother* arrived in New York, the press accurately reported that it was insured for half a million dollars, but by the midpoint in the tour, most writers preferred the handle, '$1,000,000 masterpiece'.[36] The Louvre had originally asked that the painting be insured for that sum, and those large, round numbers made excellent headlines.[37]

Whistler's *Mother* was turned back en route to southern California by an earthquake, delaying its

opening at the Los Angeles Museum until 18 March, three days later than scheduled.[38] The French consul, Ernest Didot, eventually performed the unveiling and remarked that the painting's return to the United States was 'not without bearing on international relations', or so he hoped.[39] The Los Angeles Museum exhibited the canvas alongside Alice Pike Barney's portrait of Whistler, charged no admission fee, and attracted over 80,000 visitors.[40] From the shores of the Pacific, Whistler's *Mother* travelled to the banks of the Mississippi, where nearly 30,000 visitors saw the painting in St Louis. In May, Whistler's *Mother* continued on to Columbus. Despite being one of the smaller cities on the tour and the presence of three other Ohio venues, Columbus drew 20,864 visitors during its two week run, including 5481 school children.[41] On 29 May 1933, Edward D. Jones, director of the Columbus Museum of Art, wrote to Barr:

This closes a happy adventure without one marring incident. It was a treat which caused a local poetess to burst into three stanzas of poetry, and it was an occasion which has made many friends for the Gallery. We feel you should know how much your enterprise in securing the picture and your generosity in admitting us to the schedule has benefited us.[42]

Jones's grateful letter was waiting for Barr when he returned to New York in July 1933, and no doubt the much-rested director was pleased to find such winsome praise of MoMA's industry and growing institutional clout. But as he poured over press clippings and puzzled over America's outsized affection for Whistler's *Mother*, Barr decided that the spectacle he had helped set in motion, a phenomenon that (to date) had inspired 300,000 reverent pilgrims, reams of newspaper copy and at least one Ohio poet, resembled nothing so much as an 'American mother

cult'.[43] He asked himself the logical question: 'Why is it the most popular American painting?' Barr pondered the public's fascination with 'mother cults of the past – to American Protestantism – Mother's day and its rites', before arriving at the same sentimental conclusion the press had insisted upon from the outset: 'Whistler's picture the American holy icon'.[44] But whereas American journalists wrote affectionately of the painting's symbolic stature and the public's respect for it, Barr had set up the entire 'cult' to 'icon' sequence to demonstrate just how far America's curiously emotional response had drifted from 'Whistler's intention'. The canvas would always be more of an 'arrangement' than an emblem to Barr. If Americans were under the impression that Whistler had emphasised motherhood over formal innovation, over art for art's sake aestheticism, over his refined theory of modern painting, they were, to Barr's thinking, very much mistaken.

And it was an important mistake to have persisted for so long unchallenged. In Whistler's *Mother*, MoMA missed a highly visible and accessible vehicle through which to proselytise for the institution's chosen cause, modernism. Cahill, who was pleased enough to exhibit the painting before moving on to the next project, and Goodyear, who continued to revel in the museum's contribution to world peace, had left MoMA's modernist mission unprotected from the long shadow of iconic motherhood. More troubling yet, by remaining silent, MoMA's leadership not only allowed motherhood to trump modernism, they failed to promote or even defend the museum's role in bringing Whistler's *Mother* to America in the first place. Once the painting was trundled out of New York and out of the purview of city journalists, MoMA had all but evaporated from the press coverage and public consciousness. At best Whistler's *Mother*

appeared to be crisscrossing the country under its own iconic power, and at worst, Barr's counterparts were becoming each a little bolder in accepting full credit for the painting's local presentation.[45] Barr had been the sleepy forgotten man in November 1932, when Whistler's *Mother* debuted in New York, and he was not about to allow MoMA to be similarly dismissed by glory-grabbing museum directors in Middle America. He trained his sights on Chicago, and not a moment too soon.

The World's Fair

Months before Whistler's *Mother* appeared at the *Century of Progress* World's Fair, Chicago publicists were already trumpeting the painting's arrival. In March, the syndicated article headed LOUVRE PRIZE FOR WORLD'S FAIR was published in dozens of newspapers across the country, creating a frisson of anticipation and well overemphasising Chicago's role in bringing Whistler's *Mother* to the United States.[46] Once the Fair opened in May and began picking up steam during the summer months of 1933, the press seemingly could not get enough of the painting, and no mother-loving event was too absurd for Fair organisers to promote or too trivial for Chicago journalists to describe in earnest detail. From the Goodman Theater Players' radio dramatisation of Whistler at his easel, to the framed reproduction presented to the exhibition's exultant one-millionth visitor (Fig.71), to the many (not so) amusing misidentifications of the sitter, to the young boy who waited patiently for the woman in the painting to whistle, the press coming out of Chicago was as prolific as it was ridiculous and as self-promoting as it was entertaining.[47] Now, in addition to competing

71 'A Treasured Gift,'
Chicago Herald-Examiner,
20 September 1933

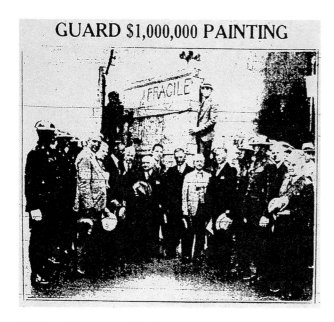

GUARD $1,000,000 PAINTING

72 'Guard $1,000,000 Painting'
The Chicago Times, 30 May 1933

with motherhood, Barr had to divert America's attention from a carnival if MoMA was to receive the acknowledgement it deserved.

Determined to stem Chicago's momentum, Barr wrote to I. T. Frary, the Publicity Secretary of the Cleveland Museum of Art, the painting's next destination:

> *You are correct in regarding some newspaper stories as inaccurate, particularly those originating in Chicago. The picture ... was not brought especially to Chicago for the Century of Progress but rather for all American museums ... We shall appreciate your mentioning the fact that the Museum of Modern Art is directing the itinerary for the picture in this country.*[48]

Barr was galled by the sprawling silliness of Chicago's promotion of Whistler's *Mother*, but World's Fair publicists struck at least one solemn chord that resonated for the remainder of the tour. On the morning that the painting arrived in Chicago, reporters and photographers trailed the armoured car that carried Whistler's *Mother* from Union Station to the Art Institute. As the crate was unloaded near the front steps of the museum, photographers hastily posed city, museum and Fair officials before the precious cargo, flanking them with the armed militia who had served as the painting's escorts (Fig.72). The photograph and headline that appeared the next day in *The Chicago Times* could scarcely have offered a more accurate tableau of America's evolving relationship with Whistler's *Mother*. The grave local dignitaries, hats in hands, and the helmeted militia, standing in ceremonial but alert attention, aptly rendered America's growing awareness of the responsibility born of keeping an icon secure. The headline over the photograph was more directive than descriptive: GUARD $1,000,000 PAINTING.[49]

Iconic motherhood quietly slipped from the headlines. Beginning with the *Century of Progress* venue, and perhaps with the photograph in *The Chicago Times*, the press reported the security measures surrounding Whistler's *Mother* with greater frequency and in increasingly urgent tones. Encouraged by exhibiting museums, which made a showy display of custodial force the official welcome in city after city, the local press (regardless of where) thrust armed men in uniforms and a crate marked FRAGILE before the cameras and on to the front page. Newspapers described in ever more excruciating detail the state-of-the-art electronic alarm, the around-the-clock officers, and the iron rail that kept enthusiastic crowds well beyond arm's reach of the canvas. Peggy and Sentry, two German Shepherds that patrolled the Art Institute of Chicago after hours, became national celebrities once the illustrated wire service article, SAVAGE DOGS GUARD FAIR ART TREASURES, appeared in newspapers, coast to coast.[50]

Perhaps it was only natural that Depression-era Americans were intrigued by the security measures taken to protect Whistler's *Mother*.[51] In such uncertain times, security filtered poignantly through the public discussion and debate of the issues that affected the country most: the economy, unemployment, farm and home foreclosures, the mounting crime rate and the threat of war in Europe and Asia. Recognising that anxiety had become an almost collective second nature by 1933, newly elected President Roosevelt reminded Americans in his first inaugural address: 'The only thing we have to fear is fear itself.'[52] Roosevelt purposefully inserted 'security' into the titles of his most dramatic legislative initiatives and recovery agencies, hoping to comfort a nation stalled as much by uncertainty and worry as by poverty. It would be years before the president's programmes significantly altered the social, economic and diplomatic landscapes or recast America's doubtful consciousness of them. However, if personal security, job security, economic security and national security were too much to hope for in such a perilous epoch, at least Americans could go to sleep knowing that Whistler's *Mother* was safe somewhere, protected by armed militia, watched over by savage dogs.

Safe and secure

On 1 November 1933, Whistler's *Mother* arrived in Cleveland 'in the dead of the night, secretly transported in an armored truck and guarded by squadrons of motorcycle police'.[53] Robert Bordner of *The Cleveland Press* itemised the 'elaborate precautions' that were or would be taken to protect Whistler's *Mother*, and described William M. Milliken, the museum's director, personally accepting the transfer from officials of the Art Institute of Chicago. I. T. Frary clearly was influenced more by Chicago's promotional strategy than by Barr's instructive letter. Even so, he had apparently made some effort to accommodate Barr, given that Bordner did acknowledge MoMA in his closing paragraph.[54]

Whistler's *Mother* drew nearly 100,000 visitors in Cleveland before returning to Missouri in December, where it took part in the inaugural exhibition of the new William Rockhill Nelson Gallery of Art in Kansas City. Amid tight security and despite the interruption of the holidays, over 50,000 visitors filed past the painting.[55] On the night of 7 January 1934, R. J. McKinney, director of the Baltimore Museum of Art, waited for the train bringing Whistler's *Mother* from Kansas City. Beside him was a reporter from *The*

Baltimore Sun, who tracked the painting's every movement from railroad car to museum:

> The picture reached Camden Station in a sealed car of the American Express Company. Inside the car with the canvas were several armed detectives of the company. As the doors of the car were opened Mr. McKinney and five motor-cycle police stepped forward. A truck was backed up as detectives and police stood close by to prevent any unauthorized persons approaching close.
>
> At a signal the truck surrounded by motor-cycle police started for the museum, where other police were waiting at the steps. The heavy crate was lifted into the building where the picture was removed and immediately photographed to ascertain if any damage had been done on its trip ...
>
> As the doors to the museum closed for the day Mr. McKinney breathed deeply and said weakly, 'I'm glad that's over.'[56]

Readers of the *Sun* would have begun their day assuming that all had gone well in transferring Whistler's *Mother* to the Baltimore Museum of Art. But all had not gone well. When McKinney opened the crate, he found the unthinkable. Whistler's *Mother* had been damaged in transit. Stunned and already concerned that Baltimore might lose its opportunity to display the painting,[57] McKinney waited two days, after Whistler's *Mother* had been placed on view, to write to Alan J. Blackburn, Jr, MoMA's Executive Secretary. He reported that Whistler's *Mother* had shifted within the road-weary container, causing the damage he reluctantly described: 'a sharp scratch about four inches long is visible and two scratches three inches long are seen in the upper right to the left of the framed picture ... a slight abrasion is noticeable also in the lower left.'[58] Surprisingly, given the seriousness of

the incident, it was two weeks before Barr's response, which, although to the point, was hardly the indignant scolding McKinney may have expected and feared:

> Would it be possible for you in any way to determine what caused the fresh scratches on the surface of the Whistler painting? Was there any material in the box which might have caused these marks? I shall appreciate any comments you may have in this regard. The picture must be safeguarded against every possible injury.[59]

McKinney had written repeatedly that the derelict condition of the crate caused the scratches in the painting's delicate surface. Indeed, by the time McKinney received Barr's polite dispatch, filled more with pleasantries than urgency, Blackburn had authorised the Baltimore director to have a new crate built, instructing him to carefully remove and transfer any transit labels from the retired container to its replacement.[60]

If Barr was less than engaged in the Baltimore incident, he may have simply had enough of Whistler's *Mother*. The national tour was in its final weeks, and he quite reasonably assumed that there were no benefits left for MoMA to wring from the painting and its over-excited public. Whistler's *Mother* was already a saturated subject, unlikely to attract more national magazine or newspaper exposure, and Barr's colleagues in the remaining venue cities (with the help of their local presses) would follow the same self-aggrandising impulses as their predecessors. He was willing to send McKinney a *pro forma* letter to assure that the painting was 'safeguarded', but by early 1934, Barr was more or less out of the business of Whistler's *Mother*. The tour would play out, the painting would go home and that would be the end of it – or so he may have believed at the time.

It is unclear whether Whistler's *Mother* received conservation treatment in Baltimore, but if it did, any cosmetic touches were performed immediately, well before Barr's tardy letter to McKinney. Despite the presence of journalists and photographers when the crate was opened, no mention of the scratches appeared in the Baltimore newspapers, or in the press of subsequent venue cities. After such fulsome discussion of security, no one in America wanted to read that Whistler's *Mother* had been damaged, and of course, no one wished to be held responsible for it. Did Barr report the damage to the Louvre? McKinney's staff successfully reinforced and salvaged the French crate, the museum and transit labels remained on the original container, and Guiffrey and Verne may have been none the wiser.[61]

After yet another record-breaking run (66,066 people saw the painting), Whistler's *Mother* was transported from Baltimore to the remaining two Ohio venues, the Toledo Museum of Art and the Dayton Art Institute.[62] In Toledo, the painting was escorted from the train station to the museum by an honour guard of boy scouts. Eschewing the police squads and motorcades that accompanied the painting in other cities, Toledo linked its presentation to the theme of motherhood. 'We want the intrinsic value of the picture to be felt in Toledo. We want the painting to be associated with Toledo mothers and children,' insisted museum curator, Arthur J. MacLean.[63] Certainly, the Toledo press did its part to assure that the connection would not be overlooked. *The Toledo Times*, *The Toledo Blade*, and *The Toledo News Bee* all published photographs of adoring scouts posing before or gazing reverently at the painting (Fig.73).[64] The Toledo Museum's director, Blake-More Godwin, made the point even more firmly than MacLean, 'No mother and no child should miss this opportunity to see one of the great gems of the

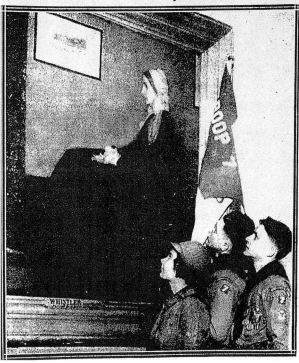

73 'Million Dollar Masterpiece in Toledo'
The Toledo Times, 15 February 1934

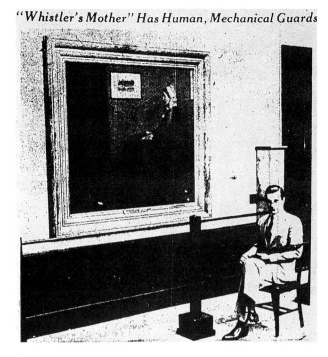

"Whistler's Mother" Has Human, Mechanical Guards

74 Fawcett, ' "Whistler's Mother"
Has Human, Mechanical Guards'
The Dayton Journal, 17 March 1934

Louvre.'[65] Whistler's *Mother* attracted 25,000 visitors in Toledo;[66] it is unknown how many were mothers or children. MoMA was never mentioned in the initial barrage of press coverage, except for a near miss by *The Toledo Blade,* which credited the tour's management to the 'American Museum of Modern Art' in an undisclosed city.[67]

When Whistler's *Mother* arrived in Dayton, Ohio, in late March 1934, the presence of four policemen armed with shotguns so alarmed the locals that 'for a brief period [the painting] caused as much excitement around the Union Station as if Dillinger or one of his gang had just been captured'.[68] The museum issued a rifle to the security guards who took turns watching over the painting. A photograph of Paul McAdams seated next to Whistler's *Mother,* the weapon cradled gently in his arms, was printed in *The Dayton Journal* (Fig.74) to discourage Public Enemy Number One or anyone else who may have been contemplating a robbery.[69] Fascination for the security measures taken to protect Whistler's *Mother* was rapidly dissolving into paranoia.

The 'Mother's Day' postage stamp

On 24 March 1934, a few days after Whistler's *Mother* debuted in Dayton, Postmaster General James A. Farley announced that the United States Postal Service would issue a postage stamp bearing the image of Whistler's *Mother.*[70] According to Farley, President Roosevelt had personally selected the subject to commemorate the approaching Mother's Day holiday. Farley assured the public that post offices would be well supplied with Whistler's *Mother* stamps by 2 May, early enough that the Mother's Day cards of America

could be conveyed to their fond destination by a 'masterpiece of the mails'.[71]

Whistler's *Mother* was shipped to Boston, the final venue of the tour, on 20 April 1934. Describing the painting's arrival, *The Boston Evening Globe* headline read, WHISTLER PAINTING HEAVILY GUARDED ON WAY TO MUSEUM, and *The Boston American* offered the somewhat ambiguous banner, RIOT GUNS GREET WORLD FAMED MOTHER IN BOSTON.[72] The Museum of Fine Arts took a page from Chicago's handbook, employing two Belgian Shepherds, Louie and Pal (Fig.75), to guard the painting, but that was only the beginning of Boston's elaborate security plan.[73] As if the alarm, the iron rail, dogs and armed policemen were inadequate, Whistler's *Mother* was removed each night to the museum's vault, and the driveways leading to the Fenway and the Huntington Avenue entrances were closed to prevent the criminal element or deranged vandals from making a quick getaway. As Michael Moore, a museum super-intendent, calmly explained, 'The thief or maniac will have to run clear across the Fenway road or Huntington av[enue] before he could get into an automobile, and special police officers who will be on duty outside the museum all during the hours of the exhibition will be able to capture him or shoot him.'[74] Although Boston enjoyed the good fortune of hosting the painting on Mother's Day, the local press ignored the event. After excitedly describing the arrival of Whistler's *Mother* and the security measures that would keep the picture safe, there was apparently little else to say.

The United States Postal Service unveiled the Whistler's *Mother* postage stamp (see Fig.69), as scheduled, on 2 May, and it more or less instantly re-engaged Barr in the business of Whistler's *Mother*.

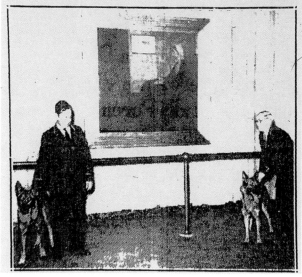

75 'Burglar Alarms Put on $1,000,000 Painting'
The Boston Post, 24 April 1934

A postal service designer had significantly cropped the image, added a pot of flowers at the feet of Mrs Whistler, and covered almost half of the stamp with the inscription: 'U.S. Postage, IN MEMORY AND IN HONOR OF THE MOTHERS OF AMERICA / THREE CENTS.' Barr was outraged by the Postal Service's use of the painting, and on 9 May he fired off an irate letter to Postmaster Farley. No doubt, Barr was sincerely angry (he had once been a philatelist),[75] but he was also not about to let a ripe public relations opportunity remain a private affair between MoMA and the US Mail. He sent a copy of his letter to *The New York Times*, which obligingly published it the following day:

> The Museum of Modern Art is directing in this country the tour of Whistler's 'Mother'. The painting was originally loaned by the Louvre to our museum for its exhibition of American painting and sculpture in October 1932. The painting will be returned to France on May 19 of this year after a four-day showing at our museum here in New York.[76]

Barr's first paragraph was written more for the *Times* than for Postmaster Farley. As if to demonstrate how effortlessly it could have been managed, in the first two sentences Barr said everything that he had expected museum officials in Cleveland, Baltimore and the other venues to plant in their local newspapers. How difficult would it have been to appropriately credit MoMA? But it was his third sentence that contained the real news. It is unclear how long Barr had been planning to reprise his museum's presentation of Whistler's *Mother*. Perhaps the postal service's abuse of the image spurred him to hastily arrange a final New York send-off. Or maybe the infernal stamp simply provided Barr with an opportunity to promote an exhibition that was already scheduled. In either case, it was the first

notice anywhere that Whistler's *Mother* would again be on view at MoMA, and no doubt the motive behind his letter to Farley.

Finally, Barr got around to the stamp:

> We are therefore especially interested in the Whistler's mother stamp and the controversy about its artistic merit.
>
> Whistler himself was so much concerned with the design of this painting that he gave it the title 'Arrangement in Gray and Black.' We are afraid that if he were alive today he would be enraged by the adulteration of his design on the stamp. We regret that Whistler's painting has been mutilated in a stamp which might have done honor to the most famous of American artists ...
>
> We believe you may wish to have from an impartial art institution like the Museum of Modern Art a suggestion for a stamp which preserves the integrity of Whistler's design ...
>
> We enclose with this letter the original design we have prepared.[77]

Barr used the remainder of his letter to correct what he believed to be the other great error that surrounded Whistler's *Mother* in America. The Postal Service's gaff allowed him to return to 'Whistler's intention', and to emphasise the painting's formal integrity while uttering not a single word about motherhood, icons, insurance values, security guards, watchdogs or good deals that got away. Barr was not simply schooling Farley in modernist aesthetics, he was demonstrating to Goodyear, Cahill, Abby Rockefeller and MoMA's trustees how the tour would have been managed had he been well enough to direct it from the very beginning. Of course, Farley never responded publicly to Barr. The Whistler's *Mother* stamp remained

in circulation as originally printed, but it was not reissued. By the middle of May, the matter was largely forgotten, but it had served Barr well.[78]

The final days

Whistler's *Mother* was back at MoMA on 15 May 1934, just as Barr had promised. For the painting's last four days in the United States, Barr arranged a minor extravaganza, including movie cameras to record the invited guests, and a WJZ (NBC) national radio broadcast featuring brief statements by Goodyear, Mrs John S. Shepherd, a MoMA trustee, and appearances by guests of honour, the French consul, General Charles de Fontnouvelle and Mrs James Roosevelt, mother of the president (Fig.76).[79]

Like every local consul at the previous stops on the tour, de Fontnouvelle adhered to the official French position. He hoped that the loan of Whistler's *Mother*, and its 20,000-mile journey across the United States, had warmed Franco-American relations:

> *Perhaps ... it has brought the citizens of France and America a little closer on the basis of art. Art knows no boundaries or frontier lines. It is universal. A fine work of art may be owned by one country, but it belongs to everyone in the world who can appreciate it.*[80]

It was a gracious, generous sentiment. Americans had indeed come to think of Whistler's *Mother* as their own, even if not in the preferred proprietary sense. The painting was perhaps America's one undisputed masterpiece, and while it was difficult to accept that Whistler's *Mother* resided permanently in France, Americans understood that French cultural authority

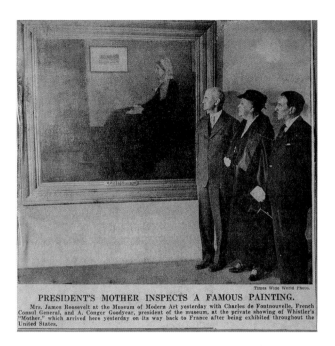

PRESIDENT'S MOTHER INSPECTS A FAMOUS PAINTING.
Mrs. James Roosevelt at the Museum of Modern Art yesterday with Charles de Fontnouvelle, French Consul General, and A. Conger Goodyear, president of the museum, at the private showing of Whistler's "Mother," which arrived here yesterday on its way back to France after being exhibited throughout the United States.

76 'President's Mother Inspects a Famous Painting'
New York Times, 16 May 1934
Press-cutting in Glasgow University Library

contributed something to its greatness. In this one specific case, where they had everything to gain and nothing to lose, Americans embraced de Fontnouvelle's notion that 'art knows no boundaries'. But as France would soon discover, the same Americans who believed that 'a fine work of art ... belongs to everyone' also believed that every nation's war debt was its own. France never persuaded the United States to sign a consultative pact, never extracted a pledge to intervene should its borders be invaded, as, of course, they eventually were.

Mrs Roosevelt was reluctant to pose with Whistler's *Mother* for the film crews, finding it 'ostentatious', but she eventually consented and even sent greetings in French to the cameras recording the event for audiences in Paris. Apparently unthreatened by the painting that challenged her position as First Mother of the United States, Mrs Roosevelt directed her remarks to what must have been for her a familiar subject – maternal pride: 'I know it would give his mother great happiness to see her son appreciated and honored by his native land.'[81]

Remarkably, after eighteen months, twelve venues, a coast-to-coast tour, pounds of newspaper copy and hundreds of thousands of visitors, it had taken the mother of the American president to speak up for Whistler himself. Barr had touched on the issue of pride for a fellow American's achievement in his letter to Farley, but very lightly and only to shame the postmaster. The vast majority of the American press coverage had positioned Whistler as a comic foil to the solemnity of his great painting. Repeatedly, he was cast as a clever, quipping, litigious rascal, so *outré*, so avant-garde, so lacking in mainstream sensibilities that he could produce an icon and call it an arrangement.

It had taken the mother of Franklin D. Roosevelt to point out the obvious. In American journalism's eagerness to anoint Whistler's *Mother* the quint-essential symbol of motherhood, and in Barr's determination to refute the popular press and to pull the artist into his own modernist camp, neither had grasped one of the painting's most fundamental attractions. After four years of economic hopelessness and a government retreat into isolationism that made the United States appear vulnerable on the international stage, Americans not only wanted, they needed to distil national pride from any source available. For all of Whistler's idiosyncrasies, the artist had been an indomitable compatriot who took on high European culture and seemingly beat them at their own game. To stand before Whistler's *Mother*, his best-known work, the painting that had battered down the door to the Musée du Luxembourg and then the Louvre, was to share in the pride of a fellow American's accomplishment. It registered rarely in the press, and probably only occurred to Barr when he was sniping at Farley, but as much as anything, Americans were drawn to Whistler's *Mother* out of patriotism, a competitive form bordering on nationalism, but pride in country none the less.

By 19 May 1934, when Whistler's *Mother* was loaded on the ocean liner *Paris* for its return voyage to France, more than two million Americans had seen the painting.[82] Although it had not been managed to Barr's satisfaction, the exhibition and national tour of Whistler's *Mother* attracted more national exposure to the young institution than any event in MoMA's early history. While it is impossible to measure just how much MoMA directly benefited, the museum made strides during the painting's eighteen months in the United States that would have been unimaginable before 1932. Just as Barr had hoped, the enthusiasm

and impressive attendance figures Whistler's *Mother* garnered in New York alone were enough to stimulate dormant trustees to honour long overdue pledges. Not only did the museum continue to operate, a point of some doubt in 1932, its membership more than doubled in 1933. As Whistler's *Mother* crisscrossed the country, MoMA added trustees, founded a library, and established departments of architecture and industrial design, publications and perhaps most notably, public relations.[83] Amazingly, before Whistler's *Mother* left the United States, Barr, Goodyear, Abby Rockefeller and the trustees raised $600,000 of the million MoMA needed to keep the Lizzie Bliss collection. Bliss executors agreed the sum was adequate evidence of the museum's permanency, and they turned over the collection.[84]

If he never quite appreciated the painting's significance to Depression-era Americans, Barr did recognise that Whistler's *Mother* had changed MoMA's fortunes more dramatically than Goodyear or anyone at the museum realised. As Edward D. Jones intimated in his grateful letter from Columbus, the stewardship of Whistler's *Mother* had vaulted MoMA into an elite category of international institutions with the power to dispense or to withdraw favour. In just over eighteen months, the perception of MoMA had shifted from petulant upstart to a mature museum with connections, ambition, wealthy supporters and an admirable public profile. MoMA may have possessed those qualities all along, but Whistler's *Mother* proved that the institution's leadership knew how to shepherd such impressive assets to good use. Indeed, it might be said that while Goodyear, Barr and the once struggling museum supervised the tour of Whistler's *Mother*, MoMA became MoMA, the powerful institution it is to this day.

Twenty years after the American tour of Whistler's *Mother*, the author and critic Dwight Macdonald was asked to write a pair of articles on the Museum of Modern Art for *The New Yorker*, and MoMA's publicity department urged Barr to co-operate. Barr had changed little in two decades, and demanded considerable editorial control in exchange for assisting Macdonald. He marked up manuscripts as if they were his own, driving the distinguished critic to near distraction. Finally, Macdonald recalled Whistler's *Mother*, and asked Barr to describe his role in bringing the painting to the United States. Barr pondered the question for days before writing back that he had played no significant part in stirring the 'excessive popular interest' that had surrounded Whistler's *Mother*'s tour of America.[85] Pleasant dreams, Mr Barr.

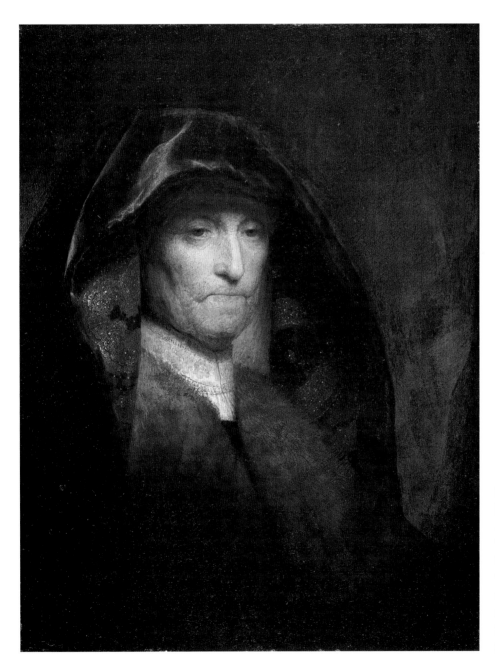

77 Rembrandt
Harmens van Rijn
An Old Woman:
The Artist's Mother (?) 1629
Oil on wood, 613 x 473 mm
The Royal Collection
© 2003 Her Majesty
Queen Elizabeth II
Photograph:
Rodney Todd-White

Chapter 5 A chance meeting of Whistler and Freud? Artists and their mothers in modern times

William Vaughan[1]

'The most unforgettable character I've met.' This is how the hero introduces his mother in Phillip Roth's *Portnoy's Complaint*.[2] Many children may recognise the feeling. The bond between mother and offspring is, at the very least, as strong as any. This is why it has featured so prominently in psychoanalytic theory, from Freud onwards. Freud was also the first to propose the view that artistic creativity was rooted in the complex drives of desire and rivalry that the artist experienced in early life in relationship to his or her mother. The ways in which artists depict this central figure in their lives would seem therefore to be a matter of some interest, though it remains curiously unexplored as a topic.[3]

Given the usual availability of the subject, it is likely that most artists have depicted their mothers at some time in their lives – and probably early on. Whistler, however, appears to have been the first to use his to make a major pictorial statement. Perhaps he did not mean to. He appears to have started the work to exercise his skills as a portraitist at a time when he was building up a professional practice in that area. He was, however, pleasantly surprised at the outcome – usually a good indication of the achievement of some unanticipated breakthrough. Despite a chilling reception when initially shown at the Royal Academy in 1872, the work soon gained cult status among the *cognoscenti*. Even at the height of the Aesthetic movement it was recognised as being far more than the arrangement of tones and lines 'independent of all clap-trap' that the artist claimed it to be.[4] The poet Swinburne, for example, spoke of the portrait's 'intense pathos ... and tender depth of expression'.[5] Its reputation was sufficient by 1891 for the French state to purchase it and place it in the Musée du Luxembourg. Once it had achieved a prominent place in the French official gallery of modern art it soon gained international fame.[6] Doubtless its renown is a key reason why (as will be seen below) representations of artists' mothers began to proliferate at the end of the nineteenth century and why the theme has remained a significant one for many painters and sculptors ever since.

Whistler's achievement in making a major artistic statement with a portrait of his mother is all the more intriguing since it seems to run counter to a trend evident in avant-garde art of the late nineteenth and early twentieth centuries in which a picture of the female nude (especially the prostitute) functions as the 'breakthrough' picture. Manet's *Olympia*, Picasso's *Demoiselles d'Avignon*, Sickert's *Camden Town Murder* and De Kooning's *Woman* are classic examples of these.[7] Feminist critics and historians have pointed to this trend as symptomatic of the male-dominated view of creativity, the testosterone concept of genius as the transposed expression of masculine sexual desire.[8] Whistler's maternal image implies an alternative to

this. With its subdued inwardness it can almost be seen as a riposte to the extrovert, flâneurial concept of modernity. This is probably why the work has created such problems for modernist critics. While acknowledging the picture's power as an icon, several have expressed doubts about its merits as a work of art.[9] Perhaps it is for this reason, too, that there has been a reawakened interest in Whistler's masterpiece in our post-modern age.

Creativity and the mother

An important reason for the growth of the genre after Whistler was the new perception of the role of the mother that developed around 1900 with the emergence of psychoanalysis. As has already been mentioned, Freud's work, particularly his study of Leonardo da Vinci, first published in 1910,[10] was critical for this. Psychoanalytical theories have played their part in interpreting the direction of many artists' depiction of their mothers. They have also led to a radical rethinking of Whistler's portrait. Under the influence of psychoanalysis attention has moved from that picture's descriptive powers and elegant restraint to a consideration of its symbolic potency. It has even been used as a test case for exploring the whole issue of maternal power and creativity in the recent treatment by Jonathan Weinberg.[11]

Since Freud, different schools of psychoanalysis have explored the role of the mother in artistic creativity in many ways. While Freud's own interest was more in the symbolic content of works of art than in their formal qualities, the followers of Melanie Klein developed an approach that took into account aesthetic value. According to one of these, Hanna Segal,

aesthetic achievement mirrors the natural creativity of the mother. Creating a work of art, she claims 'is a psychic equivalent of pro-creation'. It necessitates a 'good identification' with the mother to be successful.[12] More specifically, Segal focuses upon the act as one of reparation: 'The urge to repair what is felt to have been irrevocably destroyed, and then the desire to restore the lost, loved object (primarily the mother) is the essence of all creative achievement.'[13]

Such ideas have had an immense impact on critical theory, constituting a main theme in British criticism from Adrian Stokes to Peter Fuller. Later forms of interpretation, such as those of Lacan[14] and Kristeva[15] have brought about radical departures in the understanding of both artistic identity and the gendering of creativity. But these have not disturbed the central assumption that creative achievement is intimately connected with the artist's ability to work through his or her relationship with his or her mother. While all theories acknowledge too the importance of the father – either as a stimulus or as a focus for revolt – it is the mother who remains the key figure that the artist needs to negotiate. It must be stressed that such theories do not primarily involve the literal depicting of the mother. However, as the content of so much art has, since the early twentieth century, become increasingly autobiographical (itself a symptom, to some extent, of the impact of psychoanalytic theory), such depictions have multiplied. Furthermore, an awareness of the claims of psychoanalysts has played an increasing role in artists' conscious actions when depicting their mothers.

While hoping to draw on the insights offered by the varying psychoanalytic theories of creativity, it is not my intention to adopt any of their interpretations in a wholesale manner. Psychoanalysis deals with the

detection of biological constants, and as such it can inform but hardly replace the practices of the historian, who must investigate the changing products of temporal circumstance. To the historian it is also apparent that psychological theories about creativity are themselves the products (if not always the daughters) of time, for whatever merits they may have as methods of interpretation they are also symptomatic of the shifting perceptions of the role of art and the artist that are consequent upon wider social and political pressures. They form part of a wider matrix, which includes the differing ways in which artists have addressed the issue of depicting their mothers.

Bearing this in mind, I wish to begin by moving behind both psychoanalytical theories and modern artistic practices to consider the 'prehistory' of the theme. For while depictions of the artist's mother as a major artistic statement appear not to exist prior to Whistler's picture, individual studies, private paintings and concealed representations abound. Furthermore, the theme of motherhood itself underlies some of the most powerful, if not *the* most powerful, archetypes in the whole history of pictorial representation.

Historical mothers

What is probably the earliest surviving direct depiction of an artist's mother was undoubtedly intended as a private matter. Dürer's painfully specific drawing of his mother (Fig.78) was made, as the inscription on it tells us, just a few weeks before her death. It shows her old and careworn – broken down by a hard life nearing its end.[16]

It is revealing that this record should have been made by a Northern European artist during the time of the Renaissance. For it was the new sense of enquiry that grew in this movement that prompted artists to sharpen their sense of observation and use their descriptive powers to explore all aspects of experience. The sense of personal identity that emerged at this time (nowadays habitually regarded as 'self-fashioning',[17] but believed at the time to be self-discovery) encouraged artists to follow philosophers and writers in looking inwards. Nowhere did this happen more than in northern Europe, perhaps because the new concept of the artist was harder to establish against the prevailing craft culture than it was in the courts and cities of Italy, causing greater levels of self-doubt and the need for self-definition. Whatever the reason, it was in Germany around 1500 that what Joseph Leo Koerner has called 'the moment of self-portraiture' emerged, in which the artist's personal identity was proclaimed and examined.[18]

Dürer himself was the most persistent and penetrating of artist self-explorers at this time, producing both finished works showing himself in a plethora of roles – gentleman, intellectual, even spiritualised as the image of Christ[19] – and making private sketches of himself revealing anxiety and melancholy. His unvarnished image of his mother belongs to that latter, more personal world. At first sight it might appear merciless in its revelation. Yet this is far from being some clinical study. There is a tenderness in the steadiness with which Barbara Dürer is recorded, a need for detail suggesting sorrow and the fear of imminent loss. It reminds us of that dominating aspect of the mother/child relationship that emerges long after the initial complexities charted by Freud have done their work. This is the experience of ageing, the retreat from power to dependence, and the loss

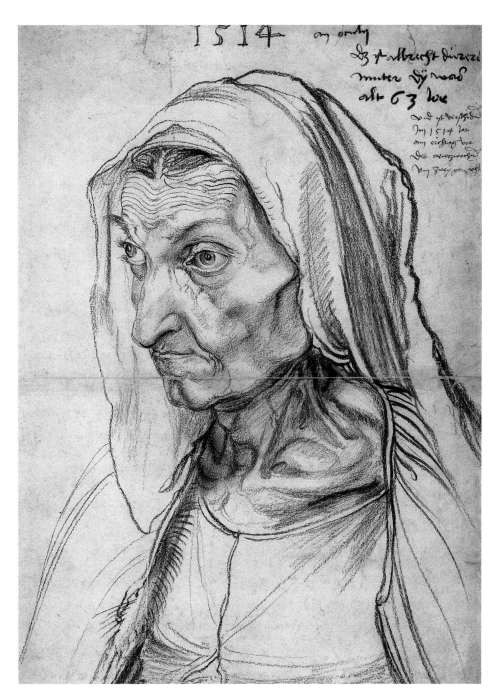

78 Albrecht Dürer

The Artist's Mother 1514

Charcoal on paper,

423 x 305 mm

Kupferstichkabinett

Staatliche Museen zu Berlin

© Bildarchiv Preussischer

Kulturbesitz, Berlin, 2002

presaging one's own annihilation. Dürer is recording here a final departure, the ultimate act in the process of separation begun at birth.

Age is, almost inevitably, a presence in any mature artist's representation of his or her mother. It dominates the maternal images of the next great self-portraitist in the European tradition – the Dutch seventeenth-century painter Rembrandt. The autobiographical tendency that emerged in the Renaissance had reached even greater heights by that era, and Rembrandt is renowned for being the most persistent and obsessive self-explorer amongst artists of the pre-Freudian era. As with Dürer, it is not surprising to find this tendency spilling over to encompass the study of the maternal. In the early stages of his career, when an up-and-coming young painter in Leyden, he produced frequent paintings and etchings in which the aged mother is shown with rare sympathy. Sometimes she is studying a book, a sign of her devoutness and wisdom – in one she is posed as a biblical prophetess – and sometimes she is shown in attitudes of stoic resignation (Fig.77). These pictures are the first in a long line of rich and sympathetic depictions of age that run through Rembrandt's career, ending with those moving last pictures in which he himself assumes the role. It is tempting to think that his witnessing of his own mother's ageing helped develop Rembrandt's sympathy for and insight into the process. Yet we should be careful here. First, none of these depictions were ever sold or displayed by the artist as representations of his mother. Second, and more importantly, we actually have no evidence that the old woman who appears so often in his own pictures, and in some painted by his early pupil Gerrit Dou, actually was Rembrandt's mother. At the time these pictures were being made, she would have been about sixty, while the woman depicted seems older.

The designation is a retrospective one, though the earliest was made within ten years of Rembrandt's death.[20] Recent scholars have tended to be sceptical about the identity.[21] Yet even if these images do not in fact represent Rembrandt's mother, they have made a powerful contribution to the genre. The belief that the pictures are of Rembrandt's mother has encouraged other artists to use them as a reference point in their representations of their own mother; including, some would argue, Whistler himself.[22]

Myths and symbols

The confusion here is a reminder that the representation of the maternal had existed as a dominating theme in imagery long before depictions of actual mothers were recorded. Already in the Stone Age the cult of the 'earth mother' had led to the production of maternal fertility symbols, such as the so-called 'Venus' of Willendorf. While the fertility goddess was excluded from the Christian religion, the tradition survives in muted form in the Madonna, in which the myth of virgin birth represents an attempt to separate out the erotic from the maternal. In imagery at least, this separation was never a successful one. Because the central representation was that of the mother with child, Mary with Christ, the maternal figure is habitually shown as young; virginally 'pure' maybe, yet desirable. The latter characteristic dominated increasingly as naturalistic representation became the norm in western art. Here one might say that a conflict between the real and imagined mother becomes intense. Whereas Dürer showed his mother as she existed before him in old age, painters of the Madonna show a young woman, the mother as she was, and the mother as relating to the Christ child –

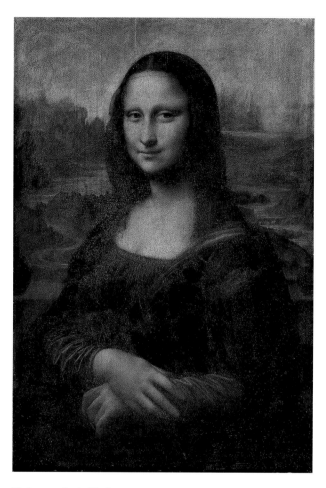

79 **Leonardo da Vinci**

Mona Lisa 1503–54
Oil on wood, 770 x 530 mm
Musée du Louvre, Paris
© Photo RMN – H. Lewandowski/LeMage/Gattelet

here uncomfortably becoming the artist's surrogate. The need to retain the power and distance of divinity, while conveying the tenderness of motherhood and a beauty that could not entirely avoid the erotic, led to all kinds of complexity.[23]

In view of the richness of this area, it seems surprising that more was not made of it by Freud in his consideration of artistic creativity. This is an omission, however, remedied in recent decades by feminist critics, notably Marina Warner and Julia Kristeva.[24] However, it was an image of the Madonna with her mother St Anne, together with the Madonna-like portrait of the *Mona Lisa* (Fig.79) by Leonardo da Vinci that triggered Freud's key study of the relation of the maternal to artistic creativity. By the time he came to write his study of Leonardo, Freud had fully developed a theory about the central role of the mother for the child, unlocking the repressed sexual desires of the oedipal complex as well as mapping out important differences in the rivalries and desires of the male and female child. Such material formed the background to his interpretation of the life and works of Leonardo. Drawing upon the richly suggestive account of the aesthetic critic and scholar Walter Pater (who had observed 'A feeling for maternity is indeed always characteristic of Leonardo'),[25] he focussed upon the 'mysterious' smile that played on the faces of Leonardo's often androgenous figures. In a series of bold moves – some of which were later proved to be dependent upon a mistranslation[26] – he saw this smile as being the smile of Leonardo's lost mother. The artist, who was illegitimate, was removed from his mother at the age of five to live in the family of his aristocratic father. This set the scene, in Freud's eyes, both for Leonardo's homosexuality and for the sublimation of loss into creative achievement. Like Pater, Freud felt that the most intense sense of beauty

also brought with it the sense of melancholy and loss. In *Mona Lisa*, he surmised, the artist had been surprised by a smile that reawakened – perhaps only in his subconscious – the memory of the lost mother, giving the picture its enigmatic and mesmeric appeal.

Even if we do not accept Freud's reading of this work as the disguised representation of the lost mother,[27] we cannot dismiss the possibility that his study sketched out – namely that the meaning of a work of art is as closely connected to the unconscious fantasy life of its creator (and also its viewers) as it is to any of the overt social, political and artistic concerns that the historian normally calls into play when attempting an interpretation. Looking at pictures has never been the same since Freud's essay was published. However sceptical we may be of specific psychoanalytical readings, we cannot ignore the central fact that the image always remains at some level mysterious and unknowable. It would be fascinating to know if anything of Pater's appreciation of Leonardo, which foreshadowed so much of Freud's interpretation, might have been known to Whistler as he developed his own mysterious painting of his mother. Pater's *Renaissance* was not published until 1873, the year after Whistler's *Mother* was shown at the Royal Academy. Yet the essay on Leonardo had appeared already in the *Fortnightly Review* four years earlier, in 1869.

After Whistler

Whatever the case may be, both Whistler's portrait of his mother and Pater's concept of the *Mona Lisa* – the ultimate, all knowing mother-mistress *femme fatale* – played their part in encouraging a new interest in pictorial symbolism. In many ways it is also significant that the Symbolist movement should have constituted the cultural milieu prevalent at the time when Freud was developing his psychoanalytic theories; for he shared the Symbolists' obsession with the power of the feminine mystique and with the imagery of the dream. The power of the mother was frequently celebrated by the Nabi painter Edouard Vuillard, whose mother lived with him throughout her life. Vuillard, like Whistler, lost his father when young. He was brought up by his strong-minded mother, who encouraged his artistic ambitions. She supported the family through a dressmaking business – run (with the aid of Vuillard's sister) from their apartment. This picture (Fig.80) like so many of Vuillard's work in his early Nabi phase, derives its decorative effect from the fabrics of the mother. It is not hard to see how this might constitute an extension of his mother into his own artistic activity. Belinda Thomson argues that Vuillard's habitual portrayal of his mother could be seen as an act of gratitude. 'Registering her familiar and solid image was perhaps one way for him to acknowledge all he owed to her equable good nature and devotion to his artistic career.'[28] Many of his numerous representations of his mother could perhaps be seen in this light. Yet this particular one seems more disturbing. The mother squats like an immovable object, while the sister floats wraith-like into the air, as though eviscerated by parental power.[29]

It is possible that Vuillard was encouraged to begin his essays on the maternal in the early 1890s by the recent appearance of Whistler's celebrated *Mother* in the Luxembourg. He was known to have an interest in Whistler, and it has been proposed that his own interest in decorative design at this time may have been inspired by seeing reproductions of Whistler's *Peacock Room*.[30] If so, then his own unrestrained representation of his mother in this work could almost

80 **Edouard Vuillard**
Mother and Sister of the Artist 1893
Oil on canvas, 465 x 565 mm
Museum of Modern Art
New York
Gift of Mrs Saidie A. May
© ADAGP, Paris and Dacs, London 2003

be seen as a kind of revision of the masterpiece in the Luxembourg. It is almost as though Whistler's mother had turned to face us. Perhaps the fact that Vuillard was working at the time providing stage sets for the Symbolist playhouse *Thèâtre de l'Oeuvre* – where the domestic psycho-dramas of Ibsen and Strindberg were frequently staged – may have given him an additional means of re-perceiving the role of the mother.[31]

It may well be that Whistler's mother was important to Vuillard because of the process of estrangement that it involves. Whistler has depicted an archetypal domestic scene – a mother seated in an interior – in such a manner that she becomes transformed into a remote icon. While the artist himself might have claimed that this metamorphosis was undertaken simply in the interests of achieving a pure aesthetic effect, painters of a younger generation could see the matter differently. Susan Sidlauskas has recently argued that the Nabis and certain other artists who came to maturity in the 1890s focussed upon problematic representations of domestic interiors in a manner that reflected the difficulties posed by changing gender relations, in which the traditional male hierarchy became challenged (either directly or implicitly) by female members of the family. In the wake of other cultural historians, she evokes the Freudian notion of the 'uncanny' (*Unheimlich*; more literally translated into English as the 'unhomely') to characterise the process of 'making the familiar strange' involved in this.[32] In this context it is interesting to note that the Danish master of the 'unhomely' interior, the painter Vilhelm Hammershøi, made two studies of his own mother in 1886 which directly borrow the pose of Whistler's mother.[33]

Vuillard's picture is also a reminder of a recurring trait in many artists' biographies. It would seem, according to these narratives, to be a common occurrence for the creative artist to have a dominating mother (sometimes necessitated, as in the case of Whistler and Vuillard through single parenthood, sometimes as a counterbalance to a remote or recessive father – as was the case with Hammershøi) who promotes the child's artistic ambition. Where there is conflict with the father (who typically is more likely to insist on the child abandoning art in favour of a 'sensible' profession), the mother is frequently a covert supporter of the aspirant artist – as was the case with Constable, Cézanne and Van Gogh. Before the mid-twentieth century it was frequently the case that the mother had herself had artistic ambitions, which had been thwarted by the prejudices and social customs of the times. She experienced a degree of transference in encouraging her offspring to go where she had wished to go. This situation can be seen to strengthen the oedipal connection for males, particularly since the child artist remains at some level indebted to the mother for his creative success. At the same time (in the Freudian model at least) this creativity could be used not only to rival the father, but also to outdo the 'natural' creativity of the mother. Perhaps the unsettling mood in Vuillard's depiction of his mother lies behind this. More generally, we can see a large number of examples in the twentieth century of male artists expressing conflict with their mothers through representations and – in some cases – through the absence of representation.

Mothers generally in early twentieth-century pictures were seen as powerful and somewhat daunting figures. The most overwhelming of these must surely be the Italian Futurist Umberto Boccioni's more than life-size image of his mother, who was a great support to him in his career.[34] Entitled *Materia* (Matter – the root of the word is shared with the Italian word for

motherhood) it shows his mother's firm features and solid hands surmounting a cubist drama of intersecting forces. There is also the domineering image of Mark Gertler's mother,[35] a London East End émigré who saw to it that her son got a proper artistic education and made it in the new world. Doubtless the Jewish tradition of the powerful mother played its part here, as it did in Ashile Gorky's image of his mother.[36] In this case the mother had engineered the family's escape from Russia to America but had died in the process. Gorky's picture is a memory tribute, and all the more moving for that. His loss was an open one, and the picture was perhaps an important therapeutic exercise for him. Quite different is the case of the Belgian surrealist René Magritte. Magritte's mother committed suicide when he was only thirteen. She drowned herself, and when some time later her body was hauled out of the water, her head was shrouded in her nightdress. It has often been supposed that Magritte's pictures showing a figure with a shrouded head[37] are a reference to that. The title of the best known of these, *L'Histoire centrale* (The Heart of the Matter; private collection), would seem to bear this out. Magritte was notorious for choosing titles that bore a problematic, often teasing relationship to the imagery in his pictures. In this case, however, he might have been speaking more directly than he realised. Beyond that one cannot help wondering whether Magritte's insistent concealment of his own biography and feelings, his almost obsessive insistence on removing his pictures from any relationship to his persona, might be a means of disguising a trauma.

The concealment of the mother might seem to be a dominating process for Picasso. Picasso was as insistent on bringing his autobiography into his art as Magritte was for excluding his, yet this might, too, be seen to be a form of disguise. Picasso's early artistic development had been presided over by a powerful and ambitious mother. The fact that Picasso chose her name rather than that of his father (which was Ruiz) for signing his works after 1901 might seem to confirm this authority. Interestingly, however, Picasso avoided painting his mother – apart from one early pastel study of her head in profile done when he was fifteen.[38] But the dominant mother seems to have already marked his own sexual relationships. According to Mary Matthews Gedo, it was Picasso's resentment of her power that formed the source of his own misogyny, which is expressed in both the savage representations of women in his pictures and in his heartless philandering.[39]

An equally striking concealment is that by the American pop artist Andy Warhol. Warhol's mother was a determined figure who had, like Ashile Gorky's mother, engineered her family's emigration to America from Eastern Europe. She was also artistically gifted and had ambitions herself in this direction, even collaborating with Andy on some of his earlier work as a commercial artist. Not only did she encourage Andy's career, she also (unlike Picasso's mother), followed him in it, moving with him to New York. In later years, as his fame grew she even tried to subsume his success, once proclaiming to startled associates of the artist, 'I am Andy Warhol'. Although closely involved with her – in an almost incestuous manner – Warhol never seems to have represented her in her lifetime, and kept her remote from his art despite her claims.[40] Perhaps his own supercool in his art – his transference of his very persona into a piece of media tinsel – was his last form of defence. His artistic persona was a most deliberate piece of public artifice.

Mothers and daughters

So far I have focussed on the male artist and his mother. But what of the female artist? Do the same kinds of conflicts and problems pertain? According to most psychologists, the situation is entirely different, for the young girl is held to have a greater difficulty in detaching herself from her mother. Kristeva even refers to the 'connivance' of the young girl with the mother to avoid separation.[41] When looking at the evidence provided by historical depictions of mothers by female artists there is certainly no suggestion of conflict or confrontation. Friendship and support seem to be more in evidence. Perhaps this has as much to do with circumstance as with desire. Prior to the mid-twentieth century the sheer difficulty for a woman of pursuing a career meant that the struggle to become an artist was of a very different character to that of most male artists. Typically a woman could only succeed when there was strong parental and family support, and the attitude of the female artist to her mother seems to have been largely that of gratitude. This is the mood that comes out in such remarkable early portraits as those by the Italian sixteenth-century painter, Sofonisba Anguisciola[42] and the early nineteenth-century Bristol painter Rolinda Sharples, whose mother (also a painter) leans forward protectively as the daughter depicts herself at work at her easel.[43] Nothing could be further from the angst-ridden view of Vuillard's mother and sister than the impressionist Berthe Morisot's tranquil scene of her own mother and sister in domestic setting.[44]

A similar calm and positive feeling can be found in Mary Cassatt's portrait of her mother reading Le Figaro (Fig.81). Cassatt's mother – like her father – had been unstintingly supportive of her child in her brave and adventurous decision to leave America to study and practise as a painter in France. Respect and love are clear in this image of this sympathetic, educated and intelligent woman reading a political paper.[45] There may indeed be an early engagement with Whistler's Mother here, since that work had already been shown and widely discussed by the time Cassatt painted her mother some five years later. But where Whistler, despite his sympathy, isolates his mother, making her sit passively in profile, Cassatt views hers three-quarters on, endowing her face with intelligent concentration. Perhaps the fact that Cassatt belonged to an age that believed women had to make a choice between having children and a career is one of the causes of the lack of conflict. She seems to have acquiesced in this. She chose a career. Her sister chose children. She did not have to experience conflict here or the problematic relationship that might have risen with her mother if she had tried both. Significantly she showed her mother playing with her grandchildren, and also produced a rich series of studies of mothers and children – which some judge to be the crowning achievement of her career. It was as though she could explore in art what she couldn't in life in a positive manner, achieving what would be, for Kleinians at least, the satisfactory form of sublimation that leads to the successful work of art.

With the growing struggle for independence in the twentieth century the situation has become more complex. Early feminists saw the dependence on the mother of the creative woman as being in some sense a faut-de-mieux. 'We think back through our mothers if we are women,' wrote Virginia Woolf in her famous essay on the predicament of the woman writer, A Room of One's Own.[46] By this she meant that this was the only pool of female experience to draw on, since achieved creative precursors were so rare, so incapable

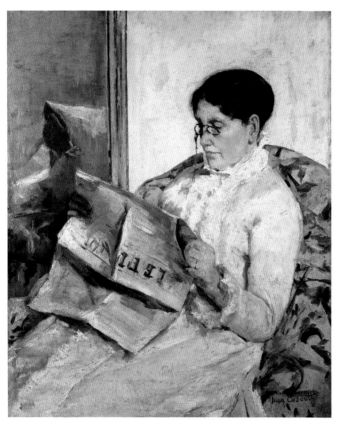

81 **Mary Cassatt**

Reading 'Le Figaro' 1877–78
Oil on canvas, 994 x 800 mm
Private collection
Washington DC
Photograph: Bridgeman Art Library

82 Frida Kahlo

My Birth 1932

Oil on metal, 305 x 350 mm

Private collection

© 2003 Banco de Mexico Diego Rivera & Frida Kahlo Museums Trust.

Av. Cinco de Mayo No.2, Col. Centro, Del Cuauhtemoc 06059, Mexico DF

of offering the continuity that male writers and artists could enjoy. The image and presence of her mother was key to her, as can be seen in the photograph of her in her mother's dress,[47] and even more so in her sister Vanessa Bell's portrait of herself in the pose of a photograph of their mother by Julia Margaret Cameron.[48] Yet while not challenging in the way that the male creative artist was supposed to be, this exploration of the role and experience of the mother was not necessarily without its questioning and bitterness. The Mexican painter Frida Kahlo painted what must seem like the ultimate reductive image of the mother in *My Birth* (Fig.82).[49] This shows the artist's mother, naked and alone on a hospital bed, giving birth to Kahlo herself (identifiable through her distinctive joined eyebrows), who emerges frontally amidst a swamp of blood and detritus. Kahlo's own physical sufferings no doubt encouraged her to give this painful and unglamorised image of birth. In reducing birth to a physiological process she seems to separate the raw fact of motherhood – the production of a child – from all emotive aspects of the event. This might seem at first like a humiliating rejection of the mother as a person. However, the work has a more tragic and compassionate dimension. For Kahlo herself had suffered two miscarriages before she set out on this work. While she was painting it, moreover, she learned of her own mother's terminal illness. Perhaps it was a later touch after this news that caused her to put the sheet over the mother's head in the picture, indicating that she was dead. This savage work is in fact an act of mourning, both for herself and her mother. It is a recognition that a chain of life that passed to her has now been broken. There will be no more progeny. The baby being born is dead, like the mother.[50]

Kahlo's work can be seen as an acknowledgement both of problems inherent in the mother/daughter relationship and in the relationship of 'artistic' and 'natural' creativity. More recently feminists have tended to focus on the reconciliation of these roles. This is a notable feature of Julia Kristeva's seminal essay 'Stabat mater'.[51] Written when Kristeva herself had recently become a mother, it constituted a kind of road-to-Damascus conversion to the traditional female role that had been so vehemently rejected by extremists. In a later essay she leans on Freudian analysis for establishing the central role of the mother for artistic creativity, while highlighting the problem that this has for women;

> It can be said that artistic creation always feeds on an identification, or rivalry, with what is presumed to be the mother's jouissance (which has nothing agreeable about it). This is why one of the most accurate representations of creation, that is, of artistic practice, is the series of paintings by De Kooning entitled Women: savage, explosive, funny and inaccessible creatures in spite of the fact that they have been massacred by the artist.

She then goes on to point out that if such pictures had been created by a woman, 'she would have had to deal with her own mother, and therefore with herself, which is a lot less funny'. Finally she postulates a feminine creativity which would move beyond this impasse by coming to terms with maternity, rather than rejecting or opposing it: 'real feminine innovation ... will only come about when maternity, female creation and the link between them are better understood.'[52]

A new dispensation

Kristeva's essays were part of a move to recon-ceptualise creativity, removing it from the aggressively male notion of a force at odds with the mother to one in which motherhood was accommodated, negotiated with almost as a partnership. This has certainly been a stimulus for artists like Mary Kelly to engage with their female nature through their work.[53] It has also joined with the earlier perceptions provided by Kleinian aesthetics to form part of a rethinking of creativity that has affected men as well as women. A significant aspect of this has been a more overt and intimate exploration of personal identity within the work of art, something that seems to have encouraged as well a renewed consideration of the mother.

David Hockney is one of the many who have undertaken this exercise (Fig.83). On the surface Hockney – as a gay pop painter with a brand-name artistic image and persona – has many similarities with Warhol. But actually his stance is very different. Where Warhol used his image as a concealment, Hockney sees his as a form of self-liberation. His artistic epiphany came with his decision to make his own homosexual experience the centre of his art. In contrast to Warhol (who might well have been influenced by aggressively male views of creativity prevalent in the United States in the heyday of Abstract Expressionism and promoted by such distinguished critics as Lionel Trilling in his *Anxiety of Influence*),[54] he does not suppress his mother in his work. He is frank about her, acknowledging her dominant role in his life, and engaging with this in a playful manner. In his celebrated dual portrait of his parents, she looks critically and attentively out at him, while his father loses himself in a book of pictures – having long ago given up attempts at communication

with his son. In the original version of the picture Hockney had his own reflected image coming between them in the mirror on the table. In the final work he substituted this with a reproduction of Piero della Francesca's *Baptism* from the National Gallery. This could be seen as a metaphor for how he had removed himself from them into the world of art. At the same time the image of Christ's baptism draws tongue-in-cheek on the associations of the artist with the divine and with allusions to his 'rebirth' as a creator of objects of artifice rather than nature.

One of the most frequent and perceptive depicters of mothers in recent decades has been Lucian Freud. The sense of alienation runs so consistently through Freud's images – with their pallid tones and unsettling spaces – that it might seem hard at first to isolate a particular strain of that mood in the records of his mother. Yet whereas this alienation seems to emanate from the artist himself in most pictures, to fall upon his sitters like a veil, in the case of his mother the roles seem reversed. A recently widowed émigré, she seemed distinctly at variance with her setting when depicted seated in the artist's barren studio (Fig.84). The concentrated inward-looking expression on her face contrasts strongly with the vacant stare of the half-naked young woman stretched out on the bed behind her. Freud seems to be genuinely questioning that inwardness as he paints. In other, later works, she is shown reclining, as though awaiting death. Yet in one of the very last of these, she turns a quizzical gaze on her son as though to ask does he know what he is doing? Even at the last, Freud could not acclimatise her to becoming one of the normative occupants of his chilling world.

With the increasing modishness of autobiographical art, the treatment of the theme of the mother has led

83 **David Hockney**

My Parents 1977

Oil on canvas, 1829 x 1829 mm

© David Hockney

Tate Britain

Photo: © Tate, London 2003

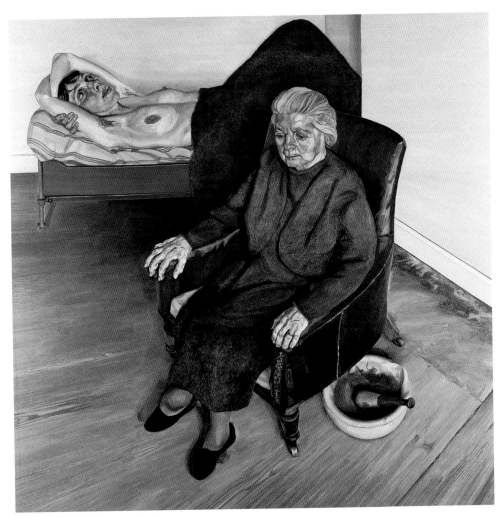

84 Lucian Freud
Large Interior W.9 (The Artist's Mother) 1973
Oil on canvas, 915 x 915 mm
© the artist
Devonshire Collection, Chatsworth
Reproduced by permission of
the Duke of Devonshire
and the Chatsworth Settlement Trustees
Photograph: Bridgeman Art Library

to greater extremes of representation. None is more remarkable than the work of the video artist Bill Viola. His *Nantes Triptych* (Fig.85) is a tripartite video, as formal in construction as an altarpiece, which illustrates the continuities of life and death through the artist's own experience. On the left his son is being born, on the right his mother is dying. The confrontation – more arresting even than Dürer's study of his mother near the end of her life – is almost unbearable. But as with Dürer, the thought and feeling behind this work redeem it from sensationalism and makes it truly moving.

Powerful though Bill Viola's work is, it pales as a piece of self-exposure besides much of what has followed in the last decade. Recently we have had Tracey Emin – author of the famous unmade bed – haranguing her mother about their shared past in a video installation[55] (a sign perhaps that the female artist is now sufficiently emancipated to be able to take over traditional male stereotypes). There has also been the Japanese artist Tatsumi Orimoto's film of his mother's decline into Alzheimer's disease, and even one sculptor (Ron Mueck) who is promising to make a statue of his mother fifty feet high![56] In an age where intimate revelation of the artist's life appears to have become the dominating art form it is almost inevitable that the mother will play a larger and doubtless in-creasingly challenging role. We have come a long way indeed from the restraint of Whistler's masterpiece.

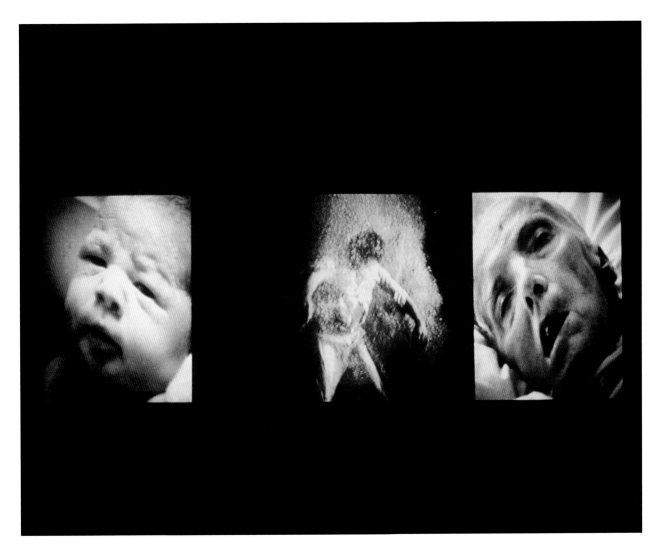

85 **Bill Viola**
Nantes triptych 1992
Video/sound installation
Tate Modern
© Tate, London 2003
Photo: Kira Perov

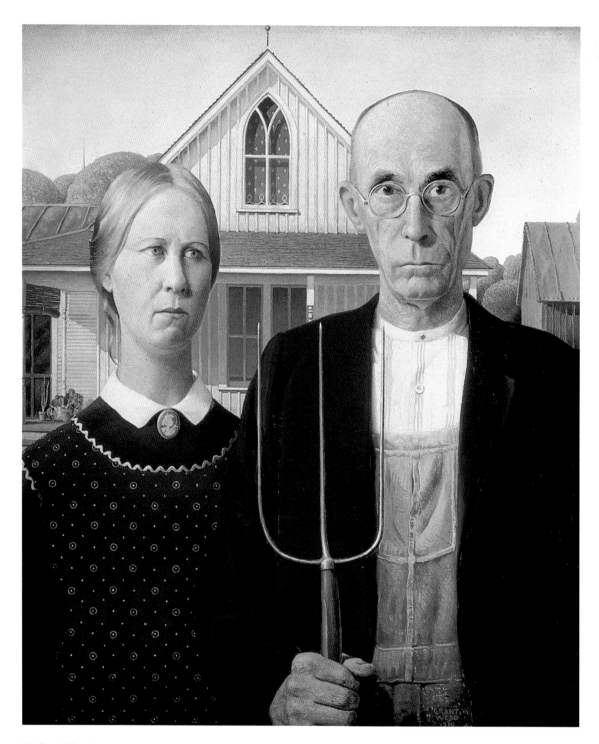

86 Grant Wood

American Gothic 1930

Oil on beaverboard, 743 x 624 mm

Friends of American Art Collection,

All rights reserved by The Art Institute of Chicago and VAGA, New York, NY

Chapter 6 The face that launched a thousand images: Whistler's *Mother* and popular culture

Martha Tedeschi[1]

I f Grant Wood's *American Gothic* (Fig.86) has come to embody for our culture the quintessential American couple, no less has Whistler's famous painting *Arrangement in Grey and Black: Portrait of the Painter's Mother* come to function as our icon of mother and motherhood.[2] The picture is one of a handful of artworks that have moved beyond general appreciation as 'masterpieces' of fine art to become images easily recognised and freely utilised in popular culture. Whistler's *Mother*, Wood's *American Gothic*, Leonardo da Vinci's *Mona Lisa* (Fig.79), and Edvard Munch's *The Scream* have all achieved something that most paintings – regardless of their art historical importance, beauty, or monetary value – have not: they communicate a specific meaning almost immediately to almost every viewer. These few works have successfully made the transition from the elite realm of the museum visitor to the enormous venue of popular culture. They have not stopped at becoming familiar to us; in fact, their very familiarity invites us to use these images for our own purposes, to inscribe on them our own words and meanings, from political cartoons to advertisements, from humorous take-offs to variants updated for the issues of each generation.

This chapter traces the evolution of Whistler's *Mother* as cultural icon, from its first encounters with the public in London and Paris in the 1870s, through to recent incarnations, such as its starring role in the 1997 comic film *Bean*. In the end, the question is not only how this extraordinary image entered the popular psyche, but why it did so. Consideration will be given not only to the many ways in which Whistler's portrait has been appropriated by popular culture but also to the inherent characteristics of the portrait that have allowed it to mean so many things to so many people, almost since the day it was painted.

Let us begin by examining briefly the concept of 'the masterpiece'. It is not unusual to hear the term used by the museum visitor to register approval, as another way of saying 'Wow, what a great picture!'

Walter Cahn, who devoted an entire volume to the phenomenon of the masterpiece in our culture, wrote, 'When a work of art impresses us as the highest embodiment of skill, profundity, or expressive power, we call it a masterpiece.'[3] There were many during Whistler's lifetime who did not consider *Arrangement in Grey and Black: Portrait of the Painter's Mother* to be the highest embodiment of skill, although certainly many critics and members of the general public found it noteworthy and a few even thought it profound. Can the enormous visibility and popularity of this picture in our time be explained simply by the skill with which it was rendered and the austere beauty of the final image? If this were the case, why do we not see more cartoons and greeting cards appropriating the image of, for example, a Degas ballet dancer or a Rembrandt self-portrait?

Cahn goes on to consider what happens once a work of art has been accepted as a masterpiece, likening the process to that through which a work of literature achieves the status of 'a classic'. He suggests that 'calling something a masterpiece is to canonise it, neutralising its asperities and making it the common cultural property of friend, foe, and the indifferent alike. We erect a kind of Hall of Fame in which the objects of our admiration can be permanently enshrined, not for our selfish contemplation only, but for the benefit of humanity at large.'[4] In other words, there are certain works of art that have the ability to transcend their historical context and to speak in an accessible and lasting way to humankind. Cahn explains that, by according masterpiece status to an object, 'we mean thereby to edify, to illustrate beyond the shifts of styles and values, the constancy of human purpose and condition.'[5]

We might take Cahn's 'Hall of Fame' idea one step further, for within this gallery of lasting masterpieces is a special room for icons. It is in this room that we find Whistler's *Mother*, surrounded by *American Gothic*, the *Mona Lisa*, *The Scream*, the *Venus de Milo*, Botticelli's *Venus* and a handful of other works that require no wall label because every visitor has seen them – in one permutation or another – a thousand times, at home, in a magazine ad, in a Saturday morning cartoon, on a billboard, a greeting card, a necktie, a Halloween costume, or a political caricature. If Cahn is correct, these works share the ability to 'illustrate ... the constancy of human purpose and condition'. Yet, when we look at the way in which popular culture has adopted these works, and the myriad uses and meanings that have now been associated with each one of them, we realise that these icons go far beyond *illustrating* a specific aspect of the human experience. It will be suggested here that

such works of art contain inherent characteristics that allowed them to become powerful symbols – nothing less than icons – of extremely basic and yet highly complex human truths. These truths are so basic that they are quite familiar to each of us, and yet they are so complex that we feel compelled to try to master them, to simplify them, to make them our own. One might say that these icons provoke in equal parts the ease of recognition and the challenge to appropriate.

Whistler's *Mother* has been widely identified as an icon of motherhood and, more specifically, an icon of American motherhood. The painting has been alternately revered, reviled, and revamped according to the context in which it found itself, but it has always been read and used as a quintessential symbol of the mother. By surveying the many ways that Whistler's *Mother* has been appropriated by popular culture, it may be possible to unpack the portrait's loaded symbolic potential and to identify at least some of the reasons why this particular portrait of a painter's mother has entered the popular psyche like no other.

The painting began its road to immortality inauspiciously, narrowly avoiding rejection at the Royal Academy in 1872 and marking the last time that Whistler would show paintings on the walls of this conservative institution. Yet, as it would continue to do every time it was exhibited in public, Whistler's *Mother* sparked ample discussion.[6] Many critics were confused by Whistler's title of *Arrangement in Grey and Black*, seemingly uncomfortable with the idea that the formal properties of the work should be emphasised over the identity of the sitter, particularly when the sitter was no less than the artist's own mother. One reviewer, finding the picture lacking in emotional content, questioned 'Why should this face fall so short of the vitality of nature? Why should the greys and

blacks be so unmeaning ...?'[7] Others did not allow themselves to be thrown off the scent by this red herring of a title but, in good Victorian fashion, went straight to the pathos of the subject. They praised the picture for 'the dignified feeling of old ladyhood'[8] or for the 'sentiment, a grave poetry of mourning – an effacement, depression, forlornness, with a strange and sweet dignity in it'.[9] Already, the restrained formality of the picture combined with the subject of an aged mother had made an impact on those who saw the picture.

The painting's early fame can be attributed, at least in part, to the regularity with which it was shown in England, France, and the United States. Its debut at the Royal Academy in 1872 was followed by a showing in Paris at the Durand-Ruel gallery the following year. A year later, in 1874, the canvas appeared in Whistler's first one-man exhibition in Pall Mall. In 1878 Whistler stated his annoyance with the persistent focus on the painting as statement about motherhood, announcing: 'Take the picture of my mother, exhibited at the Royal Academy as an "Arrangement in Grey and Black". Now that is what it is. To me it is interesting as a picture of my mother; but what can or ought the public to care about the identity of the portrait?'[10]

Whistler probably knew he was fighting a losing battle; the painting appeared in the Paris Salon of 1883 entitled simply *Portrait de ma mère*. By this time the painting had also been shown in Philadelphia (1881–2) and in New York (1882). Not surprisingly, much of the French criticism of 1883 persisted in reading the painting as a reverent *hommage*, as in this gushing reviewer's comment that: 'Votre "vénerée mere", assise de profil, monsieur, est une oeuvre sentie, sortant du coeur d'un fils respectueux et comprenant que ce que l'on a de mieux, ici-bas, c'est sa mère.'[11]

Interestingly, several reviewers felt called upon to speculate about what the sitter might be thinking in the picture, anticipating the host of caricatures that would follow in the next century in which the stony profile of Anna McNeill Whistler is given conversation bubbles to indicate the nature of her private musings. One French critic suggested that 'la mère du peintre ... réflechit peut-être aux succès, à l'avenir de son fils.'[12] Another surmised, 'Sa pensée est avec son fils ... songeant qu'il est sans doute heureux, qu'il travaille et que la gloire vicendra couronner ses efforts ... Comme vous devez aimer votre vieille mère, M. Whistler, vous me l'avez fait aimer, à moi qui ne la connais pas!'[13]

Clearly, the painting struck a chord for many of its early viewers, inspiring a kind of nostalgia around the topic of maternal love as it travelled from one exhibition to another.[14] In 1888 Swinburne chastised the artist for downplaying the 'intense pathos of significance and tender depth of expression' that others so admired in his mother's portrait.[15] When, in 1891, the picture was again exhibited in Paris, Whistler's friends Stéphane Mallarmé, Théodore Duret, Roger Marx and others, developed strategies to ensure the picture would one day hang in the Louvre.[16] Eventually a purchase was negotiated and the French government acquired the painting, which went to hang in the Musée du Luxembourg. As Geneviève Lacambre has pointed out, it was at this time that the painting – now officially recognised by the Parisian art establishment – began to be associated with the word 'masterpiece'.[17]

How did Whistler's *Mother* make the leap from controversial modern painting to revered symbol of motherhood? Certainly its frequent showings, coupled with Whistler's knack for keeping himself in the limelight using the daily press, contributed to its

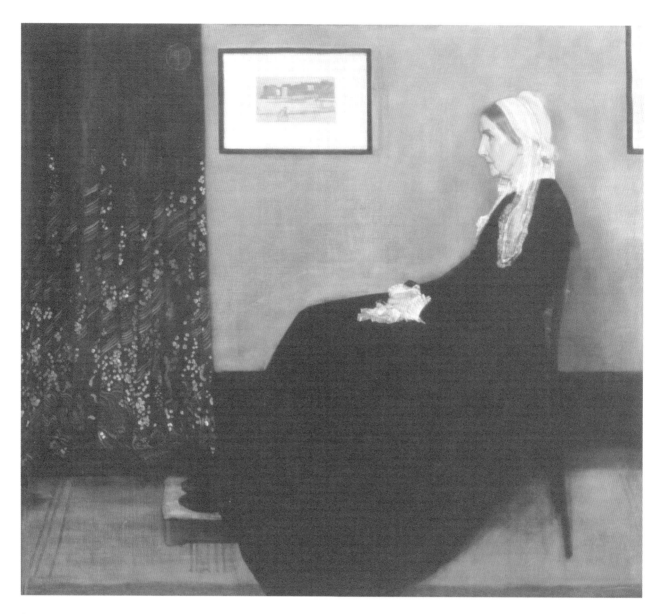

87 Richard Josey
Arrangement in Grey and Black:
Portrait of the Painter's Mother 1879
Mezzotint, 315 x 353 mm, after the painting
by James McNeill Whistler, 1871
All rights reserved by The Art Institute of Chicago

88 Frederick Kemp
Marquetry Reproduction of Whistler's Mother, 1930s
Various woods, marquetry inlay, 330 x 273 mm
Collection of David Park Curry and Rebecca Morter
Photograph by Katherine Wetzel

89 Aubrey Beardsley
Autograph letter to G. F. Scotson-Clark, 9 August 1891
Ink and gouache, detail
Collection of Mark Samuels Lasner

fame. Whistler also had a shrewd understanding of the market for reproductive prints, and early reproductions of the picture allowed the image to be seen in many places at the same time.[18] Early reproductions included the first cartoon, published in *Fun* in May 1872 (see Fig.2), a wood-engraving in the widely circulated *Illustrated London News* (8 June 1872) and more official versions reproduced in mezzotint by Richard Josey (1879; Fig.87), engraved by Henri-Charles Guérard (1883), rendered in lithography by Thomas R. Way (1891), and translated around the turn of the century into a colour etching by Auguste Brouet.[19] When the painting was shown in the Salon of 1883, caricatures immediately appeared in such popular periodicals as *L'Univers Illustré*, *La Caricature*, and *Le Salon pour rire* (see Figs.3, 64–5). Furthermore, in Whistler's retrospective at the London branch of Goupil's in 1892, the absent painting was represented by a handsome photograph of the original; likewise,

the portfolio of photographs issued by Goupil that year included one of the *Mother* mounted on card and suitable for framing.

Whistler's *Mother* was now working her way into thousands of homes, both in Europe and in America. In addition to the professional reproductions and newspaper caricatures that accompanied every major showing of the painting, examples still exist of the homespun reproductions that hung in many homes (Fig.88). The simple profile pose, rendered in large areas of black, white, and grey, was relatively easy to copy, even for self-taught artists.[20] In fact, the basic composition could be quite easily approximated from memory, as we see from Aubrey Beardsley's amusing rendition in which he grafted his own profile on to the figure of Mrs Whistler in an 1891 letter to his friend G. F. Scotson-Clark (Fig.89).[21] Not surprisingly, the composition was tremendously influential in the

90 **Stacy Tolman**
Portrait of John H. Nisbet c.1900
Oil on canvas, 1056 x 1331 mm
Museum of Art
Rhode Island School of Design
Gift of Jack C. Lehrer, 1963.013

world of professional portrait painting as well. We see Whistler's simple formula repeated in such examples as John Everett Millais' *Isabella Heugh* of 1872 (Musée d'Orsay) and in Stacy Tolman's *Man in Pose of Whistler's Mother* of about 1900 (Fig.90).[22] There are suggestions, too, that the composition of Whistler's *Mother* was intentionally imitated by portrait photographers such as Charles L. Peck, whose 1915 photograph of Lillian Bonham is a clear quotation from the painting.[23]

In its austerity and homage to an elderly mother, the image was easily adapted as a symbol of respectability and moral rectitude, a kind of secular equivalent for the most popular parlour image of the Victorian period, William Holman Hunt's *The Light of the World*. From the time of its debut at the Royal Academy in 1872, Whistler's *Mother* had been read as a clear expression of the Protestant character. For example, an English reviewer in 1872 described the painting as 'a vision of the typical Huguenot interior'; a few years later a French critic wrote 'the presence of God is felt here'.[24] The ramrod posture of the sitter, her demure white cap and dark dress, the simple interior devoid of possessions, suggested to many viewers the strict moral code and frugality of the Puritan household.

Whistler's portrait of his mother would also have reminded many viewers in both Europe and America of the ancestral photographs that filled their family albums and adorned their parlour tables. While we cannot be certain that Whistler intentionally alluded to studio photography when he posed his mother in a chair in profile and rendered the picture in mono-chrome tones, it is clear that both in composition and colour the painting echoes conventional portrait photographs of the period. Older ladies, especially, were often posed in a sitting position because they

91 **Unknown American Photographer**
Portrait of a Woman
Page from an album
of *cartes de visite*, c.1865
Photographic History Collection
National Museum
of American History,
Smithsonian Institution,
1895.736.214

were likely to tire while standing for the long exposure times necessary to capture a crisp image. The full-length, seated profile view was also considered more flattering, particularly for difficult-to-please sitters such as women past their prime and short men. In 1871, the same year that Whistler painted his mother's portrait, an editor for *The Photographic Times* advised photographers: 'Never let him stand up. Sit him with one side of his body toward the camera, and one leg stretched out nearly as far as it will go, only bending it enough at the knee to make it graceful ... Try it and your little conceited customers will like it.'[25] Younger women were likely to be photographed in more romantic, or expressive poses, either reading a book or gazing dreamily toward the photographer, for example. Older women, however, were often shown sitting and in profile, either in half length or full length (see Fig.44). Their gowns were generally dark and sober, their heads covered by white lace caps (Fig.91).

Finally, many studio portraits taken in profile share the same fixed gaze, focussed on something the viewer cannot see. Photographers employed head rests to steady the sitter's head during long exposures. In

92 Ghémar Frères
The Widow of Windsor September 1862
Photograph
The Royal Archives
© HM Queen Elizabeth II

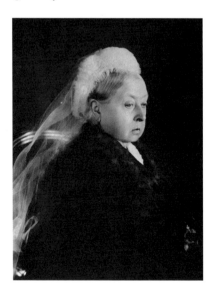

93 John Thomson (attributed)
Queen Victoria 1887
Modern silver print from original glass
negative, 119 x 163 mm
The Royal Archives
© HM Queen Elizabeth II

addition, small pictures on adjustable stands were used as 'eye rests', providing the sitter with something on which to focus in order to reduce eye movement during the exposure. The rigid pose and frozen gaze that are characteristic of nineteenth-century studio photography are also striking attributes of Whistler's depiction of his mother. These features are particularly worthy of note because they – the unreadable gaze and the stern profile – seem to tender us an irresistible invitation to enhance the picture by providing our own words and thoughts for the sitter. We saw this phenomenon in some of Whistler's earliest critics who suggested that the mother must be thinking about her son. Since then, we have seen it in countless cartoons, postcards, greeting cards, advertisements, and magazine covers.

Queen Victoria – who rivalled Whistler's *Mother* as the most iconic mother of her age – was photographed by professional portrait photographers on many occasions, including following the death of Prince Albert (Fig.92) and to mark her Diamond Jubilee. These familiar photographic conventions, designed to place the sitter beyond the whims of fashion, were used to underline her strength of character, and to elicit the respect due her as matriarch (Fig.93). By the 1890s, when Victoria was still being photographed in this manner (Fig.94) and when Whistler's *Mother* was making a splash in Paris, photographs of this sort would already have looked old-fashioned, even archaic. Advances in camera manufacture, such as George Eastman's patenting of the $25 Kodak camera in 1888, meant that photographic portraits could now be made quickly and successfully by amateurs.[26] A more animated, less formal kind of portrait gained popularity, partly because the new technologies permitted shorter exposure times, freeing sitters from the frozen facial expressions and poses that were

difficult to avoid in early studio portraits.[27] The fact that Whistler's *Mother* looked old-fashioned and triggered memories of family relics allowed the picture to be easily adopted as a symbol of motherhood; the picture's connection, however conscious or sub-conscious, to ancestor portraits resonated in the popular psyche. The portrait of Anna McNeill Whistler looked vaguely familiar, and elicited a nostalgic response in its viewers, who recognised in it the sincere expression of a most basic human sentiment, that, in the words of one early commentator, already quoted, 'the best thing we have in this life is our mother'.[28]

Scholars are just beginning to realise the profound impact of early photography not only on the creation of works of art but also on their reception. In her groundbreaking essay on Grant Wood's *American Gothic* (see Fig.86), Wanda Corn points to Wood's awareness of the work of itinerant American photographers who posed farm couples in front of their cabins for their portraits. She argues that Wood adopted for his picture the 'upright torsos, the unblinking eyes, and the mute, stony faces ... characteristic of long-exposure portraits'.[29] The simple compositional formula and the mute facial expressions of the couple, she suggests, made it possible for Americans to 'use *American Gothic* as an all-purpose "blackboard" on which to write their messages, voice their concerns, and hawk their wares. They have discovered, as the critics have before them, that the image is protean, capable of addressing an infinite number of issues.'[30] A related claim can be made about Whistler's *Mother*. The portrait's visual connection to family photographs was largely responsible for the rapidity with which the picture became accepted as an archetype of motherhood. At the same time, it was that mute photographic gaze

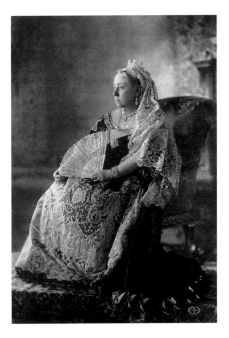

94 **W. & D. Downey**
Queen Victoria:
Diamond Jubilee Portrait 1897
Photograph
The Royal Archives
© HM Queen Elizabeth II

and simple formulaic pose that invited interpretation and appropriation.

As we have seen, Whistler's portrait of his mother had been critiqued, lampooned, interpreted, reproduced, and increasingly canonised as a 'masterpiece' ever since it was introduced to the public in 1872. However, the true appropriation of the image by popular culture came later and is wrapped up with Whistler's identity as an expatriate American. A quantum leap was made in the fame and popularity of Whistler's *Mother* in America when the painting was shown at the Museum of Modern Art in 1932. As Kevin Sharp describes (see Chapter 4), MoMA arranged to borrow the picture from the French government and, following its showing in New York, organised an extensive national tour that lasted more than two years.[31] During that tour, the painting made headlines in every city where it stopped, drawing enormous crowds and voluminous commentary. It was during this highly publicised campaign that the painting moved beyond its general status as 'masterpiece' to that of 'American master-piece'.[32] Likewise, as it was photographed with school children and boy scouts around the United States, the picture became a symbol of specifically American motherhood. 'America's most famous painting comes home!' shouted headlines (see Chapter 4). Although the picture belonged to the Louvre and returned there in 1934, America claimed the famous portrait as its own cultural property and has been doing so ever since. The fantasy was finally realised on screen in the 1997 comedy *Bean*, in which Whistler's *Mother* is actually purchased – not just borrowed – by a fictitious California art museum.

Not surprisingly, references to the picture abound in American culture of the 1930s. Legendary folk singer Woodie Guthrie, then a young man scraping his earnings together to buy art supplies, recalled painting an oil copy of Whistler's *Mother* as a learning exercise.[33] Cole Porter's lyrics in the 1934 song 'You're the Top' include a famous reference to Whistler's picture: 'You're an O'Neill drama, you're Whistler's mama, you're camembert.'[34]

In May of the same year, Whistler's *Mother* became a 'masterpiece of the mails' when it appeared on a three-cent stamp issued by the United States Postal Service in honour of Mother's Day. The inscription 'in honor of the Mothers of America' replaced the curtain that occupies the left-hand side of the original (see Fig.69). Below the inscription, the stamp designer added a small pot of flowers and cropped the image so that the sitter's feet are no longer visible, small liberties that immediately turned into a big issue. 'The United States Government stands accused of mutilating one of the world's greatest paintings,' read an editorial in the *Chicago Tribune*.[35] The American Artists Professional League, joined by officials of the Museum of Modern Art, registered their dismay in letters and telegrams to Postmaster General James A. Farley.[36] This incident is interesting in that it reveals the two primary meanings now attached to Whistler's picture. On the one hand, the picture symbolises a reverence for mother and therefore made an ideal com-memoration of Mother's Day. On the other, as we see expressed in Cole Porter's lyrics, 'Whistler's Mother' was a recognised synonym for 'one of the world's greatest masterpieces', a meaning that was solidified by the press's fascination with the painting's high value and need for stringent security in the course of the American tour (see Fig.72).

Whistler's *Mother* continued to linger in the hearts and minds of Americans long after the painting had been returned to France in 1934. In 1937, the Ashland

Boys Association in Ashland, Pennsylvania selected
Whistler's canvas as the model for an enormous
bronze sculpture honouring mothers (Fig.95). As
far as the group knew, they were the first to create a
statue from the painting. Standing seven feet high
and weighing in at 1260 lbs, the seated figure of the
mother was placed atop a four-foot high marble base
bearing the inscription 'Mother – A Mother is the
Holiest Thing Alive'. A local newspaper article
published in May 2000 sheds some light on why
Whistler's was the particular mother selected as the
model for this unusual monument: 'Mother. She is
weighed down by great burden, great sacrifice, and
immense love. And, all too often, she does not receive
the praise she deserves.'[37] Commissioned and erected
during the late 1930s, when America's entry into
World War II seemed increasingly inevitable and
young men prepared themselves to fight on Europe's
battlefields, the aged yet stoic bronze figure of Anna
McNeill Whistler epitomised the American martyr-
mother. This was not the first such use of her
uncomplaining profile: in 1918 a reproduction of
Whistler's painting had served as the frontispiece for
a collection of war poetry by Harry Tobias, whose
collection entitled *The Bravest of Them All* paid homage
to mothers and sons.[38] A British poster also dating
from the World War I years employed Mrs Whistler's
slight but unbending form to announce 'Old age must
come, so prepare for it by investing in War Savings
Certificates' (Fig.96).

References and images dating from the years of World
War II indicate that 'Whistler's Mother' was by now a
household phrase, and with familiarity came a less
reverent form of appropriation. A new plane, the
Douglas A-26 bomber, was nicknamed 'Whistler's
Mother' when it was introduced in July 1942,
presumably because of the whistling sound made by

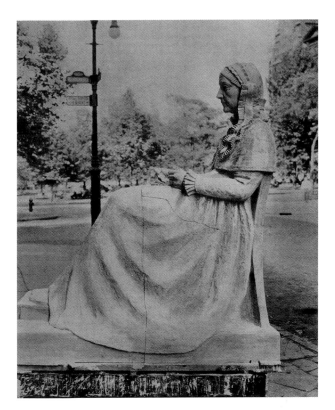

95 **Julius Loester and Emil Sieber**
The Ashland Mother's Memorial 1938
Bronze sculpture
Photograph by Ray Silcox for *The News Item*
Shamokin, PA, May 13–14, 2000
Reprinted by permission of *The News Item*

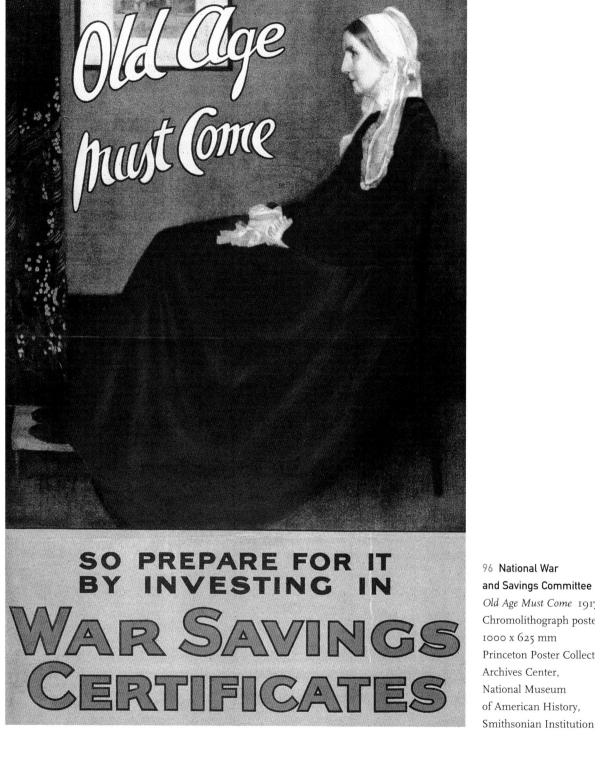

96 **National War
and Savings Committee**
Old Age Must Come 1917
Chromolithograph poster
1000 x 625 mm
Princeton Poster Collection,
Archives Center,
National Museum
of American History,
Smithsonian Institution

the bombs it released. 'The Whistler's Mother-in-law' was a popular dance hit of the war years, recorded by Woody Herman. From this point on, cultural references to Whistler's most famous painting are increasingly lighthearted and wide-ranging. Where once the painting's iconography was more narrowly defined as a respectful tribute to motherhood or to the greatest achievements of fine art, pop culture now began to tease out the humorous potential of Whistler's inscrutable old mother. Once established as an object of fun, Whistler's *Mother* became fair game for every cartoonist, animator, advertising executive, and greeting card designer. The floodgates had been opened.

A persistent form of humour explores what Whistler's *Mother* might be looking at, an obsession directly related to the pose and gaze depicted in the original. One of the most famous lampoons of this sort was created by Ward Kimball, one of the original animators at Walt Disney Studios. In a small 1964 book entitled *Art Afterpieces*, Whistler's *Mother* sits demurely watching television (Fig.97), still a relatively recent addition to many households.[39] Decades later, a 1982 *Newsweek* cover shows Mrs Whistler, again seated demurely, but this time in front of a computer monitor and accompanied by the words, 'Home is where the computer is' (Fig.98).[40] These two examples indicate not only the way in which Whistler's *Mother* has come to function as a visual synonym for 'home', but also how the image has been re-appropriated for the changing issues of each generation. In both of these instances, the juxtaposition of new technology with the archaic figure of Whistler's *Mother* speaks volumes about the 'shock of the new'.[41]

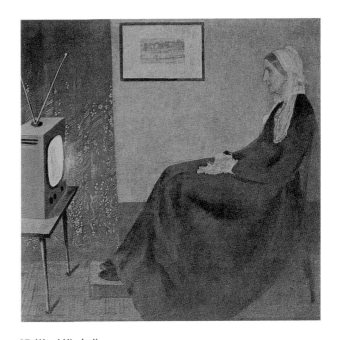

97 **Ward Kimball**
Portrait of My Mother, from *Art Afterpieces*
© 1964, 1975 by Ward Kimball.
Used by permission of Price Stern & Sloan,
an imprint of Penguin Putnam Books for Young Readers,
a division of Penguin Putnam Inc.
All rights reserved.

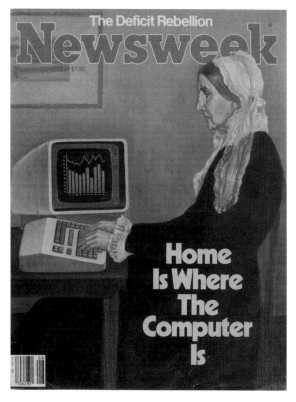

98 Kinuko Craft
Newsweek cover 22 February 1982
© Newsweek, Inc.
All rights reserved
Reprinted by permission

If it is tempting to conjecture about what Mrs Whistler might be seeing, the invitation to guess what she might be thinking has proved irresistible. We saw this phenomenon in some of the earliest art criticism devoted to the picture, although early commentators attributed only the most honourable maternal thoughts to the respectable Mrs Whistler. However, the early reading of the sitter's character as typically Protestant and puritanical has paved the way for recent lampoons in which her prudishness is only skin deep. 'Come on sonny boy, this picture would be a lot more interesting if I posed in the nude!' she quips in a postcard of the 1980s, while a recent internet image entitled *Whistler's Overbearing Mother: Derangement in Grey and Black* shows a grim Mrs Whistler holding a whip.[42] Other images show her smoking a cigarette,[43] blowing a party horn, or stripping down to her lacy undies in a card that suggests 'It's your birthday. Don't just sit there! Show 'em stuff!' Her very immobility, it seems, is provocative; we feel compelled to help Whistler's *Mother* loosen up, as well as stand up and stretch her legs occasionally.

In a related usage of the image, we find Whistler's *Mother* serving as an icon of old age, prudishness, old-fashioned viewpoints, and conservative politics. In a *Herald Tribune* article of 26 June 1984, examining the question 'Is 74 too old to be president?' the face of Ronald Reagan was grafted to the prim figure of Mrs Whistler (Fig.99), one of many examples of aged or outdated politicians to suffer such a fate. On 25 April 1997, *The Washington Post* found Whistler's *Mother*, convincingly doctored up to look pregnant, the perfect way to illustrate a news story entitled 'Inconceivable? When a 63-year-old gives birth, it raises more than eyebrows'. The prudish Mrs Whistler is frequently called upon to register disgust at vulgar or licentious behaviour, as she does, for example, in a *Little Annie*

Fanny comic when a beauty contestant removes her clothes during the talent portion of the contest.[44]

Not always irreverent, however, some references still find Whistler's portrait to be a moving portrayal of old age, as in this 1999 poem by Edwin Brock:

> *Whistler's mother was probably not*
> *That dominating triangle*
> *Watching from the edge of darkness*
>
> *But some frail old lady*
> *living out her years*
> *On supplementary benefits*
> *in sheltered accommodation*
>
> *Visited by the home help,*
> *Or a caring neighbour or,*
> *On high days, her GP*
>
> *And her son? He's there*
> *On the other side of darkness*
> *Trying to sort out night from*
> *Nightmare, faith from fear*
> *And dying for something happy to happen*[45]

Certainly, the sentimental subtext of the picture has served greeting card vendors and florists well. Whistler's *Mother*[46] remains the mother of choice on Mother's Day cards, her long-suffering profile perfect for instilling guilt in even the most attentive of children. One clever greeting card designer replaced the framed etching on the wall in the original painting with a sign reading simply 'Call Your Mother'. Edward Sorel, in his variation on this theme, created a witty Mother's Day cover for *The New Yorker* in 1996 (Fig.100); here an irritated Mrs Whistler glares at the telephone, waiting, one presumes, for her negligent progeny to call.

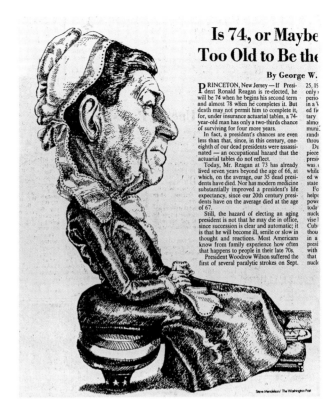

99 Steve Mendelson/*The Washington Post*
Ronald Reagan as Whistler's Mother
Illustration in *Herald Tribune*
26 June 1984, p.4

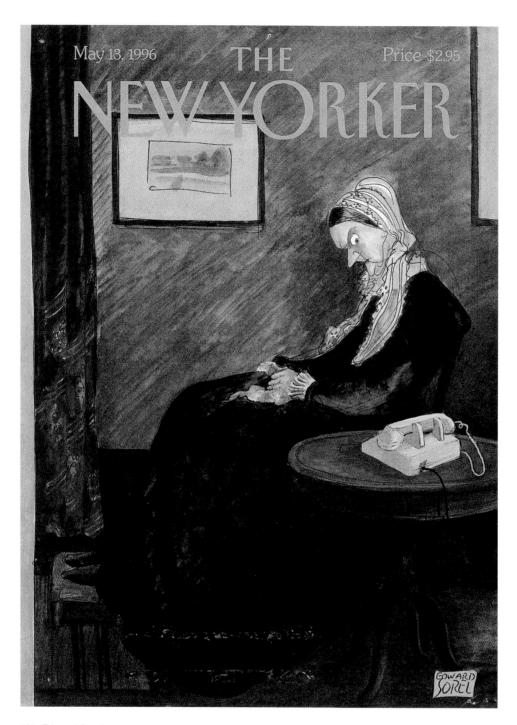

100 **Edward Sorel**
Mother's Day Cover
The New Yorker, 13 May 1996
© The New Yorker Collection 1996
Edward Sorel from cartoonbank.com
All Rights Reserved

Over its long history *The New Yorker* has played a leading role in generating witty cartoons based on Whistler's *Mother*. For the most part, these are inside jokes for the educated, cosmopolitan readers who make up the magazine's principal audience. They presume some knowledge of art or art history, as in *Whistler's Mother at Sharkey's* in which Mrs Whistler is tangled in the ropes that surround the ring in George Bellow's famous boxing match (Fig.102). Another depicts the meeting between the mothers of Toulouse-Lautrec and Whistler; while the former is verbally insulting, Whistler's stony-faced mother simply thumbs her nose in contempt (Fig.103). A splendid cartoon from 1970 depicts mother *and* son; Whistler – dressed to go out – gazes in dismay at the rain outside their window. 'Surely, Son, you can find something to paint indoors,' admonishes Mrs Whistler, already in position (Fig.104).

Ever since Aubrey Beardsley depicted himself as Whistler's *Mother* in 1891, we have delighted in merging the identities of celebrities, cartoon characters, politicians, and practically everyone else with the famous countenance of this respectable old lady.[47] This is far and away the largest category of lampoons and send-offs; a huge number have been generated by the animation industry alone. Such eminent personalities as Donald Duck (Fig.105), Bullwinkle the Moose (Fig.101), Tigger;[48] Wile E. Coyote,[49] the Animaniacs,[50] the Muppets,[51] and Barbie (Fig.106) have struck the upright pose made famous by Mrs Whistler.[52] Although these are characters created for children, the superimposition of Whistler's *Mother* is clearly meant to appeal to adults, providing the kind of inside joke that children's programming employs to keep parents watching. However, dolls and animated characters are not the only ones who would switch seats, if they could, with Whistler's

101 *The Adventures of Rocky and Bullwinkle: Whistler's Moose* (vol. 7)
Video box cover
Buena Vista Home Video
Courtesy of Jay Ward Productions

102 **Danny Shanahan**
'Whistler's Mother at Sharkey's'
The New Yorker, 22 May 1989
© The New Yorker Collection 1989
Danny Shanahan from cartoonbank.com
All Rights Reserved

103 **J. B. Handelsman**
'La Rencontre des Mères
de Toulouse-Lautrec et Siffleur'
The New Yorker, 24 June 1991
© The New Yorker Collection 1991
J. B. Handelsman from cartoonbank.com
All Rights Reserved

Mother. Animals have frequently done so (Fig.107). Celebrities, too, have found it impossible to resist the temptation of stepping into a masterpiece. When, in 1946, Rita Hayworth was asked how she would cast herself by *Look* magazine, she chose Whistler's *Mother* (Fig.108). The article explained that 'Rita Hayworth, a mother herself, longs to portray Whistler's Mother with emphasis on the whistle.'[53]

A darling of popular culture for more than a century, Whistler's *Mother* has functioned as a powerful symbol of our love, respect, nostalgia, and occasional annoyance with our mothers. Simultaneously, the picture is recognised as a visual synonym for 'the masterpiece', that priceless and consummate example of human creativity. Recent incarnations demonstrate that these meanings are with us still, as attached to this remarkable picture today as they ever have been. In watching *Bean*, the 1997 comedy in which the Mr Bean character escorts Whistler's *Mother* to California only to destroy it when he sneezes, one could see and feel the audience cringe as the original face of Mrs Whistler was wiped away. Too real was the sensation that this irreplaceable work of art could indeed vanish in a flash, that we might lose this image that has come to feel like communal property. At the same time, the movie ends rather cheerfully when Bean slips a photographic reproduction of the picture into its original frame and gets away with it. Is it Whistler's painting itself that we prize so highly, or is it really Whistler's *Mother* the icon, a set of collective meanings formed over the last century by cultural appropriations of the image? Who can say? Perhaps for now we must allow popular culture to have the last word since, after all, the afterlife of Whistler's *Mother* will continue to evolve in the years to come. Here, for example, are the highly relevant musings of Klara, a young female character in Don DeLillo's novel *Underworld*:

She had a small print of a Whistler, the famous Mother, and she hung it in a corner of the spare room because she thought it was generally unlooked at and she liked the formal balances and truthful muted colours and because the picture was so clashingly modern, the seated woman in mobcap and commodious dark dress, a figure lifted out of her time into the abstract arrangements of the twentieth century, long before she was ready, it seemed, but Klara also liked looking right through the tonal components, the high theory of colour, the theory of paint itself, perhaps – looking into the depths of the picture, at the mother, the woman, the mother herself, the anecdotal aspect of a woman in a chair, thinking, and immensely interesting she was, so Quaker-prim and still, faraway-seeming but only because she was lost, Klara thought, in memory, caught in the midst of a memory trance, a strong elegiac presence despite the painter's, the son's, doctrinal priorities.[54]

104 A. Kovarsky
'Surely, Son, you can find something to paint indoors'
The New Yorker, 14 December 1957
© The New Yorker Collection 1957
A. Kovarsky from cartoonbank.com
All Rights Reserved

Don's Whistling Mother (Whistler)

105 Walt Disney studios
Don's Whistling Mother 1945
Reprinted by permission
of Disney Publishing Worldwide

106 **Dean Brown**
Barbie as Whistler's Mother 1983
Colour photograph
Courtesy of Dean Brown

107 **Jeanne Heilman**
Whistler's Mother
Greeting Card, Paws a Moment,
Animal Actors Guild
Photographed by Jeanne Heilman
Paws a Moment Greeting Cards
www.PawsAMomentCards.com
PO Box 1243, Arcadia, CA 91007

108 'How Stars Would Cast Themselves'
Look, 19 February 1946, p. 76
Library of Congress
Prints and Photographs Division
Look Magazine Photograph Collection
[LC-L914-45-2150#1]

Abbreviations

GUL Glasgow University Library, Special Collections, Whistler Collection

GUW The Correpondence of James McNeill Whistler, 1855–1903, edited by Margaret F. MacDonald, Patricia de Montfort and Nigel Thorp; and of Anna Matilda Whistler, edited by Georgia Toutziari. On-line Centenary edition, Centre for Whistler Studies, University of Glasgow, 2003. www.whistler.arts.gla.ac.uk/correspondence

LC PWC Library of Congress, Pennell-Whistler Collection

K: Edward G. Kennedy, *The Etched Work of Whistler*, The Grolier Club, New York, 1910 (reprint Alan Wofsy Fine Art, San Francisco, 1978)

M: Margaret F. MacDonald, *James McNeill Whistler. Drawings, Pastels, and Watercolours. A Catalogue Raisonné*, New Haven and London, 1995

C: Nesta R. Spink, H. K. Stratis, M. Tedeschi with B. Salvesen, *The Lithographs of James McNeill Whistler*, Chicago, 1998

YMSM: Andrew M. Young, Margaret F. MacDonald, Robin Spencer with Hamish Miles, *The Paintings of James McNeill Whistler*, New Haven and London, 1980

Notes

1 Anna Matilda Whistler: a life

1 Luke Ionides, *Memories*, Paris, 1925, p.14.

2 See Elizabeth Mumford, *Whistler's Mother: The Life of Anna McNeill Whistler*, Boston, 1939; Kate MacDiarmid, *Whistler's Mother: Her Life, Letters & Journal*, unpublished MS in Glasgow University Library; excerpts from letters to her friends the Gambles and Wanns were published in 'The lady of the portrait: letters of Whistler's mother', *Atlantic Monthly*, cxxxvi, no.3, September 1925, pp 310–28.

3 See Barbara Welter, 'The cult of true womanhood, 1820–1860', *American Quarterly*, vol.18, 1966, pp 151–74. Also see Nancy F. Cott, *The Bonds of Womanhood: Woman's Sphere in New England*, New Haven, CT, 1977; Caroll Smith-Rosenberg, 'The female world of love and ritual: relationships between women in nineteenth-century America', *Signs*, 1, Autumn 1975; Glenna Matthews, *Just A Housewife*, New York, 1987.

4 268 of Anna Whistler's letters have survived, and are mostly in Glasgow University Library and the Library of Congress: see G. Toutziari, *Anna Matilda Whistler's Correspondence – An Annotated Edition*, PhD thesis, University of Glasgow, 2002.

5 See A. T. B. Stuart, 'The North Carolina Settlement of 1739', *The Kintyre Antiquarian and Natural History Society Magazine*, 1984, pp 3–12; David Dobson, *Directory of Scots in the Carolinas*, Baltimore, 1986, p.210; William McNeill, 'The McNeill family of Bladen County', *Bladen County Heritage North Carolina*, Waynesville, NC, 1, 1999, p.210. There were two clans of the McNeill name who emigrated to North Carolina in 1739: one from Barra, one from Gigha. Anna McNeill was descended from the latter.

See Douglas F. Kelly and Caroline S. Kelly, *Carolina Scots: An Historical and Genealogical Study of over 100 Years of Emigration*, Dillon, SC, 1998, pp 47–77, 162–3.

6 See Robin Spencer, 'Whistler's early relations with Britain and the significance of industry and commerce for his art', *Burlington Magazine*, cxxxvi, April 1994, p.216.

7 McNeill 1999.

8 See A. M. Whistler to J. McN. Whistler, 11 and 13 April 1853, GUL W422; GUW 06427.

9 E. Jasiulko-Harden, 'Major George Washington Whistler, railroad engineer in Russia: 1842–49', in *Ex Oriente Lux, Mélanges*, 1, Brussels, 1991, p.149.

10 A. M. Whistler to C. J. McNeill, 22 November 1829, GUL W344; GUW 06347.

11 L. D. Ginzberg, *Women and the Work of Benevolence: Morality, Politics, and Class in the Nineteenth-Century United States*, New Haven and London, 1990, pp 1–10.

12 See 'Centenary of Whistler's birth recalls Springfield connections', *The Springfield Union, Springfield Republican*, Springfield, MA, 8 July 1934, p.1; Thomas Storrow, 'George Washington Whistler in Stonington', *Historical Footnotes*, iii, no.3, Stonington, CT, May 1966, pp 1–5.

13 A. M. Whistler to D. D. Haden, 4 August 1863, GUL W515; GUW 06521. See also Margaret MacDonald, *Whistler's Mother's Cook Book*, London, 1979; 2nd edition, Rohnert Park, CA, 1995.

14 R. Mowbray Haywood, *Russia Enters the Railway Age, 1842–1855*, New York, 1998, p.367. See also Jasiulko-Harden 1991, p.152.

15 See A. M. Whistler, 'St Petersburg Diary', 1843–8, James McNeill Whistler Papers, New York Public Library.

16 See H. Pitcher, *Muir & Mirrielees: The Scottish Partnership that became a Household Name in Russia*, Norwich, 1994, p.33; Gordon Fleming, *The Young Whistler*, London, 1978, pp 35–7.

17 J. G. Kohl, *Russia and the Russians in 1842*, London, 1842, p.208.

18 See *James Nasmyth, Engineer, An Autobiography*, ed. Samuel Smiles, London, 1883, p.288.

19 ibid, p.289.

20 See *The Sun*, Baltimore, vol.49, no.59, 27 July 1861, and vol.83, no.22, 11 June 1878; and A. M. Whistler to J. McN. Whistler, 23 March 1858, GUL W490; GUW 06495.

21 A. M. Whistler to J. McN. Whistler, 8 and 9 January 1849, GUL W377; GUW 06381.

22 See A. M. Whistler to J. McN. Whistler, 1 and 2 November 1848, GUL W366 (GUW 06270); J. G. Kohl, *Russia and the Russians in 1842*, ii, London, 1842, p.68.

23 Both Haden and Whistler became leaders of the British etching revival in the 1860s, but by the spring of 1867 they had fallen out; see Katharine A. Lochnan, 'The Thames from its source to the sea: an unpublished portfolio by Whistler and Haden', in Ruth Fine (ed.), *James McNeill Whistler: A Re-examination, Studies in the History of Art*, xix, Centre for Advanced Studies in the Visual Arts, Washington DC, Symposium Papers vi, 1987, pp 29–45.

24 See W. Bruce Lincoln, *Nicholas I: Emperor and Autocrat of All the Russias*, Northern Illinois University Press, 1989, p.277.

25 A. M. Whistler to J. McN. Whistler, September 1848 and 16 April 1849, GUL W387; GUW 06391.

26 See *Estate of Whistler, George W., St Petersburg, Russia, 1850*, no.4350, Connecticut State Library (formerly of Pomfret), G. 16.

27 A. M. Whistler to J. McN. Whistler, 13 February 1855, GUL W447; GUW 06452.

28 See A. M. Whistler to Joseph Harrison, 8 August 1849, LC PWC 34/39–40; GUW 07636.

29 The Russian chapter in Anna Whistler's life was briefly reopened in 1855 when she pleaded poverty and money owed to her by the tsar. See A. M. Whistler to Thomas Henry Seymour, February 1855, Connecticut Historical Society, Hartford, CT, Thomas Henry Seymour Papers (64928). Seymour was the Minister to Russia from 1853 to 1858.

30 See John S. Barnum, *History of Stonington*, Mystic, CT, 1966.

31 A. M. Whistler to J. McN. Whistler, 10 May 1849, GUL W318; GUW 06392.

32 I Timothy, 5: 3–7.

33 See Susan Jewett Griggs, *Folklore and Firesides of Pomfret, Hampton and Vicinity*, Connecticut, 1949.

34 See A. M. Whistler to Joseph Harrison, 19 June 1849, LC PWC 34/15–18; GUW 07629.

35 See A. M. Whistler to M. G. Hill, 8 October 1851, LC PWC 34/33–4; GUW 07638.

36 Influential friends probably instigated J. McN. Whistler's choice; see A. M. Whistler to M. G. Hill, 20 and 21 [September 1850], LC PWC 34/19–20; GUW 07631.

37 See A. M. Whistler to M. G. Hill, 20 and 21 [September 1850], and 8 October 1851, LC PWC 34/19–20, 34/33–4; GUW 07631, 07638.

38 See A. M. Whistler to J. McN. Whistler, 25 November 1851, GUL W403; GUW 06407. Popham's affluent income (stated in the US Census of 1850) makes him the probable man behind the building of the cottage. See Hellen Lorraine Hultz, *Scarsdale Story: A Heritage History*, New Jersey, 1987, p.543.

39 ibid, p.578.

40 See, for example, A. M. Whistler to J. McN. Whistler, 30 September and 12 October 1848, GUL W364; to M. G. Hill, 3 August [1851], Department of Manuscripts and University Archives, Cornell University Library, Ithaca, New York, (Carl A. Kroch Library), 1629; and to James H. Gamble, 12 June 1864, GUL W519; GUW 0638, 09557, 06525.

41 See G. H. Fleming, *James Abbott McNeill Whistler: A Life*, Adlestrop, 1991, pp 49–50.

42 He experimented instead with mechanics; Anna Whistler strongly disapproved. See A. M. Whistler to J. McN. Whistler, 19 and 24 April 1855, GUL W453 and W454, and 16 November 1853, GUL W425; and to James H. Gamble, 3 April 1854, GUL W453; GUW 06458, 06459, 06437.

43 George William Whistler after his marriage to Julia De Kay Winans also went to Russia, and worked for the 'Alexandroffsky Mechanical Works'; see A. M. Whistler to James H. Gamble, 13 January 1857, GUL W474; GUW 06479.

44 See A. M. Whistler to J. McN. Whistler, 26 and 27 November 1854, GUL W441; GUW 06446.

45 A. M. Whistler to J. McN. Whistler, 24 April 1855, GUL W454; GUW 06459.

46 N. G. Flagg and L. C. S. Flagg, *Family Records of the Descendants of Gershom Flagg of Lancaster, MA*, Quincy, IL, 1907.

47 See Spencer 1994, p.216.

48 A. M. Whistler to J. McN. Whistler, 3 August 1861, GUL W510; GUW 06516.

49 See A. M. Whistler to J. H. Gamble, 5 December [1858], GUL W497; GUW 06502.

50 See for example A. M. Whistler to J. McN. Whistler, 7 May 1858, GUL W491, and to J. H. Gamble, 17 October [1858], GUL W494; GUW 06496 and 06499.

51 See Roger G. Kennedy, *Architecture, Men, Women and Money in America, 1600–1860*, New York, 1985, pp 385–7.

52 A. M. Whistler to J. McN. Whistler, 18 November 1858, GUL W496; GUW 06501. Earlier, she was on good terms with the family of Joseph Harrison, and valued his help; see, for example, A. M. Whistler to J. McN. Whistler, 16 November 1853, GUL W425; GUW 06430.

53 Sharon Historical Society, *Reflections on Sharon, 1797–1997: A Pictorial History*, Sharon, NY, 1997, p.21.

54 A. M. Whistler to J. McN. Whistler, 11 July 1856, GUL W469; GUW 06474.

55 Tercentenary History Committee (eds), *The Northampton Book: Chapters from 300 Years in the Life of A New England Town, 1654–1954*, Northampton, MA, pp 124–5.

56 Anna Whistler's reaction was probably a combination of ideological disagreement and maternal fear for the safety of her son. See A. M. Whistler to D. D. Haden, [15/31 July 1861], GUL W507; GUW 06512.

57 He served in various Richmond hospitals including Libby Prison, and Drewry's Bluff on the James River near Petersburg. In March/April 1863 he was at Camp Jackson, near Richmond.

58 A. M. Whistler to J. McN. Whistler, 11 July 1861, GUL W506; GUW 06511.

59 See A. M. Whistler to James H. Gamble, 7 June 1864, GUL W518; GUW 06524.

60 A. M. Whistler to J. McN. Whistler, 3 August 1861, GUL W510; GUW 06516.

61 A. M. Whistler to D. D. Haden, 4 August 1863, GUL W515; GUW 06521.

62 By this time, Anna Whistler had crossed the Atlantic and the Baltic on numerous occasions (she had, for instance, visited Britain in the summer of 1860). It took courage and an enormous amount of endurance to do so, when travelling was, by modern standards, very uncomfortable.

63 See J. McN. Whistler to Fantin-Latour, 4 January–3 February 1864, LC PWC 1/33/15; GUW 08036. Hiffernan was succeeded in J. McN. Whistler's household and studio by Maud Franklin, who had an enormous influence on his life and work; see Margaret F. MacDonald, 'Maud Franklin', in Fine 1987, pp 13–26.

64 See, for example, A. M. Whistler to J. McN. Whistler, 3 March 1852, GUL W407; GUW 06412. It is almost certain that Anna Whistler knew of her son's lifestyle, but barely mentioned it in her letters, probably to protect her family's social standing.

65 A. M. Whistler to J. McN. Whistler, 27 November 1854, GUL W441; GUW 06446.

66 Translation: 'All of a sudden in the middle of all this my mother arrives from the United States! – Well! general upheaval!! I had a week or so to empty my house and purify it from cellar to attic! – Find a "buen retiro" for Jo – A place for Alphonse [Legros] – go to Portsmouth to meet my Mother! Well you see the goings-on! some goings-on! goings-on up to my neck!' J. McN. Whistler to Fantin-Latour, 4 January–3 February 1864, LC PWC 1/33/15; GUW 08036.

67 A. M. Whistler to Catherine ('Kate') Jane Palmer, 21 May–3 June [1872], Princeton University Library, Department of Rare Books and Special Collections; GUW 09938.

68 A. M. Whistler to James H. Gamble, 10–11 February 1864, GUL W516; GUW 06522.

69 Freer Gallery of Art, Washington DC; YMSM 47 and 56; A. M. Whistler to

J. H. Gamble, 10–11 February 1864, GUL W516; GUW 06522.

70 For William McNeill Whistler's personal recollections of the Civil War see his letter to Robert R. Hemphill, [1898], GUL W1017; GUW 07028.

71 A. M. Whistler to James H. Gamble, 10–11 February 1864, GUL W516; GUW 06522.

72 A. M. Whistler to M. G. Hill, 14 December 1868, LC PWC 34/49–50; GUW 11473.

73 A. M. Whistler to F. R. Leyland, 11 March [1869], LC PWC 34A1–1; GUW 08182.

74 ibid.

75 A. M. Whistler to J. Harrison, 14 May 1868, LC PWC; GUW 11470.

76 See A. M. Whistler to J. McN. Whistler, 29 and 31 July [1852], GUL W411; and to Charles W. McNeill, 10–12 October 1877, GUL W554; GUW 06416 and 06551.

77 For example, A. M. Whistler to J. McN. Whistler, 5 and 21 November 1848, and 6 August 1851, GUL W367, W368, W394; GUW 06371, 06372, 06398.

78 A. M. Whistler to Charles W. McNeill, 10–12 October 1877, GUL W554; GUW 06561.

79 A. M. Whistler to J. McN. Whistler, 29 June [1878], GUL W550; GUW 06557.

80 See A. M. Whistler to Catherine Jane ('Kate') Palmer, 3–4 November 1871, LC PWC 34/67–8 and 75–6; GUW 10071.

81 ibid.

2 The painting of Whistler's *Mother*

1 J. McN. Whistler to A. M. Whistler, [22 April/May 1867], GUL W523; GUW 06529.

2 See M. F. MacDonald, 'Whistler: The Painting of the "Mother"', *Gazette des Beaux-Arts*, LXXXV, February 1975, pp 73–88.

3 J. McN. Whistler to A. M. Whistler, [22 April/May 1867], 10 October 1855, [27 September 1876]; GUL W523, W461–2, W557; GUW 06529, 06466, 06564.

4 A. M. Whistler to J. McN. Whistler, 20 January 1849, 1 February 1855, GUL W378, W446; GUW 06382, 06451.

5 A. M. Whistler to J. McN. Whistler, 13 February 1855, GUL W447; GUW 06452.

6 A. M. Whistler to J. McN. Whistler, 13–15 July [1857], GUL W480; GUW 06485.

7 Sarah A. Wallace and Frances E. Gillespie (eds), *The Journal of Benjamin Moran, 1857–1865*, University of Chicago Press, 1948, I, p.693.

8 A. M. Whistler to J. H. Gamble, 7 June 1864, states that only models may enter Whistler's studio, GUL W518; GUW 06524.

9 Whistler to T. Winans, [September/November 1869], Metropolitan Museum, New York; GUW 10632. *The Three Girls* (YMSM 88) was destroyed, but a study (Freer Gallery of Art; YMSM 87), fragment (private collection, in Courtauld Institute of Art; YMSM 90) and copy (Tate Britain; YMSM 89) survive.

10 Freer Gallery of Art, Washington, DC (YMSM 56); exhibited Royal Academy, London, 1870, cat.no.468.

11 Hunterian Art Gallery (YMSM 79).

12 A. M. Whistler to C. J. Palmer, 3–4 November 1871, LC PWC 34/67–8 and 75–6; GUW 10071.

13 A. M. Whistler to J. H. Gamble, 29 November 1871, GUL W541; GUW 06547.

14 *Harmony in Grey and Green: Miss Cicely Alexander* (Tate Britain); see Elizabeth R. and Joseph Pennell, *The Life of J. McN. Whistler*, London and Philadelphia, 1908, I, p.173; and YMSM 129.

15 J. McN. Whistler to W. Grapel, [1869/1873], GUL G161; GUW 01795.

16 J. McN. Whistler to W. Grapel, [August 1871/1874], GUL G160; GUW 01794.

17 *Variations in Violet and Green*, Musée d'Orsay, Paris (YMSM 104) and *Harmony in Blue-Green – Moonlight*, later called *Nocturne: Blue and Silver – Chelsea*, Tate Britain (YMSM 103).

18 Walter Greaves, 'Notes on Old Chelsea', in W. Marchant, *Walter Greaves*, exh.cat., Goupil Gallery, London, May 1922, p.19.

19 ibid.

20 A. E. Gallatin, *The Portraits and Caricatures of James McNeill Whistler*, London, New York and Toronto, 1913, cat.no.36, records an oil painting by Greaves of Whistler painting his mother, dated 1869, then owned by the Rosenbach Company, Philadelphia. Another version is reproduced in Elisabeth R. and Joseph Pennell, *The Whistler Journal*, Philadelphia, 1921, facing p.154.

21 Private collection, YMSM 250; Cassatt's diary, quoted in R. Dorment and M. F. MacDonald, *James McNeill Whistler*, Tate Gallery, London; Musée d'Orsay, Paris; National Gallery, Washington DC, 1994–5, cat.no.128.

22 A. M. Whistler to Whistler, 29 January 1857, GUL W475; GUW 06480.

23 A. M. Whistler to C. J. Palmer, 3–4 November 1871.

24 E. G. Kennedy, *The Etched Work of Whistler*, New York, 1910, cat.no.97. The plate was one of fifty-seven cancelled etchings published by the Fine Art Society c.1878. The cancelled copperplate is in the Hunterian Art Gallery, Birnie Philip Gift 1935.

25 See for instance *Nocturne* (K.184), in M. F. MacDonald, *Palaces in the Night: Whistler in Venice*, London and California, 2001, pp 82, 92.

26 *Study for Arrangement in Black, No. 2: Portrait of Mrs Louis Huth*, Ashmolean Museum, Oxford (M.455) and Art Institute of Chicago (M.454). *Arrangement in Black, No. 2: Portrait of Mrs Louis Huth*, Lord Cowdray (YMSM 125).

27 *The Examiner*, 22 June 1872, p.622; *Pall Mall Gazette*, 14 June 1872, p.12; *The Standard*, 22 May 1872, p.6; quoted in C. C. Goebel, *Arrangement in Black and White: The Making of a Whistler Legend*, PhD thesis, University of Michigan 1988, Part 2, Appendix 10, notes 6, 9, 11.

28 Freer Gallery of Art (YMSM 50 and 56); see M. F. MacDonald, Susan G. Galassi and Aileen Ribeiro with Patricia de Montfort, *Whistler, Women and Fashion*, Yale University Press and The Frick Collection, 2003, p.61.

29 Otto Bacher, *With Whistler in Venice*, New York, 1908, pp 41–2.

30 Marchant 1922, p.19.

31 Thomas R. Way, *Memories of J. McN. Whistler*, London, 1912, p.71. The painting appears to have been relined, at an early date, before it went to the Musée du Luxembourg. Many of Whistler's paintings were relined during his lifetime and relining may have been done before the painting of the *Mother* was sold. The present frame, done to Whistler's design by the London frame-maker F. H. Grau, who worked for Whistler in the years 1890–2, may have been added at the same time.

32 See Whistler to Henry Cole, [27 April 1873?], LC PWC 1/18/1; GUW 07887. An example of an elaborate cartoon, pricked for transfer, is *Venus*, 1869, Freer Gallery of Art, Washington DC (M.357). It is close in style and technique to cartoons by Albert Moore, for example, *Figure Cartoon for 'Battledore'* (1869, Victoria and Albert Museum). An example of squaring

up an oil is *Sketch for 'The Balcony'* (YMSM 57), Hunterian Art Gallery.

33 Pennell 1908, I, p.169. See also T. Armstrong, *A Memoir*, London, 1912, repr. opp. p.32; A. L. Baldry, *Albert Moore*, London 1894, repr. pp 92, 36; *Albert Moore & His Contemporaries*, exh.cat., Laing Art Gallery, Newcastle upon Tyne, 1972, p.7 and cat.no.46.

34 For discussion of Moore's work in relation to Whistler see letter from W. E. Nesfield to Whistler, 19 September 1870, GUL N20; GUW 04263.

35 For example, *Polymnie* in Quatremere de Quincy, *Canova et ses ouvrages*, Paris, 1823, facing p.240.

36 P. G. Hamerton, *Saturday Review*, 15 June 1872, p.762.

37 *Pall Mall Gazette*, 14 June 1872, p.762; Goebel 1988, Appendix 10, n.9.

38 C. Y. Lang, ed., *The Swinburne Letters*, II, 1869–75, New Haven, 1959, no.534, pp 309–10, letter dated 15 July 1874 referring to exhibition at Bain's, 1 Haymarket, London, of 527 watercolours by William Blake. See G. E. Bentley and M. K. Nurmi, *A Blake Bibliography*, University of Minnesota, 1964, pp 167–70, no.422: Edward Young, *The Complaint, or Night Thoughts*, London, 1797.

39 See, for example, GUL PH3/1–9, PH3/64, PH3/51.

40 The original, in the Museo Thyssen-Bornemisza, Madrid, is tempera on panel, c.1488/1490.

41 *The Academy*, 15 May 1872, p.185; Goebel 1988, Appendix 10, n.1.

42 See Jean K. Cadogan, *Domenico Ghirlandaio, Artist and Artisan*, Yale University Press, 2000, cat.no.46, pp 277–9. Whistler exhibited works in Brighton and had patrons there, including Captain Henry Hill.

43 Sara Stevenson, *Facing the Light: The Photography of Hill and Adamson*, National Gallery of Scotland, Edinburgh, 2002, pp 80–1, 83–4.

44 ibid, p.80.

45 In turn this reflects Whistler's possible knowledge of Millais' portrait of Eliza Wyatt and her daughter Sarah of about 1850 (Tate Britain).

46 See YMSM 24; see also MacDonald, Galassi and Ribeiro 2003.

47 *Good Words for 1862*, repr. p.649; *Once a Week*, VI, 21 June 1862, repr. p.712; M. 301–2.

48 *The Academy*, 15 May 1872, p.185; GUL pc1/25; quoted in Goebel 1988, Appendix 10, n.1.

49 See Joanna Meacock, *Saintly Ecstasies: The Appropriation and Secularisation of Saintly Imagery in the Paintings and Poems of Dante Gabriel Rossetti*, History of Art PhD, University of Glasgow, 2001. Interestingly, in 1857 Whistler copied Jules-Claude Ziegler's 1839 oil of *La Vision de St Luc* (the original is now in Dunkerque Museum, and Whistler's copy, in a private collection). It shows the saint in profile left, with the madonna and child above.

50 Photograph, GUL PH3/11.

51 An 'icon' (deriving from the Greek, *eikon*) is an image of a sacred personage, and may itself be regarded as sacred.

52 Signed and dated 'Alfred Stevens 1859', photograph stamped MARION & CO. / 22–25 SOHO SQUARE / LONDON, published in Paris by Bingham, 58, rue de La Rochefoucauld.

53 Fantin-Latour to Whistler, 12 February 1867, GUL F14; GUW 01083.

54 Fantin-Latour, *Deux Soeurs*, or *Les Brodeuses*, 1859, oil, City Art Museum of St Louis (8.37); Douglas Druick and Michel Hoog, *Fantin-Latour*, Réunion des Musées nationaux, National Gallery of Canada and Fine Arts Museums of San Francisco, 1983, cat.no.20.

55 1867–8, Musée d'Orsay; see F. Cachin, C. S. Moffett (curators), *Manet 1832–1883*, Grand Palais, Paris, Metropolitan Museum of Art, New York, 1983, cat.no.107.

56 Arts Council, *Monet*, exh.cat., London, 1957, p.21; John House, 'New material on Monet and Pissarro in London in 1870–71', *Burlington Magazine*, CXX, no.907, October 1978, pp 636–42.

57 A. M. Whistler to C. J. Palmer, 3–4 November 1871.

58 For example, photograph in New York Public Library, signed and dated by Whistler, 1872, and inscribed to Avery; also signed by Whistler's mother on 22 June 1873. The first photograph known of the portrait was taken [1871/1872] by Parsons, according to letters from Whistler to C. W. Deschamps [11/13 December 1872], 21 December 1872, LC PWC 1/24/07, 1/22; GUW 07906, 11438.

59 Photographs of the *Mother* under infrared and raking light, and X-rays, taken by the laboratory of the Musée du Louvre, were used in evaluating a visual examination of the painting. I am most grateful for their assistance. Extending to the left, below the curtain and footstool, infrared photography shows a preliminary drawing, probably in ink, of several folds of drapery, which does not seem to relate to the hanging or the dress.

60 Mary Carlyle Aitken to Whistler, [1872/1873], Glasgow Museums; GUW 07564. See Dorment and MacDonald 1994–5, cat.nos 60–1; see also Aileen Ribeiro, 'In search of Carlyle's hat', *Costume*, 1996, no.30, pp 86–97.

61 Pennell 1908, I, p.168.

62 To H. E. Whistler, [16 December 1881], GUL W689; GUW 06695.

63 *Examiner*, 22 June 1872, p.622; Goebel 1988, n.5.

64 'colours should be so to speak <u>embroidered</u> on it – in other words the same colour reappearing continually here and there like the same thread in an embroidery – and so on with the others – more or less according to their importance – the whole forming in this way an harmonious <u>pattern</u> – Look how the Japanese understand this! – They never search for contrast, but on the contrary for repetition', Whistler to Fantin-Latour, 30 September–22 November 1868, LC PWC 1/33/28; GUW 11983.

65 'If I have made progress it is in the science of colour which I have almost entirely understood and reduced to a system – But I torment myself a lot and I would like to talk to you … The portrait of my mother I will have photographed and I will send you a print of it – Also I am thinking of sending the canvas to Paris for the next Salon', Whistler to Fantin-Latour, [August 1872?], LC PWC 1/33/22; GUW 08041. This letter was dated incorrectly by J. Sandberg in '"Japonisme" and Whistler', *Burlington Magazine*, CVII, no.747, November 1964, p.507, 'Appendix: the date of "Whistler's Mother"'; and also by myself (in YMSM 101), as c.January 1867.

66 GUL pc1/9, with note by Whistler, 'I fancy this is poor old Sala' (G. A. Sala, journalist).

67 See the analysis of 1872 reviews by Goebel 1988, p.246.

68 A. M. Whistler to C. J. Palmer, 3 November 1871.

69 ibid.

70 A. M. Whistler to J. H. Gamble, 10–20 April 1872, GUL W543; GUW 06549; excerpts mis-dated and misquoted in 'The lady of the portrait: letters of Whistler's mother', *Atlantic Monthly*, CXXXVI, no.3, September 1925, p.326.

71 A. M. Whistler to J. H. Gamble, 13 March 1872, GUL W542; GUW 06548.

72 Pennell 1908, I, pp 157–8. Sir William Boxall's portrait of Whistler was painted 1848–9 (Hunterian Art Gallery). When Whistler settled in London ten years later they renewed the family friendship.

73 *Daily Telegraph*, 4 May 1872, p.5; Goebel 1988, Appendix 10, n.4.

74 *Vanity Fair*, 4 May 1872, p.138; *The Saturday Review*, 15 June 1872, p.762; Goebel 1988, Appendix 10, n.13.

75 Clipping in one of Whistler's press cutting books, GUL pc1/9; with note by

Walter R. Sickert, signed 'W.S.'.

76 Unidentified press cutting, [June 1872], GUL pc4/87.

77 *Examiner*, 22 June 1872, p.622; Goebel 1988, n.5.

78 *The Athenaeum*, 25 May 1872, No.2326, p.661; GUL pc1/9. Whistler's painting, cat.no.941, is mentioned between Val Prinsep's *Lady George Hamilton* and Frank Holl's *I am the Resurrection and the Life*.

79 A. M. Whistler to J. H. Gamble, 10–20 April 1872, *op.cit.*

80 J. McN. Whistler to A. M. Whistler, [1876], copies in Concord Art Association, Concord, MA and LC PWC 19/1783–4; GUW 09563.

81 Mortimer Menpes, *Whistler as I Knew Him*, London, 1904, p.73; YMSM 315. The portrait is in the Carnegie Institute, Pittsburgh.

82 Pennell 1908, 1, p.170.

3 The selling of Whistler's *Mother*

1 Whistler to W. B. Pearsall, [4/11 December 1884], LC PWC 2/40/5; GUW 08109.

2 Whistler to W. McN. Whistler, [7/14 February 1892], GUL W995; GUW 07006; see M. F. MacDonald and J. Newton, 'The selling of Whistler's *Mother*', *The American Society Legion of Honor Magazine*, XLIX, no.2, 1978, pp 97–120, at p.114.

3 W. McN. Whistler to J. A. Rose, 28 February [1874], LC PWC; GUW 12235. He refers to 'the portrait of my mother by Jim' then in his possession. In *Mr Whistler's Exhibition*, French Gallery, 1874, the *Mother* was cat.no.4. See also Robin Spencer, 'Whistler's one-man exhibition reconstructed', in G. P. Weisberg and L. S. Dixon (eds), *The Documented Image: Visions in Art History*, Syracuse University Press, 1987, pp 27–49.

4 C. A. Howell to Henry Graves & Co., 9 September 1878, GUL H281; GUW 02184.

5 Howell published a subscription form for the engraving, which was to cost three guineas: see form signed by J. A. Rose, 1 January 1879, LC PWC; GUW 11902.

6 London Bankruptcy Court, copy of proceedings sent to J. A. Rose, 7 May 1879, Freer Gallery of Art; GUW 11711.

7 To satisfy demand, Howell offered to let Whistler have impressions of the engraving in exchange for etchings. Whistler was due twenty-five impressions from a total of a limited edition of one hundred; see C. A. Howell to Whistler, 25 August 1879, GUL H283; GUW 02187.

8 T. R. Way to B. Whistler, 17 January 1892, GUL W89; GUW 06092.

9 Receipt for £50 towards £200 lent on security of the *Mother*, signed Henry Graves, 10 January 1881, GUL G166; GUW 01800. By 9 February 1881 £300 was due on the portrait of Carlyle; Henry Graves & Co. to Whistler, 9 February 1881, GUL G167; GUW 01801; and A. Graves to Whistler, 23 January 1882, GUL G169; GUW 01803.

10 A. Graves to Whistler, 11 October and 17 November 1884, GUL G179 and G183; GUW 01813, 01818. The portraits were insured at those values for Dublin in 1884. The portrait of Carlyle was retrieved from H. Graves & Co. on 29 January 1891 on payment of £220, receipt, GUL G197; GUW 01832. This was arranged through the lawyer, George Lewis; Whistler to G. Lewis, [29 January 1891?], GUL L85; GUW 02550.

11 Graves sent Whistler their account on 11 December 1888: of the original £200 loan, he had repaid £50 on 10 February 1881 and 9 May 1882; interest at five per cent came to £41.13.4; see A. Graves to Whistler, 5 November 1887 and [26 December 1888?], GUL G187, G192; GUW

01822, 01827.

12 Helen Lenoir to Whistler, 9 December 1886, 31 January and 15 April 1887, GUL D138, D143 and D144; GUW 00932, 00937, 00938.

13 H. Cauty, RBA secretary, to Whistler; Lewis & Lewis to Whistler; N. Pocock to P. Macnab, 15 January 1887, 26 June and 9 July 1888, GUL R173, L73, P630; GUW 05277, 02538, 04990.

14 1863, Musée d'Orsay; see F. Cachin, C. S. Moffett (curators), *Manet 1832–1883*, Grand Palais, Paris, Metropolitan Museum of Art, New York, 1983, cat.no.62; Anne Coffin Hanson, *Manet and the Modern Tradition*, New Haven and London, 1977, pp 92–5.

15 'A piece of painting of incontestable beauty ... what elegance, what ability, what grace in this work that makes idiots laugh!', *Le Boulevard*, 31 May 1863; GUL pc1/29; see Joy Newton and Margaret F. MacDonald, 'Whistler: search for a European reputation', *Zeitschrift fur Kunstgeschichte*, XLI, 1978, pp 148–59.

16 'Baudelaire finds it charming, charming, of exquisite delicacy', H. Fantin-Latour to Whistler, [15 May 1863], GUL F12; GUW 01081. See also Baudelaire in *La Revue Anecdotique*, 2 April 1862 (Baudelaire, *Curiosités esthétiques*, Paris, 1958). Whistler offered Baudelaire a set of etchings, and probably met him in June 1863; see Robin Spencer, 'Whistler's *The White Girl*: painting, poetry and meaning', *Burlington Magazine*, CXL, no.1142, May 1998, pp 300–11, at pp 308–9.

17 'the White Girl, a strange vision from the eye of a great artist ...', Emile Zola, on the Salon of 1863, in *L'Oeuvre*, 1886, reprinted in *Oeuvres complètes*, Paris, 1967, v, pp 533–4.

18 For example, *Le Temps*, 29 April 1889 and *La Semaine française*, 3 June 1889. Whistler was well aware of French opinion. He arranged to have reviews sent to him and kept them in press-cutting books; these are in GUL pc11/10 and 13.

19 Whistler to G. A. Lucas, [12 December 1867], Baltimore Museum of Art, W–Lucas file; GUW 09195.

20 Whistler to G. A. Lucas, [18 January 1873], Baltimore Museum of Art; GUW 09182.

21 Théodore Duret, *Histoire de J. McNeill Whistler*, Paris, 1904, pp 99–102, 153–4.

22 E. Manet to T. Duret, [22 November 1880], enclosing letter to Whistler, GUL M/257b; GUW 03986. Théodore Duret, 'James Whistler', *Gazette des Beaux Arts*, XXIII, April 1881, pp 365–9, republished in *Critique d'Avant-Garde*, Paris, 1885, pp 247–60, of which Duret sent Whistler an inscribed copy, GUL Whistler. See Margaret F. MacDonald and Joy Newton, 'Correspondence Duret–Whistler', *Gazette des Beaux-Arts*, November 1987, pp 150–64.

23 Metropolitan Museum of Art, New York; YMSM 252.

24 'after her death'; press cuttings in GUL pc6/4–5, 16–17.

25 'This delicate painting, full of subtle effects, in delicate shades of grey, strikes a new and most attractive note.' 26 May 1883; in GUL pc7/4.

26 *Gazette des Beaux-Arts*, 1 July 1883 vol.28, 2 pèriode, pp 10–1, repr. f. p.10.

27 'White, black, some yellows, some reds, and that's all. But what poetry in the interplay of these four tones, where the former dominate with a strange pungency.' 5 May 1883; in GUL pc6/7.

28 'Her thought is with her son ... dreaming that he is doubtless happy in his work and that glory will crown his efforts ... I am reminded of Washington's mother.' 24 May 1883; in GUL pc6/7.

29 A. M. Whistler to Kate Palmer, 3–4 November 1871, LC PWC 34/67–8; GUW 10071.

30 5 June 1883; in GUL pc6/29.

31 GUL pc3/35: from article by Albert Wolff in *Supplément du Figaro: Le Figaro–Salon*, May 1883, 30 April 1883.

32 Whistler to First Secretary of International Art Exhibition, Munich, [3 September 1888], LC PWC 2/12/2; GUW 07979.

33 *Le Figaro*, 10 May 1884.

34 'M. Whistler is one of the most astonishing individuals of modern art. His portraits are the work of an unrivalled practitioner and reveal moreover a strange and profound psychological penetration.' *Le Progrès artistique*, 6 June 1884; in GUL pc6/23.

35 Whistler to H. S. Theobald, 25 April 1888, British Museum Print Room, Alexander album 59-11-14-6; GUW 09668.

36 *L'Art Moderne*, 24 May 1885, said it was hung 'dans les hauteurs inaccessibles aux yeux des mortels' (too high for the eyes of ordinary mortals), GUL pc7/2; see also review in *Le Gaulois*, 30 April 1885.

37 'These curiosities create an elusive figure of distinctive elegance.' *La Réforme*, 13 February 1886; picture in Carnegie Institute, Pittsburgh; YMSM 315.

38 'very pretty little painted studies'; letter to Lucien Pissarro, 14 May 1887, in J. Rewald, *Lettres de Camille Pissarro à son fils Lucien*, Paris, 1950, p.146.

39 'really highly superior, even luminous, which is a strange thing for an artist who does not seek for this effect in his colour', ibid.

40 'M. Whistler is not like anyone else. His art is original and refined, concealing profound thought beneath its elegant dandyism, and is unique to him alone.' *Gil Blas*, 13 March 1887.

41 B. Morisot to C. Monet, [June 1888], in D. Rouart, *The Correspondence of Berthe Morisot*, London, 1957, p.138.

42 Philadelphia Museum of Art; YMSM 242.

43 'the treasure of a museum', *Gil Blas*, 16 May 1891.

44 Tate Britain, YMSM 23; see reviews, *Le Jour*, *Le Paris*, *Le Voltaire*, all 15 May 1891; in GUL pc11/44–5.

45 'one of the most noble female figures that one could meet ... the seascape is exquisite ... I would like to see this landscape in the Luxembourg museum.' *Le Gaulois*, 14 May 1891.

46 C. P. Barbier, *Mallarmé–Whistler Correspondence*, Paris, 1964, p.93.

47 'the remarkable portrait of obscurity', *La Justice*, 1 July 1891; see Newton and MacDonald 1978, p.159.

48 See Joy Newton, *La Chauve-Souris et le Papillon*, University of Glasgow, 1990, p.1; and Edgar Munhall, *Whistler and Montesquiou: The Butterfly and the Bat*, New York and Paris, 1995; YMSM 397–8.

49 '"sixty sittings" it is a lot, but it is not enough!' Whistler to Montesquiou, [August 1892], The Frick Collection, New York, A1847 a, b; GUW 09298.

50 J. McN. Whistler, *Le 'Ten o'clock'*, translated by S. Mallarmé, Paris, 1888.

51 An impression of the etching of Mallarmé, plate mark size 227 x 170 mm; and a cancelled drypoint copperplate size 102 x 67 mm, labelled in Whistler's hand 'Mallarmé Drypoint' are in the Hunterian Art Gallery.

52 Whistler to Deborah Haden, [April 1897], Freer Gallery Archives; copy, GUL H33; GUW 01932.

53 See M. F. MacDonald, 'Palaces in the night: site and symbolism in Whistler's prints', *Whistler Review*, 2003.

54 'Whistler is a sort of symbolist who borrows precise effects from nature, real visions, in order to derive from them harmonies of colour or clashing tones.' *La Patrie*, 7 July 1891; quoted in MacDonald and Newton 1978, p.98.

55 *Olympia*, 1863 (Salon, 1868), Musée d'Orsay; see Cachin and Moffett 1983, cat.no.64. Letter from S. Mallarmé to Whistler, [14 November 1891], GUL

M157; GUW 03823; see Barbier 1964, no.LXVIII, p.117.

56 See E. A. Walton to Whistler, and Glasgow Art Club to Glasgow Museums, 12 January 1891, GUL W10–11; GUW 06013, 06014.

57 'There is no doubt that the idea of getting one of Mr Whistler's paintings into the Luxembourg, and above all the one which you mention, is an excellent idea, and that plenty of people would support it, because the sympathies of both artists and collectors have been with Mr Whistler for a long time.' M. Joyant to D. C. Thomson, 13 October 1891, GUL B79; GUW 00156; see MacDonald and Newton 1978, p.100.

58 Whistler to B. Whistler, [28/29 October 1891], GUL W594; GUW 06601.

59 *Le Gaulois*, 4 November 1891.

60 'The "disciples", who had been to Goupil's, were, when your name was mentioned by me, full of admiration, which O. Wilde echoed: and these were the high-points of this Tuesday.' S. Mallarmé to Whistler, [3 November 1891], GUL M151; GUW 03817; Barbier 1964, no.LXI, p.105.

61 'People keep coming, reporters as well.' M. Joyant to Whistler, 18 November 1891, GUL B157; GUW 00380.

62 'The figures on these canvasses have an intense life, their character and manner grab one's attention. His mother and Carlyle were painted in profile, seated on a chair, in a pose at once severe and relaxed.' T. Duret, *Whistler et son oeuvre*, Paris, 1888, p.7, repr. facing p.6.

63 Whistler to S. Mallarmé, [10 November 1891], GUL M154; GUW 03820. Barbier 1964, no.LXV, p.111.

64 S. Mallarmé to Whistler, [11 November 1891], GUL M155; GUW 03821; Barbier 1964, no.LXVI, pp 112–13.

65 M. Joyant to Whistler, 18 November 1891, GUL B157; GUW 00380.

66 'It is largely due to Clemenceau that things have been speeded up.' S. Mallarmé to Whistler, [27 November 1891], GUL M163; GUW 03829; Barbier 1964, no.LXXII, pp 123–4.

67 'We are all happy to see the excellent turn that affairs have taken.' T. Duret to Whistler, 18 November 1891, GUL D194; GUW 00988.

68 'the one work of yours that both critics and public have quite rightly noticed', L. Bourgeois to Whistler, 19 November 1891, GUL M160; GUW 01494.

69 23 November 1891, GUL F427; GUW 01495; Duret 1904, pp 154–5.

70 'tonight the Minister will sign the order to buy for 4000 francs Portrait de ma mère for the Musée du Luxembourg.' Duret to Whistler, and Marx to Duret, 27 November 1891, GUL D195, M296; GUW 00989, 04025; see MacDonald and Newton 1978, p.106.

71 'Yes, it is going to the Louvre, that goes without saying, the Luxembourg is just the antechamber.' S. Mallarmé to Whistler, [27 November 1891], [30 November 1891]; GUL M163; GUW 03829, 13464; Barbier 1964, nos LXXVI, LXXVIII, pp 128–9, 131–2.

72 *Le Figaro*, 27 November 1891.

73 S. Mallarmé to Whistler, [30 November 1891], op.cit.

74 *Le Gaulois*, 30 November 1891.

75 M. Whistler ... with infinite graciousness and disinterestedness has sold – you could say offered – his painting to the State. Everyone must rejoice at this happy solution.' *La Justice*, 30 November 1891.

76 Arsène Alexandre, *Le Paris*, 28 November 1891.

77 'The State ... finally gave Whistler a sign of approval, once his subtlety and astonishing distinction had been sung in all possible keys.' ibid.

78 'It has all turned out very well, has it not?' 4 December 1891, GUL B158; GUW 00381.

79 'I am very well aware of all the good will, energy and tact, that you have

exercised on my behalf, in this affair, and of the extent to which your great artistic appreciation facilitated a speedy result.' [5/12 December 1891?], LC PWC 3/21/3; GUW 07841.

80 Whistler to B. Whistler, [19 January 1892], GUL W600; GUW 06607.

81 R. de Montesquiou, *Les Pas effacés*, Paris, 1923, 11, p.258. *Moth* was dedicated to Beatrice Whistler and published in R. de Montesquiou, *Les Chauves-souris*, Paris, 1892. 'And even greater than these is the *Mother*; It is the greatest of all and it is my pleasure to evoke it here to pay to it the homage due to the immortals.' (a free translation, not in verse!)

82 'amounts to an artistic victory and will serve to effectively establish his reputation among the Americans and the English'. Duret 1904, p.154.

83 C. L. Freer to B. Whistler, [29 February 1892], GUL F435; GUW 01503; Linda Merrill, *With Kindest Regards: The Correspondence of C. L. Freer and J. McN. Whistler*, Washington, 1995, no.10, pp 81–2.

84 1 December 1891, GUL B18; GUW 00244.

85 T. R. Way, *Memories of James McNeill Whistler*, London and New York, 1912, p.85. Chelsea Arts Club held a dinner to celebrate the honour: cf. letter from T. S. Lee to Whistler, 9 December 1891, GUL C99; GUW 00598.

86 *Gil Blas*, 2 February 1892.

87 Whistler to B. Whistler, [1 February 1892], GUL W604; GUW 06610.

88 ibid.

89 'Fantin approached and said to him, as he touched the red ribbon freshly stuck in the button-hole of the illustrious author of the "Gentle Art": "It is for this that you have sold your mother!"' Fonds Montesquiou, Bibliothèque Nationale, Paris; see MacDonald and Newton 1978, p.113.

90 Whistler to B. Whistler, [2 November 1891], GUL W595; GUW 06602.

91 15 March 1892, GUL T50; GUW 05705.

92 See D. C. Thomson to Whistler, 4 March 1892, GUL T40; GUW 05695; and, regarding possible sale of *Arrangement in Black and Brown: The Fur Jacket*, Worcester Art Museum; YMSM 181.

93 'Mr Whistler, initially misunderstood, is recognised today as an English master, and yet it fell to France, supreme arbiter in artistic matters, to establish a glorious reputation for the painter. But Mr Whistler is not English, he is American, or rather French; the English want him back at the moment, quite justifiably. But notwithstanding he remains French. The cross of *Officier de la Légion d'honneur* that he wears ostentatiously shows his sentiments, and it pleased me to witness the pride and the joy that he showed on receiving this great and well-earned honour', *Le Moniteur des Arts*, 1 April 1892.

94 Whistler to D. C. Thomson, [11 May 1892], LC PWC; GUW 08204.

95 14 December 1894, GUL W1232; GUW 07244; see MacDonald and Newton 1978, p.117.

96 29 July 1899, Freer Gallery Archives; GUW 03196. See also Whistler to J. C. Bancroft, [28 June 1892], GUL B272; GUW 00489.

4 Pleasant dreams: Whistler's *Mother* on tour in America, 1932–4

1 See A. C. Goodyear, *The Museum of Modern Art: The First Ten Years*, New York, 1943, p.16.

2 For MoMA's accounts in 1932, see ibid, appendix G; and 'Estimated Income and Expenses, April 1–October 1, 1932' by Alan J. Blackburn, MoMA's Executive Secretary, sent to Abby Rockefeller, 14 March 1932, in The Museum of Modern Art Archives, NY: Alfred H. Barr, Jr Papers [AAA: 2164; 147–9]; hereafter cited as MoMA Archives, NY: AHB (available on microfilm from the Archives of American Art, Smithsonian Institution).

3 See A. H. Barr to A. C. Goodyear, 7 June 1932, MoMA Archives, NY: AHB [AAA: 2164; 123–5].

4 See Goodyear 1943, p.33 and Alice Goldfarb Marquis, *Alfred H. Barr, Jr.: Missionary for the Modern*, Chicago, 1989, p.116.

5 See A. H. Barr to Abby Rockefeller, 8 April 1932, MoMA Archives, NY: AHB [AAA: 2164; 139].

6 *Murals by American Painters and Photographers*, Museum of Modern Art, New York, May 1932. See A. H. Barr to A. C. Goodyear, 18 April 1932, Goodyear to Barr, 20 April 1932, and Barr to Goodyear, 29 April 1932, MoMA Archives, NY: AHB [AAA: 2164; 710, 708 and 707].

7 See Marquis 1989, p.104.

8 See A. C. Goodyear to A. H. Barr, 22 July 1932, and Barr to Abby Rockefeller, 28 June 1932, MoMA Archives, NY: AHB [AAA: 2164; 698 and 116].

9 See Brentano's to A. H. Barr, 17 September 1932, MoMA Archives, NY: AHB [AAA: 2164; 638]. See H. Addington Bruce, *Sleep and Sleeplessness*, 1915.

10 See Margaret S. Barr, 'Our campaigns', *The New Criterion*, special issue, 1987, pp 29–30; Edward A. Jewell, 'Art in review: Museum of Modern Art plans', *The New York Times*, 17 September 1932, p.9. See Barr's 'Memorandum on the exhibition of American Art ... December, 1930 ...', 21 October 1930, MoMA Archives, NY: AHB [AAA: 2164; 469–70].

11 *International Exhibition of Painting*, 6–26 February 1933, New York. See 'Hors d'Europe', *Beaux-Arts*, no.7, 17 February 1933, p.6; and Eustache de Lorey, 'Deux grands amis de l'Art français', *Beaux Arts*, no.26, 30 June 1933, p.1.

12 Charles A. Beard, *American Foreign Policy in the Making, 1932–1940: A Study in Responsibilities*, New Haven, 1946, pp 67–116 and Melvyn P. Leffler, *The Elusive Quest: America's Pursuit of European Stability and French Security, 1919–1933*, Chapel Hill, 1983, pp 273–300. See also 'Les Etats-Unis: New York', *Le Bulletin de l'art ancien et moderne*, December 1932, no.792, p.408.

13 *The New York Times*, 13 October 1932, p.23.

14 Holger Cahill to A. H. Barr, 19 October 1932, MoMA Archives, NY: AHB [AAA: 2164; 642].

15 H. I. Brock, in *The New York Times*, Sunday Magazine, 23 October 1932.

16 The article appeared in some sixty-nine small-town papers, for example, *The Monterey* [Virginia] *Recorder*, *The Spencerville* [Ohio] *Journal News*, *The Westfield* [New Jersey] *Standard*, *The Diver* [Delaware] *Index*, *The Milan* [Illinois] *Independent*, *The Springdale* [Arkansas] *News*, 27 October 1932. Luce's Press Clipping Bureau in New York collected clippings for MoMA. See The Museum of Modern Art Archives, NY: Public Information Scrapbooks [3; 687] (hereafter referred to MoMA Archives, NY: PI). I am grateful to Michelle Elligott, Archivist at the Museum of Modern Art, and to her predecessor, Rhona Roob, for assistance in studying these records.

17 See 'Whistler's "Mother" on view this week', *The New York Times*, p.20. Elizabeth R. Pennell was guest of honour: see Donna Risher, 'Pennell's widow looks like Whistler's "Mother" ...', *New York World Telegram*, 31 October 1932.

18 Edward A. Jewell, 'Art in review', *The New York Times*, 1 November 1932, p.26.

19 See Royal Cortissoz, 'Whistler and his confreres at the Museum of Modern Art', *The New York Herald-Tribune*, 6 November 1932, p.10; Malcolm Vaughn, 'Excellent show of American art since 1862 on view', *The New*

York American, 5 November 1932; Henry McBride, 'Whistler's "Mother" proves the great attraction ...', *The New York Sun*, 5 November 1932; Marguerite Breunning, 'Last seventy years of American art surveyed', *The New York Post*, 5 November 1932, p.8; also 'Age and youth', *The Art Digest*, VII, no.4, 15 November 1932, p.9.

20 See 'Modern museum opens fine show of American art', *The Art News*, XXXI, no.6, 5 November 1932, pp 3–4; 'Review of seventy years of American art opens at modern museum', *The Art Digest*, VII, no.3, 1 November 1932, p.5; Elizabeth Stuyvesant, 'Around the galleries', *Creative Art*, XI, no.4, December 1932, pp 309–10; L. Kalonyme, 'Arts in New York ...', *Art and Decoration*, no.38, January 1933, pp 52–3; Margaretta Salinger, 'Americans in two exhibitions', *Parnassus*, IV, no.6, November 1932, pp 5–6. See also 'Whistler's "Mother" revisits home', *Literary Digest*, 12 November 1932, pp 13–14; 'Art', *Time Magazine*, 14 November 1932; 'The art galleries', *The New Yorker*, 12 November 1932.

21 See Holger Cahill to A. H. Barr, MoMA Archives, NY: AHB [AAA: 2164; 641]; and A. C. Goodyear to A. H. Barr, 1 November 1932, MoMA Archives, NY: AHB [AAA: 2164; 695].

22 See A. H. Barr to A. C. Goodyear, 21 November and 1 December 1932, MoMA Archives, NY: AHB [AAA: 2164; 685–90 and 679–80]; and A. H. Barr to Alice Malette, 28 December 1932, MoMA Archives, NY: AHB [AAA: 2164; 613, 637].

23 See '50,000 visitors', *The Art Digest*, VII, no.6, 15 December 1932, p.8. See also Leffler 1983, pp 305–13.

24 See C. J. Bulliet, 'Noted Whistler painting to be shown at Fair', *The Chicago Daily News*, 29 December 1932; 'Whistler's "Mother" to tour country', *The New York Times*, 22 January 1933.

25 See M. Barr 1987, pp 30–4 and Marquis 1989, pp 105–10; also A. H. Barr, Jr, 'Art in the Third Reich – Preview, 1933', *Magazine of Art*, October 1945, pp 212–22.

26 *Bulletin of the Museum of Modern Art*, June 1933, p.2.

27 '"Mother" to Leave', *The Art Digest*, VIII, no.14, 15 April 1934, p.12; 'Louvre extends loan period for Whistler's Mother', *The Art News*, XXXI, no.22, 25 February 1933, p.11.

28 'Museum to show art masterpiece', *The Los Angeles Times*, 11 February 1933, p.2.

29 See The Museum of Modern Art Archives, NY: Department of Circulating Exhibitions Records II.1/93(1), Album 1 (hereafter referred to as MoMA Archives, NY: CE).

30 See Alexander Fried, 'Throngs see Whistler art', *San Francisco Chronicle*, 13 February 1933, p.16.

31 See 'San Francisco pays attention', *San Francisco Chronicle*, 24 February 1933.

32 See 'Whistler's "Mother" in Los Angeles', *The Art Digest*, VII, no.13, 1 April 1933, p.14.

33 See Alexander Fried, 'Looking About', *San Francisco Chronicle*, 22 February 1932; James O'D. Bennett, '"Mother" turns public fancy to Whistler's art, what's it worth?' *Chicago Daily Tribune*, 20 June 1933.

34 'World famed Whistler on exhibit', *San Francisco Chronicle*, 12 February 1933.

35 The Pennsylvania Academy of the Fine Arts and Metropolitan Museum of Art were both said to have been offered the painting in 1881, but that information is now in dispute. My thanks to Sylvia Yount at the High Museum of Art in Atlanta. See *Chicago Daily Times*, 30 May 1933.

36 *The Toledo Times*, 15 February 1934, p.1; and *The Boston Post*, 24 April 1934.

37 ibid and see also, 'Whistler painting on final view here', *The New York Times*, 16 May 1934.

38 See 'Whistler's "Mother" in Los Angeles', *The Art Digest*, VII, no.13, 1 April 1933, p.14.

39 Angeleno Cholly, 'Cholly's Note Book', *The Los Angeles Examiner*, 23 March 1933; see also 'France's generous act', *The Los Angeles Times*, 2 May 1933, p.4.

40 'Whistler's "Mother" at Museum', *The Los Angeles Times*, 19 March 1933, p.14; and MoMA Archives, NY: CE, II.1/93(1), Album 1.

41 A. H. Barr to I. T. Frary, Publicity Secretary, Cleveland Museum of Art, 28 October 1933, MoMA Archives, NY: CE, II.1/93(1).

42 29 May 1933, MoMA Archives, NY: CE, II.1/93(11), Album 1.

43 Barr's notes for radio series, see A. H. Barr to Edward M. M. Warburg, 5 July 1933, MoMA Archives, NY: AHB [AAA: 2164; 1230, 1234].

44 See A. H. Barr, Jr, *What is Modern Painting?*, Museum of Modern Art, New York, 1943, p.8; also Jonathan Weinberg, *Ambition and Love in Modern American Art*, New Haven and London, 2001, pp 4–5.

45 See Redfern Mason, 'Legion Palace puts Whistler on view today', *The San Francisco Examiner*, 12 February 1933; 'San Francisco Chronicle: Rotogravure Pictorial Section', and Alexander Fried, 'Throngs see Whistler art', *The San Francisco Chronicle*, 12 February 1933, p.7 and 13 February 1933, p.16; also John O'Brian, 'MoMA's public relations, Alfred Barr's public, and Matisse's American canonization', *Canadian Art Review*, XVIII, nos 1–2, 1991, pp 18–30.

46 See, for example, 'Louvre prize for World's Fair', *Corning* [New York] *Leader*, 23 March 1933; *Noblesville* [Indiana] *Ledger*, 9 March 1933; *Hot Springs* [S. Dakota] *Evening Star*, 18 March 1933; *Sparks* [Nevada] *Tribune*, 20 March 1933. MoMA Archives, NY: PI [3; 30–6, 41–4].

47 See 'Whistler skit to be first in radio series', *The Chicago Herald and Examiner*, 27 May 1933, p.15; *The Chicago Herald and Examiner*, 20 September 1933; also D.D., 'Sauce for the goose', *The Chicago Daily Tribune*, 6 August 1933, part 8, p.1 and 1 October 1933, part 8, p.1; June Provines, 'Front views and profiles', *The Chicago Daily Tribune*, 22 August 1933, p.13.

48 See A. H. Barr to I. T. Frary, 28 October 1933, MoMA Archives, NY: CE, II.1/93(1).

49 *The Chicago Times*, 30 May 1933.

50 For example, 'Savage dogs guard fair art treasures', *The Berkeley* [California] *Gazette*, 9 June 1933; *The Chicago News and Post*, 8 June 1933; *The Syracuse* [New York] *Herald*, 9 June 1933; *The Dayton* [Ohio] *Herald*, 9 June 1933.

51 For example, 'They tested burglar alarms when this famed masterpiece was exhibited!' *The Morgantown* [West Virginia] *Post*, 18 February 1933; *The Schenectady* [New York] *Union Star*, 16 February 1933; *The North Adams* [Massachusetts] *Transcript*, 16 February 1933; *The New Haven* [Connecticut] *Register*, 21 February 1933; *The Erie* [Pennsylvania] *Dispatch Herald*, 17 February 1933.

52 Inaugural address, 4 March 1933, *The Presidents Speak*, Davis N. Lott (ed.), New York, Chicago and San Francisco, 1961, p.231. See Otis L. Graham, Jr and Meghan R. Wander (ed.), *Franklin D. Roosevelt, His Life and Times: An Encyclopedic View*, Boston, 1985, p.287.

53 Robert Bordner, 'Police squads guard painting; ... at Museum of Art', *The Cleveland Press*, 2 November 1933, p.11.

54 ibid.

55 MoMA Archives, NY: CE, II.1/93(1), Album 1. See 'Kansas City's

magnificent new museum to open in December', *The Art Digest*, VIII, no.2, 15 October 1933, p.1.

56 'Whistler canvas safe in Baltimore', *The Baltimore Sun*, 8 January 1934.

57 Roland J. McKinney to Alan Blackburn, Jr, 4 March 1933 and 27 October 1933 in MoMA Archives, NY: CE, II.1/93(1).

58 Roland J. McKinney to Alan Blackburn, Jr, 10 January 1934, MoMA Archives, NY: CE, II.1/93(1).

59 A. H. Barr to Roland J. McKinney, 25 January 1934, MoMA Archives, NY: CE, II.1/93(1).

60 Roland J. McKinney to Alan Blackburn, Jr, 11 and 18 January 1934, and Blackburn to McKinney, 13 January 1934, MoMA Archives, NY: CE, II.1/93(1).

61 Roland J. McKinney to Alan Blackburn, Jr, 8 February 1934; and 'Form Letter #5', condition report drafted by Blackburn in MoMA Archives, NY: CE, II.1/93(1) and Album 1.

62 'Popularity of display is cause', *The Baltimore Sun*, 14 January 1934; and R. J. McKinney to Alan Blackburn, Jr, 16 February 1934, MoMA Archives, NY: CE, II.1/93(1).

63 *The Toledo Times*, 15 February 1934.

64 'Hundreds view arrival of Whistler's Mother', *The Toledo Times*, 15 February 1934; 'Unveil Whistler portrait', *The Toledo Blade*, 15 February 1934; 'Whistler's painting on view here', *The Toledo News Bee*, 15 February 1934.

65 *The Toledo Times*, 15 February 1934.

66 MoMA Archives, NY: CE, II.1/93(1), Album 1.

67 'Whistler art treasure here', *The Toledo Blade*, 15 February 1934.

68 See 'Whistler's Mother, famous painting valued at million, arrives in Dayton ...', *The Dayton Herald*, 16 March 1934.

69 *The Dayton Journal*, 17 March 1934.

70 See 'Whistler's Mother portrait will be motif of new stamp', *The Washington Star*, 6 March 1934.

71 See 'Mother's Day stamp to be issued May 2', *Literary Digest*, CXVII, no.12, 24 March 1934, p.12; 'Masterpiece of the mails', *The New York American*, 11 March 1934.

72 *The Boston Evening Globe*, 23 April 1934 and *The Boston American*, 23 April 1934.

73 Alice Lawton, in *The Boston Post*, 24 April 1934.

74 'Strong guard for $1,000,000 picture', *The Boston Globe*, 23 April 1934, pp 1 and 7.

75 M. Barr 1987, p.38.

76 'Museum protests "Whistler" stamp', *The New York Times*, 10 May 1934, p.19.

77 ibid.

78 New York Arts organisations previously hostile to MoMA joined the museum's critique; see 'Towards a more fitting commemoration of Mother's Day, a pertinent suggestion to the Federal Government', *The Art Digest*, VIII, no.16, 15 May 1934, p.31.

79 See 'Programs scheduled for broadcast this week', *The New York Times*, 13 May 1934. The opening was broadcast at 4.30 pm. See Marquis 1989, p.112.

80 'Whistler painting on final view here', *The New York Times*, 16 May 1934, p.21.

81 ibid.

82 MoMA Archives, NY: CE, II.1/93(1), Album 1.

83 See Goodyear 1943, appendices E and G.

84 See 'Bliss art collection now the property of modern museum', *The Art News*, XXXIV, no.24, 17 March 1934, pp 5–6; and 'Bliss gift stands', *The Art Digest*, VIII, no.13, 1 April 1934, p.20; also A. H. Barr, Jr to A. H. Barr, Sr, 24 March 1931, MoMA Archives, NY: AHB; *The Lillie P. Bliss Collection, 1934*, edited by A. H. Barr, Jr, New York: Museum of Modern Art, 1934.

85 See Marquis 1989, pp 272–4. See also A. H. Barr to Dwight Macdonald, 2 December 1953, MoMA Archives, NY: AHB [AAA: 2180, 730–1 and 783]. For the published article, see Dwight Macdonald, 'Action on 53rd Street I', *The New Yorker*, 12 December 1953, pp 49–76.

5 A chance meeting of Whistler and Freud? Artists and their mothers in modern times

1 The thought of making a full-length study of the theme of artists' depictions of their mothers has been pursuing me for some time. I am most grateful to Margaret MacDonald for encouraging me to produce this essay, which may become the prelude to the fulfilment of a larger project, or its epitaph. I would also like to express my thanks to both Tag Gronberg and Laura Morowitz for having read through an earlier draft of the text and made many helpful suggestions.

2 Phillip Roth, *Portnoy's Complaint*, New York, 1969, p.5.

3 While I was completing this essay I became aware of the treatment of the theme by Jonathan Weinberg in *Ambition and Love in Modern American Painting*, Yale University Press, 2001. In his brilliant and stimulating first chapter, entitled 'Origins: the artist's mother' (pp 3–28), Weinberg covers some of the areas explored in this article, though largely with different issues in mind.

4 See J. McN. Whistler, 'The Red Rag', letter to *The World*, 22 May 1878, reprinted in *The Gentle Art of Making Enemies*, London, 1890, pp 126–8. Cited in Ronald Anderson and Anne Koval, *James McNeill Whistler: Beyond the Myth*, London, 1994, p.485, n.10.

5 *Fortnightly Review*, June 1888, reprinted in Whistler 1890, pp 250–8 at p.252. See Anderson and Koval 1994, p.180.

6 See Geneviève Lacambre's entry in R. Dorment and M. F. MacDonald, *James McNeill Whistler*, exh.cat., Tate Gallery, London, Musée d'Orsay, Paris and National Gallery of Art, Washington, 1994–5, cat.no.60.

7 Edouard Manet, *Olympia*, 1865, Musée d'Orsay, Paris; Pablo Picasso, *les Desmoiselles d'Avignon*, 1907, Museum of Modern Art, New York; Walter Sickert, *The Camden Town Murder*, c.1908, Yale Center for British Art, New Haven; Willem de Kooning, *Woman, I*, 1950–2, Museum of Modern Art, New York.

8 See, for example, Christine Battersby, *Gender and Genius; Towards a Feminist Aesthetics*, The Woman's Press, London, 1989; especially Chapter 4, 'The male gift', pp 35–42.

9 See, for example, Donald Kuspit, 'Representing the mother: representing the unrepresentable?' in Barbara Coller, *The Artist's Mother: Portraits and Homages*, Herscher Museum, Huntingdon, NY, 1987, p.25. In 'Origins: the artist's mother' (Weinberg 2001), Weinberg is more guarded in his criticisms. However he does feel there are unresolved conflicts in Whistler's depiction of his mother that lead to aesthetic problems.

10 The full text is published in English in *The Standard Edition of the Complete Psychological Works of Sigmund Freud* (translated and edited by James Strachey in collaboration with Anna Freud), IV, London, 1964; see especially pp 107–35. See also Peter Gay, *Freud: A Life for Our Time*,

London, 1988, pp 270–7.

11 Weinberg 2001.

12 H. Segal, 'A psycho-analytic approach to aesthetics', in *New Directions in Psycho-Analysis*, ed. Melanie Klein, Paula Heinman and R. E. Money-Kyrle, New York, 1955, pp 404–5.

13 Nicola Glover, *Psychoanalytic Aesthetics: The British School*, Chapter 3, 'The development of Kleinian aesthetics: 1 The aesthetics of Hannah Segal'; online reference http://human-nature.com/free-associations/glover.

14 Bruce Fink, *The Lacanian Subject: Between Language and Jouissance*, Princeton University Press, 1995, pp 54–60.

15 See especially Kristeva's essays 'Stabat mater', 'Women's time' and 'Freud and love: treatment and its discontents'; republished in Toril Moi (ed.), *The Kristeva Reader*, Oxford, 1986, pp 160–86, 187–213, 238–71.

16 Friedrich Winckler, *Albrecht Dürer: Leben und werk*, Berlin, 1957, p.266; Moi 1986.

17 See in particular Stephen J. Greenblatt, *Renaissance Self-Fashioning: From More to Shakespeare*, Chicago University Press, 1980.

18 Joseph Leo Koerner, *The Moment of Self-Portraiture in German Renaissance Art*, Chicago University Press, 1993.

19 Albert Dürer, *Self-Portrait as Christ*, 1500, Munich, Alte Pinakothek.

20 In the inventory of the estate of the Amsterdam print-seller Clement de Jonge. See L. Munz, *Rembrandt's Etchings*, II, London, 1952, pp 210–11.

21 Christopher White, *Rembrandt*, London, 1984, p.11.

22 Weinberg 2001, p.23.

23 For a discussion of this issue see Margaret R. Miles, 'The Virgin's one bare breast', in Norma Broude and Mary D. Garrard (eds), *The Expanding Discourse: Feminism and Art History*, New York, 1992, pp 27–38.

24 Marina Warner, *Alone of All her Sex; The Myth and Cult of the Virgin Mary*, London, 1976. Julia Kristeva, 'Stabat mater', in Moi 1986, pp 160–86.

25 In *The Renaissance*, 1873. Reference here is to the World's Classics Edition, Oxford University Press (ed. Adam Phillips), 1986, p.73.

26 Gay 1988, p.273.

27 Most historians nowadays do not accept Freud's reading, though the idea of the Mona Lisa as an 'earth mother' has persisted. For a reading of the Mona Lisa as *natura creatrix* see Mary D. Garrard 'Leonardo da Vinci: female portraits, female nature', in Broude and Garrard 1992, pp 59–85, especially pp 69–72. As Garrard points out, Freud's reading of the Mona Lisa is still essentially accepted by Kristeva in 'Motherhood according to Bellini', in *Desire and Language: A Semiotic Approach to Literature and Art*, New York, 1980, pp 237–70.

28 Belinda Thomson, *Vuillard*, Oxford, 1988, p.10.

29 Vuillard's portraits of his mother are studied in depth in Elizabeth Easton, *The Intimate Interior of Edouard Vuillard*, Museum of Fine Art, Houston, with Smithsonian Institute Press, 1989. They are also explored in the following publications by Susan Sidlauskas; 'Psyche and sympathy: staging interiority in the early modern home', in Christopher Reed (ed.), *Not at Home: The Suppression of Domesticity in Modern Art and Architecture*, London, 1996, pp 65–75, see particularly pp 71–4; 'Contesting femininity: Vuillard's family picture', in *Art Bulletin*, LXXVIII, no.1, March 1997, pp 85–111, and *Body, Place and Self in Nineteenth-Century Painting*, Cambridge University Press, 2000, Chapter 4: 'The "Surface of Existence" – Edouard Vuillard's *Mother and Sister of the Artist*'.

30 Gloria Groom, *Edouard Vuillard, Painter–Decorator*, Yale University Press, 1993, p.37.

31 For a discussion of Vuillard's theatre work in relation to this theme see in particular G. Mauner, 'Vuillard's mother and sister paintings and the Symbolist theatre', in *Artscanada*, XXVIII, 1971–2, pp 124–6.

32 Sidlauskas 1996 (see note 29 above).

33 The relation of Hammershøi to Whistler and the affinities between his interiors and those of the Vuillard and other Nabi painters are explored by Alette Scales in her unpublished PhD thesis, *Vilhelm Hammershøi (1864–1916) and Fin-de-siècle Copenhagen: Visualising Interiority and Imaging the Feminine*, Birkbeck College, University of London, 2002. I am most grateful to Alette Scales for permission to refer to her work here.

34 Umberto Boccioni, *Materia*, 1912, oil on canvas, 225 x 150 cm, Gianni Mattioli Collection, Peggy Guggenheim Museum, Venice. Boccioni made many studies of his mother between 1906 and 1912. During this period she was strongly supportive of his career. See Guido Ballo, *Boccioni, la vita e l'opera*, Milan, 1982, p.224.

35 Mark Gertler, *The Artist's Mother*, exh. 1911, oil on canvas, 66 x 55.9 cm, Tate Gallery, London.

36 Ashile Gorky, *Ashile Gorky and his Mother*, oil, painted and reworked 1926–42, National Gallery of Art, Washington.

37 René Magritte, *L'histoire centrale*, 1928, oil on canvas, 116 x 81 cm, private collection, Brussels. See S. Gablik, *Magritte*, London, 1970. p.61.

38 Pablo Picasso, *Portrait of the Artist's Mother*, pastel, 1896, Museo Picasso, Barcelona.

39 Mary Mathews Gedo, *Picasso: Art as Autobiography*, University of Chicago Press, 1980, pp 19–21.

40 He did, however, paint a posthumous portrait of her, two years after her death. Described by one observer as 'a haunting memory, at once closed and distant' it has also been considered 'strikingly like Andy as an old woman'. Victor Bockris, *Warhol*, Harmondsworth, 1989, p.442.

41 In 'Women's Time', Moi 1986, pp 187–213, especially pp 204–5.

42 Sofonisba Anguisciola, *Portrait of the Artist's Mother, Bianca Ponzoni Anguisciola*, 1557, Staatliche Museen, Berlin.

43 Rolinda Sharples, *The Painter and her Mother*, c.1820, oil on panel, City Art Gallery, Bristol. See Kathryn Metz, 'Ellen and Rolinda Sharples: mother and daughter painters', *Woman's Art Journal*, XVI, no.1, Spring 1995, pp 3–11.

44 Berthe Morisot, *The Artist's Mother and Sister*, 1869–70, Washington, National Gallery of Art. See Kathleen Adler and Tamar Garb, *Berthe Morisot*, Oxford, 1987, p.32.

45 Griselda Pollock, *Mary Cassatt*, London, 1998, pp 134–7.

46 Virginia Woolf, *A Room of One's Own*, London, 1928 (Penguin edn, 1973, p.76).

47 Maurice Beck and Helen Macgregor, Photograph of *Virginia Woolf in her Mother's Dress*, published in *Vogue*, May 1926; reproduced in Lisa Tickner, 'Meditating generation: the mother–daughter plot', *Art History*, XXV, no.1, February 2002, pl.8.

48 For a discussion of these see ibid, pp 23–46.

49 Frida Kahlo, *My Birth*, oil, 1932, private collection. See P. Darbyshire, 'Understanding the life of illness: learning through the art of Frida Kahlo', *Advances in Nursing Science*, XVII, no.1, September 1994, pp 51–9.

50 The status of this picture as the icon of modern female experience has been enhanced in recent years since it has been acquired by the pop star Madonna. Apparently she uses this picture to 'test' her guests. If they cannot stand it, then they are not for her. BBC News, Entertainment/Arts, 9 December 2001, Tate Press release online.

51 Moi 1986, pp 160–86.

52 'A new type of intellectual: the dissident' (1977) in Moi 1986, pp 297–8.

53 Mary Kelly, *Post-Partum Document*, foreword by Lucy R. Lippard, University of California Press, 1999.

54 The impact of Trilling's *Anxiety of Influence* is discussed in Tickner 2002, pp 26–8.

55 Sarah Kent, 'Tracey Emin: Flying High', in *Tracey Emin*, London, 1997, p.34. Kent also quotes from Emin's book *Exploration of the Soul*, London, 1994, where the artist says of her mother: 'She told us she loved us – that she would do anything for us – strange to think that we were an accident – strange to think – she'd booked into a clinic – to have us aborted ...'

56 *Sensation: Young British Artists from the Saatchi Collection*, exh.cat., Royal Academy, London, 1997, p.203.

6 **The face that launched a thousand images: Whistler's *Mother* and popular culture**

1 I am grateful to the following for their help in tracking down the many images and references cited in this chapter: Dean Brown, David Park Curry, Meghan Doherty, Mark Samuels Lasner, Tim Lennon, Michael Lukasiewicz, Margaret F. MacDonald, Mark Pascale, Shannon Perich, Kevin Sharp, Whitney Winslow, Nigel Thorp and the Centre for Whistler Studies.

2 In fact, it is not unusual for these two iconic works to be referenced together in popular culture. See for example, Wiley Miller's comic strip *Non Sequitur* (entitled 'Hollywood Gothic', 26 March 1998) in which the *American Gothic* couple is seen posing for Grant Wood in his studio. The female figure begins to break her pose as she explains, 'I'm sorry Mr Wood, but there's a limo waiting outside to take me to my gig at Whistler's studio.'

3 Walter Cahn, *Masterpieces: Chapters on the History of an Idea*, Princeton, 1979, p.xv.

4 ibid, p.xvi.

5 ibid.

6 For a summary of the early criticism of Whistler's *Arrangement in Grey and Black: Portrait of the Painter's Mother* both in England and France, see Catherine Carter Goebel, 'Whistler and his critics: out of their own mouths shall ye judge them', *Whistler Review*, II, 2003 (forthcoming).

7 'Exhibition of the Royal Academy', *The Illustrated London News*, 8 June 1872, pp 550–1; quoted in Goebel 2003.

8 'The Royal Academy', *Pall Mall Gazette*, 3 May 1872, p.11; quoted in Goebel 2003.

9 'Pictures of the Royal Academy', *Pall Mall Gazette*, 14 June 1872, p.12; quoted in Goebel 2003.

10 'Celebrities at Home. no.XCII: Mr James Whistler at Cheyne-Walk', *The World*, 22 May 1878, pp 4–5; quoted in Goebel 2003.

11 'Your "venerated mother", seated in profile, monsieur, is a work full of feeling, coming from the heart of a respectful son who understands that the best thing we have in this life is our mother.' Unidentified press cutting, labelled 'May 1883?' GUL pc6/20; quoted in Goebel 2003.

12 'the mother of the painter ... is reflecting perhaps on the future successes of her son.' Anon, 'Portrait et paysages', *Le Progres artistique*, GUL pc6/29; quoted in Goebel 2003.

13 'she is thinking about her son ... and that his efforts will be crowned with glory ... How much you must really love your old mother since you have made me love her and I do not even know her.' *Nancy Artiste*, 24 May

1883, GUL pc6/7; quoted in Goebel 2003.

14 Following the Paris Salon, the picture was shown in Dublin (1884), Munich (1888), London (1889), Amsterdam (1889), Glasgow (1889), London (1891), and Paris (1891); for a complete exhibition history of the picture see YMSM 101.

15 Algernon Swinburne, 'Mr Whistler's Lecture on Art', *The Fortnightly Review*, XLIII, No.258 (n.s.), pp 745–51; reprinted in J. McN. Whistler, *The Gentle Art of Making Enemies*, 1890, pp 250–8; quoted in Robin Spencer, *Whistler: A Retrospective*, London, 1989, pp 252–4.

16 For a full account of the painting's history during the artist's lifetime and the circumstances surrounding the sale to the French government, see YMSM 101; see also Chapter 3 above.

17 See Geneviève Lacambre's entry in Richard Dorment and M. F. MacDonald, *James McNeill Whistler*, Tate Gallery, London; Musée d'Orsay, Paris; National Gallery, Washington, 1994–5, cat.no.60. For example, Lacambre quotes the Symbolist poet Rodenbach's use of the term.

18 For a discussion of the role of reproductive prints in Whistler's marketing strategy, see Martha Tedeschi, 'Whistler and the English print market', *Print Quarterly*, XIV, no.1, March 1997, pp 15–41.

19 Birmingham Museum and Art Gallery, 41'06.

20 I am grateful to David Park Curry for sharing information, as well as photographs, of two interesting examples from his own collection, one a hand-painted lithograph, the other created in marquetry by Frederick Kemp.

21 Aubrey Beardsley to G. F. Scotson-Clark, 9 August 1891; Beardsley refers to his caricature as 'a vile libel', and signed the drawing with an imitation of Whistler's butterfly monogram. The letter is in the collection of Mark Samuels Lasner, to whom I am grateful for providing photographs of the letter and permission to reproduce it here. See also Henry Maas(ed.), *The Letters of Aubrey Beardsley*, London, 1971, p.25.

22 Millais' painting is in the Musée d'Orsay; see Peter Funnell and Malcolm Warner, *Millais: Portraits*, London, 1999, cat.no.50, p.204; see also John Baur, 'A painter of painters: Stacy Tolman', *The American Art Journal*, XI, no.1, January 1979, p.44, fig.7.

23 See S. Hartmann, *The Valiant Knights of Daguerre*, ed. Harry W. Lawton and George Knox, Berkeley and London, 1978, p.13.

24 Emilia F. S. Pattison, writing 15 May 1872, quoted in Spencer 1989, p.103; the French review appeared in *Le Consitutionnel*, GUL pc2; quoted in Goebel 2003.

25 'Being photographed', *The Photographic Times*, I, no.2, February 1871, pp 19–20.

26 'You press the button – we do the rest' was the early advertising slogan for the Kodak camera, signalling its ease of use for the amateur photographer. See Douglas Collins, *The Story of Kodak*, New York, 1990, p.56.

27 The gelatin dryplate process, which came into general use around 1880, significantly reduced exposure times. For the first time, exposures of only a few seconds were possible under the right lighting conditions. See Brian Coe, 'The techniques of Victorian studio photography', in Bevis Hillier, *Victorian Studio Photographs*, Boston, 1976, p.26.

28 Unidentified press cutting, GUL pc5/2.

29 Wanda Corn, *Grant Wood: The Regionalist Vision*, New Haven and London, 1983, p.130.

30 ibid, p.134.

31 See Kevin Sharp, Chapter 4 above.

32 One newspaper commentator estimated that there were five million

reproductions of Whistler's *Mother* in homes around the world by this time. See Edwin C. Hill, 'Human Side of the News', *The Chicago American*, 17 November 1933; quoted in Sharp, Chapter 4 above.

33 Elizabeth Partridge, *This Land Was Made for You and Me: The Life and Songs of Woody Guthrie*, New York, 2002, p.36.

34 Cole Porter, 'You're the Top', from the 1934 musical *Anything Goes*, produced by Norman Granz and performed by Ella Fitzgerald.

35 'New Whistler stamp arouses U.S. artists; complain to Farley', *Chicago Tribune*, 5 May 1934.

36 Sharp discusses this episode in Chapter 4 above.

37 Caroline Glassic, 'Ashland's mother's memorial remains a sacred site for all', *The News-Item Weekender*, Shamokin, PA., 13–14 May 2000. I am grateful to Harry Strouse, director of the Schuylkill Area Community Foundation, for sharing clippings, brochures, and photographs of the Ashland mother's memorial, which was restored by the town in 1994.

38 Harry Tobias, *The Bravest of Them All*, 1918, publisher unknown.

39 Ward Kimball, *Art Afterpieces*, Los Angeles, 1964. In the same volume, we see the *Mona Lisa* in curlers and Botticelli's *Venus* in the *risqué* get-up of a Playboy bunny.

40 *Newsweek*, 22 February 1982, cover illustration.

41 No doubt this kind of juxtaposition will continue; one recent internet site includes an image of Whistler's *Mother* in space, headphones on her ears and a huge *Star Wars*-like space station visible outside her porthole. (David Mattingly illustration, www.davidmattingly.com/Pages/WisMomlgm.html.)

42 The image, one of several in the *Museum of Depressionist Art*, a current internet site, is copyrighted by Ernie Jurick and Andrea Hagadorn, 2001.

43 Mrs Whistler is shown leaving the studio in a mink coat and smoking a cigarette in a collection called *Artoons: The Hystery of Art* by Kevin Reeves, Toronto, 1985.

44 Harvey Kurtzman and Will Elder, *Playboy's Little Annie Fanny*, Milwaukie, Oregon, Dark Horse Comics, 2000, p.43.

45 Edwin Brock, 'Arrangement in Grey and Black', in *And Another Thing*, London, 1999.

46 The picture is frequently used in commercial advertisements, with products ranging from remote-control window blinds (Duette PowerRise blinds – 'It moves ... you don't!') to office furniture (Adirondack fine office furniture – 'It's a sale to make a mother whistle') and milk cartons ('Moms Love Sip Ups').

47 Even serious scholars of Whistler's art have been drawn to pose as Whistler's *Mother*, as several did in front of the picture (including our editor!) when it was shown at the National Gallery of Art in Washington in 1995.

48 We see the face of Tigger, one of the animal characters from Winnie the Pooh, inserted into a version of Whistler's *Mother* as he sings about his family tree in *The Tigger Movie*, Walt Disney Pictures, 2000.

49 The Warner Bros Store on 57th Street in Manhattan sports a façade decorated with bas reliefs and giant canvases parodying works of art; one of these is Wile E. Coyote as Whistler's *Mother*.

50 Warner Brothers' Animaniacs starred in a September 1995 animated cartoon entitled *The Not-So-Model Mother*.

51 *Arrangement in Gray and Black with Creep (Whistler's Weirdo)*, published in Henry Beard (ed.), *Miss Piggy's Treasury of Art Masterpieces from the Kermitage Collection*, New York, 1986, p.17.

52 The image of Barbie as Whistler's *Mother*, a photograph made by Dean Brown in 1983 and later posted on the internet, gained wide exposure in *Newsweek* (19 May 1997) when Mattel moved to shut down unofficial websites devoted to Barbie. I am grateful to Dean Brown for this information and for permission to reproduce his blue version of Whistler's *Mother* here.

53 'How the stars would cast themselves', *Look*, 10 February 1946, p.76.

54 Don DeLillo, *Underworld*, New York, 1997, p.278.

Select bibliography

Richard Dorment and M. F. MacDonald, *James McNeill Whistler*, exh.cat., Tate Gallery, London; Musée d'Orsay, Paris; National Gallery of Art, Washington, DC; 1994–5 (print entries by R. E. Fine)

Robert H. Getscher and P. Marks, *James McNeill Whistler and John Singer Sargent, Two Annotated Bibliographies*, New York and London, 1986

Kate MacDiarmid, *Whistler's Mother: Her Life, Letters & Journal*, unpublished MS in Glasgow University Library; and book, privately printed, no date

Margaret F. MacDonald, *Whistler's Mother's Cookbook*, London, 1979 (2nd edition, California, 1994)

Elizabeth Mumford, *Whistler's Mother: The Life of Anna McNeill Whistler*, Boston, 1939

Elizabeth R. and J. Pennell, *The Life of James McNeill Whistler*, London and Philadelphia, 1908

Robin Spencer (ed.), *A Retrospective*, New York, 1989

Nigel Thorp (ed.), *Whistler on Art: Selected Letters and Writings 1849–1903 of James McNeill Whistler*, Manchester, 1994, and Washington, 1995

James McN. Whistler, *The Gentle Art of Making Enemies*, London, 1890 (2nd edition, 1892)

Chronology

1804 27 September: Anna Matilda McNeill born in Wilmington, North Carolina.

1831 3 November: Anna marries George Washington Whistler.

1834 11 July: Anna's eldest son, James Abbott Whistler, is born in Lowell, Massachusetts. (Her second son, William, is born in 1836.)

1843 28 September: Anna arrives in St Petersburg with James, William and step-daughter Deborah, joining Major Whistler, who was civil engineer on the St Petersburg to Moscow railroad.

1847 Summer is spent in England, where on 16 October James was groomsman at the marriage of his step-sister Deborah to the surgeon, Francis Seymour Haden.

1848 6 July: After a bout of rheumatic fever, which is to have lasting effects on his health, James goes with his mother and brother to London, and remains in England when they return to Russia.

1849 7 April: Major Whistler dies. In August Anna and her sons leave for America, and settle in Pomfret, Connecticut.

1851 1 July: James Whistler enters the United States Military Academy at West Point.

1853 Death of Anna's brother William Gibbs McNeill. Anna regularly stays at 'The Cottage' in Scarsdale, New York, near her friends Margaret and Sarah Hill.

1854 16 June: James Whistler is discharged from West Point. In November, he joins the drawing division of the US Coast and Geodetic Survey, Washington, DC, but resigns in February 1855.

1855 29 July: James Whistler obtains a visa for France in order to study art. In September he leaves New York for England and stays with the Hadens in London en route to Paris.

1858 William Whistler starts medical studies in Philadelphia; Anna joins him.
14 August: James Whistler sets off on an etching tour of France, Luxembourg and the Rhineland from which he returns in October and prints the 'French Set' etchings at Delâtre's in Paris. Meets Bracquemond, Fantin-Latour, and through him, Courbet. The 'Societé de Trois' – Fantin-Latour,

Whistler and Legros – is formed.
November: In London Whistler begins his first important painting, *At the Piano* (YMSM 24).

1859 April: Two etchings accepted for the Salon, *At the Piano* rejected, but praised by Courbet.
6 May: Moves to London, begins the 'Thames Set' etchings.

1860 May: *At the Piano*, his first painting, exhibited at the Royal Academy (hereafter RA). Whistler's mother visits England.

1861–5 The American Civil War. William Whistler joins the confederate army as a surgeon. His mother's health deteriorates and she visits relatives and spas in search of treatment.

1861–2 In the winter James Whistler is in Paris living with Joanna Hiffernan, his mistress and principal model, and painting *The White Girl*, later called *Symphony in White, No. 1: The White Girl* (YMSM 38).

1862 January: Thames etchings are exhibited in Paris and praised by Baudelaire.
21 June: *Once a Week* publishes the first of several illustrations.
1 July: *Athenaeum* publishes Whistler's first letter to the press, about *The White Girl*, rejected at the RA but exhibited in a London gallery.
28 July: Meets Dante Gabriel Rossetti and Algernon Swinburne.
October–December: En route to see Velazquez's paintings in Madrid, Whistler stops at Guéthary and paints *Blue and Silver: Blue Wave, Biarritz* (YMSM 41).

1863 March: Moves to 7 Lindsey Row in Chelsea, near Rossetti, and meets the Pre-Raphaelite circle; and the Greaves brothers.
April: *The White Girl*, rejected by the Salon, enjoys a controversial success at the *Salon des Refusés*.
May: Whistler's etchings win a gold medal at The Hague. Visits Amsterdam.
August: Anna Whistler is in Richmond, VA, nursing William's wife, Ida, and after the latter's death travels to London; by December she is living with James.
December: Whistler paints Oriental subject pictures incorporating his collection, including *La Princesse du pays de la porcelaine* (YMSM 50).

1864 May: *Wapping* (YMSM 35) and *Purple and Rose: The Lange Leizen of the Six Marks* (YMSM 47) are exhibited at the RA.

1865 April: Dr William Whistler settles in London.
May: *Symphony in White, No. 2: The Little White*

Girl (YMSM 52) is exhibited at the RA as *The Little White Girl*. Whistler meets Albert Moore.
October–November: He joins Jo (Joanna Hiffernan) and Courbet at Trouville.

1866 January: Whistler sails to South America, hoping to sell arms, during a dispute between Chile and Spain. In Valparaiso, he paints seascapes including his first night scenes (YMSM 73, 76). September: Sails for England.

1867 February: Moves to 2 Lindsey Row (96 Cheyne Walk) after parting amicably from Jo.
23 April: During a family quarrel knocks his brother-in-law Haden through a window in Paris.
May: *Symphony in White, No. 3* is exhibited at the RA, the first picture he exhibited with a musical title (YMSM 61).

1868 During the summer, works on the *Six Projects* (YMSM 82–7). Paints *The Three Girls* (YMSM 88) in Frederick Jameson's studio.

1869 May: Perfecting cartoon of *Venus* (M.357): the first work signed with a butterfly monogram. Autumn: Visits Speke Hall, home of the Liverpool ship-owner, F. R. Leyland, who commissions family portraits.

1870 10 June: Birth of Charles James Whistler Hanson, child of Whistler and Louisa Hanson, a parlourmaid.

1871 Spring: Publishes *Sixteen Etchings of Scenes on the Thames* (the 'Thames set'). Begins painting 'Moonlights' of the Thames.
Summer: Paints his mother's portrait.

1872 February: Becomes engaged, briefly, to Mrs Leyland's sister, Elizabeth Dawson.
May: *Arrangement in Grey and Black: Portrait of the Painter's Mother* (YMSM 101) is admitted to the RA after Sir William Boxall threatens to resign if it is rejected. It is the last picture he exhibits at the RA.
November: In an exhibition at the Dudley Gallery Whistler uses the word 'Nocturne' for the first time to describe his night pictures (YMSM 117–18).

1873 January: The *Mother* exhibited at Durand-Ruel's in Paris.
July: Whistler paints the portrait of Thomas Carlyle (YMSM 137).
Winter: Maud Franklin, now Whistler's mistress and chief model, stands in for Mrs Leyland's portrait, *Symphony in Flesh Colour and Pink* (YMSM 106).

1874 June: Whistler holds his first one-man exhibition, in the Flemish Gallery, Pall Mall, with

thirteen oils and thirty-six drawings, including portraits of his mother, Carlyle and the Leylands.

1875 8 August: Whistler's mother, on doctor's advice, goes to live in Hastings for the rest of her life. Whistler begins to entertain lavishly.
September: Paints Nocturnes of Cremorne Gardens. *Nocturne in Black and Gold: The Falling Rocket* (YMSM 170) is exhibited at the Dudley Gallery in November.

1876 March: Whistler engaged in decorating the hall of Leyland's London house, 49 Princes Gate. By September he is painting the dining room with peacock motifs.

1877 9 February: Press view of the Peacock Room, *Harmony in Blue and Gold* (YMSM 178). Having exceeded his commission, Whistler is paid half the 2000 guineas he expected.
17 April: William Whistler marries Miss Helen Ionides.
May: Whistler's exhibits at the Grosvenor Gallery include *Nocturne in Black and Gold: The Falling Rocket*. John Ruskin writes in *Fors Clavigera* that he 'never expected to hear a coxcomb ask two hundred guineas for flinging a pot of paint in the public's face'. Whistler sues him for libel.
September: Commissions E. W. Godwin to build the White House in Tite Street.
May: Exhibits *Nocturne: Grey and Gold–Chelsea Snow* (YMSM 174). In the *World* on 22 May he declares his aesthetic theories: 'The picture should have its own merit, and not depend upon dramatic, or legendary, or local interest.'
25 June: Whistler's tenancy of 96 Cheyne Walk ends; in September he moves to the White House.
25–6 November: In his libel action against Ruskin, Whistler is awarded a farthing's damages without costs; in December he publishes *Whistler v. Ruskin: Art and Art Critics*, the first of a series of brown paper pamphlets.

1878 9 September: Deposits the portrait of his mother with Graves and Co. as security for a loan.

1879 2 February: Birth of Maud McNeill Whistler Franklin, daughter of Whistler and Maud Franklin.
8 May: Whistler is declared insolvent; bailiffs take possession of the White House, but Whistler remains in residence.
June: The *Mother* is engraved by Richard Josey.
September: Whistler leaves for Venice with a commission from The Fine Art Society for twelve etchings.

1880 Summer: In the Casa Jankowitz on the Riva degli Schiavoni living with Frank Duveneck's art students; returns to London in November.
December: Exhibits twelve etchings of Venice at The Fine Art Society.

1881 9 January: Private view of fifty-three Venice pastels at The Fine Art Society.
31 January: Whistler's mother dies.
22 March: Whistler leases flat and studio at 13 Tite Street.
August: Painting three portraits of Lady Meux (YMSM 228–30). Becomes friendly with Oscar Wilde.

1881–2 The *Mother* is exhibited at Pennsylvania Academy of the Fine Arts in Philadelphia, and then in New York; priced at $1200, it remains unsold.

1883 17 February: Private view of fifty-one etchings, mostly of Venice, at The Fine Art Society in rooms decorated in white and yellow.
7 May: In Paris. Walter Sickert escorts the *Mother* to the Salon, where it is awarded a third-class medal, and praised by Théodore Duret, whom Whistler painted (YMSM 252).

1884 January: At St Ives, Cornwall, with his pupils Mortimer Menpes and Walter Sickert.
17 May: One-man exhibition, *Notes – Harmonies – Nocturnes*, at Messrs Dowdeswell.
11 October: Leases studio at 454A Fulham Road.
November: Whistler rejects an offer from Jonathan Hogg in Dublin to buy the *Mother*.

1885 20 February: Delivers the 'Ten O'Clock' lecture in Princes Hall, London.
Summer: At the 'Pink Palace', The Vale, Chelsea.

1886 April: *Twenty-Six Etchings of Venice* issued by Messrs Dowdeswell.
May: Second one-man exhibition, *Notes – Harmonies – Nocturnes*, at Messrs Dowdeswell.
1 June: Is elected president of the Society of British Artists (SBA), takes office in December and sets out to reform the Society.
6 October: Death of E. W. Godwin. Whistler's portrait of Godwin's widow Beatrice (YMSM 253) is sent to the SBA winter exhibition.

1887 May: Fifty works are shown at *Exposition Internationale de Peinture*, Galerie Georges Petit.
20 June: Whistler sends an illuminated Address congratulating Queen Victoria on the occasion of her Jubilee, on behalf of the SBA; the Society receives a royal charter, becoming the Royal Society of British Artists (RBA).

1888 4 June: Resigns as RBA president but retains the post until November.

13 June: In Paris, Monet introduces Stéphane Mallarmé who translates the 'Ten O'Clock' lecture into French. Moves to 14 Upper Cheyne Row and then the Tower House, Tite Street.
Summer: The *Mother* is awarded a second-class gold medal in Munich *Internationale Kunst-Austellung*.
11 August: Whistler marries Beatrice Godwin, abruptly abandoning Maud.

1889 February: The *Mother* is exhibited at the Glasgow Institute of the Fine Arts.
March: *Notes – Harmonies – Nocturnes* at Wunderlich's in New York.
May: Retrospective exhibition is organised by Sickert in the College for Working Men and Women, London, and includes the *Mother*.
4 September: Whistler's *Mother* is included in the *International Exhibition* in Amsterdam; the artist is awarded a gold metal.

1890 February: Whistler moves to 21 Cheyne Walk. An unauthorised edition of Whistler's letters, *The Gentle Art of Making Enemies*, edited by Sheridan Ford, is suppressed by Whistler's lawyers. William Heinemann publishes Whistler's version in June. It includes letters, pamphlets and statements on art and aesthetics.
March: Meets C. L. Freer of Detroit, a major collector of Whistler's work.

1891 13 February: Comte Robert de Montesquiou-Fezensac commissions his portrait (YMSM 398).
2 April: Local artists persuade the Corporation of Glasgow to buy the portrait of Carlyle – the first of Whistler's pictures bought for a public collection.
October: Whistler's *Mother*, after being exhibited at the Society of Portrait Painters in London, is shown 'privately' at Goupil's in Paris.
2 November: Whistler's *Mother* is bought for the Musée du Luxembourg, largely through the efforts of Mallarmé, Duret and Roger Marx.

1892 January: Whistler promoted *Officier de la Légion d'honneur*.
19 March: Retrospective exhibition, *Nocturnes, Marines, Chevalet Pieces*, opens at the Goupil Gallery, London.
April: In Paris, moves into 110 rue du Bac in September; takes a studio at 186 rue Notre-Dame-des-Champs.

1893 Works in Paris on portraits and lithographs, and in Brittany on seascapes.

1894 *La Dame au brodequin jaune* (YMSM 242) is bought for the Wilstach Collection, the first work bought for an American public collection.

December: Beatrice Whistler's health deteriorates and he takes her to London for medical advice.

1895 April–May: Paints portraits of his sister-in-law Ethel Philip in Paris.
June: In Paris painting a self-portrait, in the pose of Velazquez's *Pablo de Valladolid* (YMSM 440)
15 September: In Lyme Regis in Dorset, working on lithographs and paintings.
Exhibition of seventy-five lithographs at The Fine Art Society.

1896 January–March: Beatrice Whistler very ill.
March: Whistler takes a studio at 8 Fitzroy Street. The Whistlers move to St Jude's Cottage on Hampstead Heath.
10 May: Beatrice Whistler dies of cancer. Whistler makes his sister-in-law Rosalind his ward and executrix.
5 November: Opening of first annual exhibition at Carnegie Institute, Pittsburgh, which includes the *Portrait of Sarasate* (YMSM 315), bought by the Institute on 30 November.

1897 2 April: Whistler establishes The Company of the Butterfly at 2 Hinde Street to sell his work. (It closed in 1901.)
Summer: Elizabeth R. and Joseph Pennell begin to keep a journal about Whistler.

1898 16 February: Whistler is elected chairman, and in April, president, of the newly established International Society of Sculptors, Painters and Gravers (ISSPG), and attends the opening of the first exhibition on 16 May at the Skating Rink, Knightsbridge.
9 September: Whistler, ill in London, is deeply affected by death of Mallarmé.
October: Whistler returns to Paris. His model, Carmen Rossi, opened an academy at 6 Passage Stanislas, with Whistler and the sculptor F. MacMonnies as visiting tutors.

1899 7 May: Opening of second ISSPG exhibition in Knightsbridge.
13 May: *Eden versus Whistler: The Baronet and the Butterfly*, a record of a dispute over ownership of his portrait of Lady Eden, was published in Paris.

1900 February: Dr William Whistler dies.
28 May: Heinemann asks the Pennells to write the life of Whistler.
15 December: Whistler sets out for Algiers on doctor's orders, then falls ill in Marseilles.

1901 Stays in Hotel Schweizerhof, Ajaccio.
1 May: Returns by boat from Corsica via Marseilles to England, but in September is again in poor health.
October: Closes his house and studio in Paris.

1902 April: Leases 2 Cheyne Walk and lives there with the Birnie Philips.
July: While on holiday with Freer Whistler becomes ill, at the Hotel des Indes, The Hague. On 3 August he congratulates the *Morning Post* on their premature obituary.

1903 April: Receives an honorary degree from the University of Glasgow but is too ill to attend the ceremony.
30 June: The gambler, Richard Canfield, tells Duret in Paris that Whistler's health has improved and that he has been working on his portrait.
17 July: Whistler dies in London, having suffered, according to the death certificate, a 'cerebral embolism'.

Index